# THE PRICE GUIDE
# TO
# 18TH CENTURY ENGLISH
# PORCELAIN

by Simon Spero

published by   THE ANTIQUE COLLECTORS' CLUB
5 Church Street
Woodbridge
Suffolk

Printed in England by
Baron Publishing, Woodbridge, Suffolk.

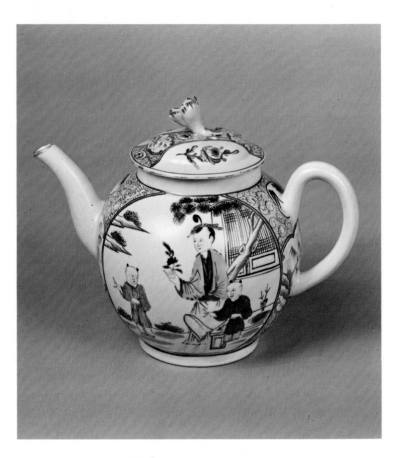

## WORCESTER c.1770-72

This attractive teapot illustrates a standard Worcester shape of the early 1770's. A fine and varied range of colours was used and these were vigorously if not always delicately applied. The 'Chinese Mandarin' style of decoration was popular at all the early English factories although the quality and sophistication of the decoration varied considerably and did not always reach the standard of the example illustrated.

*see page 72*

# FOREWORD

The Antique Collectors' Club, formed in 1966, pioneered the provision of information on prices for collectors. The Club's monthly magazine *Antique Collecting* was the first to tackle the complex problems of describing to collectors the various features which can influence prices. In response to the enormous demand for this type of information the *Price Guide Series* was introduced in 1968 with **The Price Guide to Antique Furniture**, a book which broke new ground by illustrating the more common types of antique furniture, the sort that collectors could buy in shops and at auctions, rather than the rare museum pieces which had previously been used (and still to a large extent are used) to make up the limited amount of illustrations in books published by commercial publishers. Many other price guides have followed, all copiously illustrated, and greatly appreciated by collectors for the valuable information they contain, quite apart from prices.

Club membership, which is open to all collectors, costs £6.95 per annum. Members receive free of charge *Antique Collecting,* the Club's monthly magazine, which contains well-illustrated articles dealing with the practical aspects of collecting not normally dealt with by magazines. Prices, features of value, investment potential, fakes and forgeries are all given prominence in the magazine.

In addition members buy and sell among themselves; the Club charges a nominal fee for introductions but takes no commission. Since the Club started many thousands of antiques have been offered for sale privately. No other publication contains anything to match the long list of items for sale privately which appears monthly.

The presentation of useful information and the facility to buy and sell privately would alone have assured the success of the Club, but perhaps the feature most valued by members is the ability to make contact with other collectors living nearby. Not only do members learn about the other branches of collecting but they make interesting friendships. The Club organises weekend seminars and other meetings.

As its motto implies, the club is an amateur organisation designed to help collectors to get the most out of their hobby; it is informal and friendly and gives enormous enjoyment to all concerned.

*For Collectors -- By Collectors – About Collecting*

**The Antique Collectors' Club, 5 Church Street, Woodbridge, Suffolk.**

To: G. J. H.

# CONTENTS

## ACKNOWLEDGEMENTS

Firstly I would like to thank John Howell who was responsible for much of the provision and organisation of the photography for this book. He was also a source of great assistance and advice in the writing of it.

My thanks are also due to David Gibbins, Diana Thorpe and John Steel who were involved in this project from its inception and who have given me help and advice as well as organising the photography done in East Anglia.

I am also indebted to the following who gave me the benefit of their advice and knowledge in the compiling of the book: Arthur Filkins, Janette Howell, Kit Holgate, Peter Pryce, Mrs. S. Richards and Roy Truman.

The following fellow-collectors helped me greatly by supplying photographs of pieces in their private collections: Mr. and Mrs. Peter Bennett, Mr. and Mrs. Peter Dunk, Gilbert Bradley, Mr. H. Dalziel Smith, Mr. L. Darke, David Gibbins, Mr. and Mrs. David Holgate, Mr. and Mrs. John Howell, Peter Pryce, Mr. and Mrs. D.M. Sawdon, Charles Silburn, Dr. and Mrs. I. Sutherland, Dr. Bernard Watney and John Worrell.

I would also like to express my gratitude to the various firms which supplied photographs for this book. They include:

> Chichester Antiques (Porcelain Department)
> China Choice
> Messrs. Christie's
> Delomosne & Son Ltd.
> Mercury Antiques
> Messrs. Sotheby & Co.

Finally I would like to thank Miss Jane Gwilliam and Miss Philippa Spero for interpreting and typing my notes.

# PRICE REVISION LISTS

### 1st October annually

The prices in this book can be updated annually by completing the banker's order form which is enclosed and sending it to the Club at the address given below.

Over the period of a year prices can change substantially, not just overall but in different areas as fashion and interest centres on one particular type of porcelain.

By subscribing to the annual revision lists your book will never be outdated, and you will have a guide to prices which is much more reliable than prices quoted at auction which can fluctuate wildly.

Damage, a dealers' ring or just lack of interest can result in a very low price, on the other hand competition between private buyers can have the effect of raising the price to above retail price.

Price revision lists cost £1.25 per annum by banker's order, or £1.50 cash.

*From:*
**The Antique Collectors' Club**
**5 Church Street**
**Woodbridge**
**Suffolk**

\*     \*     \*

# PREFACE

In choosing the four hundred or so objects to illustrate in this book, I have tried to pick those which the collector is most likely to have the chance of buying. I have added to these a sprinkling of rare and fine pieces which are well-known or in some way particularly characteristic of their factory. No doubt some people will wish that I had illustrated more Longton Hall, for example, and perhaps less Worcester. However, the fact is that all Longton Hall is scarce whilst many Worcester shapes are still quite common. Similarly, I have illustrated many more teabowls and saucers than any other shape because they are the most commonly found articles. I have in other words tried to illustrate pieces which can still be found today.

Almost any piece of eighteenth century English porcelain is liable to a price variation of up to 50%, sometimes more according to the area, shop or saleroom in which it is offered for sale. The rarer the article is, the greater the variations in price will be. Consequently the difficulties in setting a price within a range of about 25% are considerable. The prices I have chosen are those which in my opinion a collector would be required to pay in a shop specialising in early English porcelain. By this I mean a shop which has a stock of fifty or so pieces and whose proprietor should be fairly knowledgeable about what he is selling.

It is a mistake to assume that because a dealer seems expensive for one type of porcelain, he will necessarily be expensive for another. An individual dealer's prices are governed by two main considerations: the price that he gave for the article and the value and rarity of it in his opinion. For instance, a dealer might have bought an article cheaply or not have realised the full extent of its value and rarity. In either case he is likely to sell it for less than its probable market value. Similarly if he has had to pay highly for it or if he has an inflated idea of its rarity and value, it will be rather expensive. Prices then are a matter of opinion and like opinions they will vary from person to person.

Where then is it best to buy early English porcelain? Continual searching in junk shops and their like may occasionally result in bargains but these will be few and far between. The general antique shop might well have the odd piece of early porcelain but the owner's possible ignorance of its value will not always cause it to be cheap. Moreover one can hardly expect a non-specialist dealer to guarantee all his stock. There are many all-too-obvious disadvantages (for the inexperienced collector) in buying at auctions. Only the main London salerooms and

a few provincial ones offer any guarantee of the period, provenance and condition of what they are selling. Strangely enough, comparatively ordinary pieces can often be bought more cheaply in the main London salerooms than in the smaller country sales.

What about the specialist dealer? Whilst he will not often be the source of a bargain, there are three distinct advantages to be gained by buying from him. Firstly, the more specialised he is, the larger the selection of pieces he has to offer. Secondly the collector should have the benefit of his experience and specialised knowledge; and thirdly the specialist dealer can be expected to provide a detailed guarantee of the condition, provenance and approximate date of anything in his stock. Any dealer who refuses to give a detailed invoice should be regarded with caution.

It is difficult and hazardous to generalize about comparative prices in different parts of the country but several points can be safely made. The term 'provincial prices' with its various implications is one that is bandied about quite freely. What is not generally known by collectors is that many provincial dealers buy a large proportion of their stock in London. I am not suggesting that London prices are always lower than those elsewhere, but they are not necessarily always higher. London is very much the centre of the antique porcelain trade in this country and its numbers of specialist shops and range of prices is vastly greater than elsewhere.

Certain porcelains tend to be more expensive in or near their place of origin due to the particularly high demand among collectors in that area. This applies especially to Derby, Lowestoft, Plymouth and hard paste Bristol.

The truth of the matter is that the collector must decide for himself which dealers combine a fairly large stock, and sound knowledge of what they are selling, with fair or average prices. It should be remembered that any shop which had a reputation for low prices would very soon have no stock at all.

## DAMAGE

All pieces in this book are priced as for a perfect article although sometimes when damage can be clearly seen from the photograph an appropriate price is also given. There are two main reasons for buying a damaged piece of porcelain: if one cannot obtain it in perfect condition or if one cannot afford to buy a perfect example. Nowadays when most good porcelain is scarce and expensive, many damaged pieces are

quite sought-after and the rarer ones sometimes command surprisingly high prices. As an investment however, damaged or restored articles appreciate at a slower rate than comparable perfect ones. Moreover, in the event of a recession in prices, the first types of porcelain to suffer will be the damaged pieces.

How much does damage affect the price? This is a very difficult question as damaged pieces will vary in price even more than perfect ones. It is probably fair to say that the more common the article or shape is, the greater the effect any damage will have on its price. Another important consideration is whether the damage is unsightly and spoils the shape, line or decoration of the article. A chip is generally considered to be less important than a crack particularly if it is on the underside of a plate or saucer. It is important to differentiate between a 'fire crack' and an ordinary one. The former is a fault in manufacture and usually has only a slight effect on the article's value. The presence of glaze over chips or cracks usually indicates a factory fault. It is a sad reflection on the increasing scarcity of early porcelains that nowadays even some of the more humble damaged pieces are being restored. This usually entails an article being sprayed with paint in order to disguise the presence of a crack or some other defect.

Many of the foregoing comments do not apply to figures. Few of the more elaborate models are entirely free of damage and if the restoration is slight and skilfully done, the value is only slightly reduced. If the model is a rare one, it can still be a valuable and desirable piece even when quite badly damaged; the quality of the restoration is the all-important factor. As a general guide therefore, do not expect absolute perfection in a figure because you will seldom get it.

## INVESTMENT

In the last ten years or so most types of early English porcelain have risen in price by at least 300% - 400%, in many cases more. This of course is no more than a reflection of the remarkable rise in prices which has taken place in all branches of antiques and fine arts. It has been caused by inflation together with the increasing awareness and interest of many people in antiques. The considerable publicity in the press and on television has made a surprisingly large and varied cross-section of the community antique-conscious. This in its turn has been reflected in the veritable flood of books on different aspects of antiques which have appeared over the last few years. A great interest has been aroused in what can be that most rewarding of past-times, a profitable

hobby. At its best, collecting antiques combines the pleasure of posessing things of the past with a sound and sometimes spectacular investment for the future. Naturally some branches of antiques provide a better investment than others, but there is one rule that always holds good: quality counts. This might seem trite and self-evident but there is no doubt that a really good specimen of its type will always be as sound an investment as one can hope to find in antiques.

There is however a danger of the collector becoming so pre-occupied with values and rates of appreciation that he loses the essential enjoyment of collecting and instead becomes merely an investor. After all, antiques are part of our cultural heritage and it is in a way a pity that they have become so inextricably associated with commercialism. On the other hand the cynic might enquire how many collectors there would be if antiques had no monetary value at all. It is therefore up to each individual collector to find his own particular balance between the pleasures of collecting and the profits of investing.

I will conclude by saying that while I hope that most of what I have written in the introductory chapters and captions is relatively indisputable, the prices given are very much a matter of opinion rather than of fact.

# CHELSEA 1745-1770

The best-known and probably the most highly prized porcelains ever made in this country were those produced at Chelsea. The factory had an international reputation unmatched by any of its English rivals. Chelsea produced a much higher percentage of non-useful wares than any other factory and had virtually a monopoly of the highly decorated porcelains in rococo style which were in fashion in the 1760's. The figures of the red anchor period bear comparison with any made in Europe and certainly represent the summit of figure modelling in this country.

Chelsea has always been a wealthy man's factory and indeed many of the wares were collectors' pieces when they were originally sold. The products of the triangle period (1745-49) are now very scarce and invariably very costly. Perhaps the best-known articles are the 'goat and bee' creamjugs which, like so many of the early shapes, are based on silver prototypes. Other forms are beakers with raised moulding, crayfish salts and the wonderful 'tea plant' coffee pots. Many objects are left undecorated but when overglaze painting occurs, it is very finely done and usually in Chinese or Kakiemon style.

The wares of the raised anchor period (1750-53) are only slightly less scarce and expensive. Teawares are often octagonal, as are bowls and creamboats. Plates, dishes and beakers are the most often found shapes apart from teawares, but mugs and coffee pots are extremely rare. Many of the shapes are derived from contemporary silver or from Meissen and the decoration is either in Kakiemon style or in a rather sparse floral style. A few botanical plates date from this period and these are invariably very finely painted. The most sought-after useful wares are those painted by J.H. O'Neale. The decoration is nearly always of subjects taken from Aesop's Fables and specimens always command particularly high prices. Also highly-prized are the scarce teawares and dishes decorated with European scenes in the Meissen manner. Any specimen of this period bearing a raised anchor mark is worth up to 30% more than its unmarked counterpart.

In the red anchor period (1754-58) the decoration is mainly influenced by the Meissen factory. Characteristic of the period is the fine flower painting which is found on plates, dishes, mugs, fingerbowls and stands, sauceboats and teawares. The fine botanical plates are decorated with flowers, plants, vegetables and insects and vary considerably in

1

price according to their quality. Leaf moulded wares are rare and invariably expensive, as are the Longton Hall examples which date from the same period. Plates and dishes were easily the most common shapes made at Chelsea. Other standard forms of this period include teawares, sauceboats, mugs, leaf dishes of various types, baskets and small tureens and stands; coffee pots and creamjugs are very scarce. A little over half these wares are marked with a small red anchor.

The gold anchor period (1758-70) is the age of rococo, of copious rich gilding and of the famous Chelsea 'mazarine' blue. The shapes, decoration and often the objects themselves are more flamboyant than in the earlier periods and the style was much influenced by the fashionable Sèvres factory. Exotic birds are a commonly found form of decoration as is flower and fruit painting in an altogether fuller richer and less restrained style than that of the red anchor period. Flatware of all kinds is common and plates and dishes usually have shaped edges and sometimes elaborate border designs. Whilst leaf dishes, open-work baskets, small tureens and even vases were produced in quantity, teawares are less plentiful than one might expect. The glaze is thick and tends to craze and pool, and footrings are often ground. Some pieces were bought 'in the white' by James Giles and decorated in his workshop in Kentish Town.

In the past, Chelsea porcelain has been very much subject to changes of fashion and taste; this has of course affected its price. In the late nineteenth century for example, gold anchor wares were much collected and consequently expensive, whereas there was hardly any demand for the earlier wares. As late as the 1930's, whilst gold anchor porcelains were expensive, raised anchor marked beakers could be bought for under £2 each. Nowadays some of the more exotic specimens of the gold anchor period are not fetching as high a price as they have done in the past; the same could not be said for many other types of English porcelain. The comparatively small number of people who can afford to collect Chelsea cause its price to be more uneven than those of Worcester for example. However, a good specimen (or better still a rare one) bought at a sensible price should always be a sound investment.

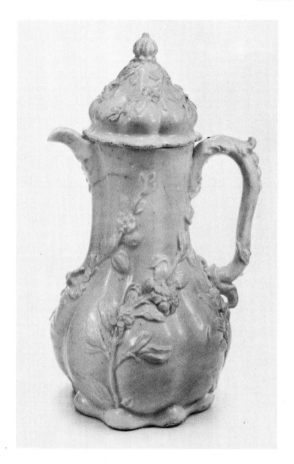

### Coffee Pot c.1745-49
#### Height 9in.  triangle mark

A superb white 'tea plant' coffee pot, the shape being derived from contemporary silver. This is one of the finest and most beautiful of all the English eighteenth century porcelain shapes. Extremely rare.

*£1,200–2,000*

# Chelsea
## Undecorated

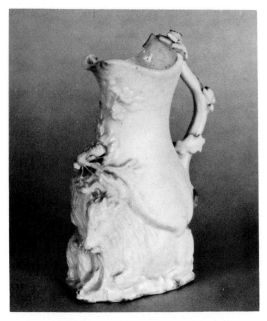

**Creamjug c.1745-49**
**Height 3¾in. incised triangle mark**

One of the well-known Chelsea 'Goat and Bee' creamjugs. This shape was taken from a silver original and occurs sometimes in polychrome although it was more often left undecorated. A famous, rare and desirable form, it was consequently copied by several factories including Coalport. Beware also of later decorated Chelsea examples and specimens which have had their triangle mark incised in the base at a later date.

*£270–350*

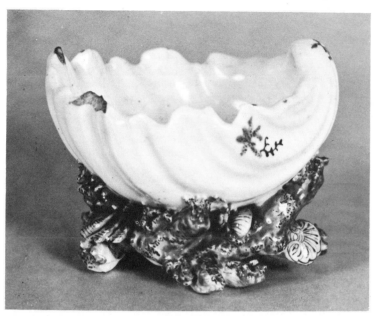

**Salt c.1745-49**
**Diameter 3in. incised triangle**

A very rare coloured Chelsea salt supported on coral branches and encrusted with small shells and aquatic weeds. Many specimens were left undecorated and are consequently less valuable. All wares of the triangle period are very rare today and in great demand, particularly when marked.

*£480–650*

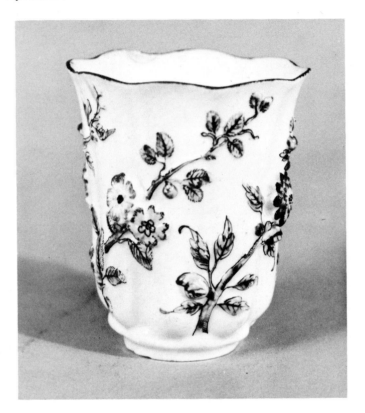

**Beaker c.1748-49**
**Height 3in.  no mark**

A rare triangle period beaker with moulded decoration picked out in fine strong colours. The raised 'teaplant' decoration is reminiscent of that found on the wonderful coffee pots of the same period. It seems that no saucers were made to go with these beakers. A triangle mark increases the value considerably. Very rare.

*£170–220*

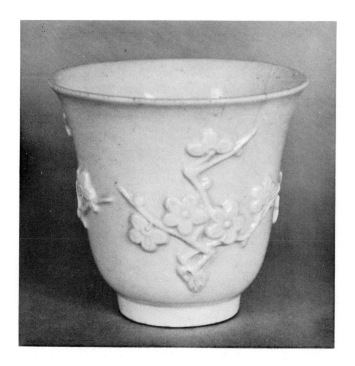

**Beaker c.1750-52**
**Height 3¼in. no mark**

A raised anchor period white beaker with raised moulding. The shape and decoration is inspired by the Chinese 'blanc-de-Chine' originals. A raised anchor mark would increase the value of this beaker by about 40%. Examples are scarce.

*£90–115*

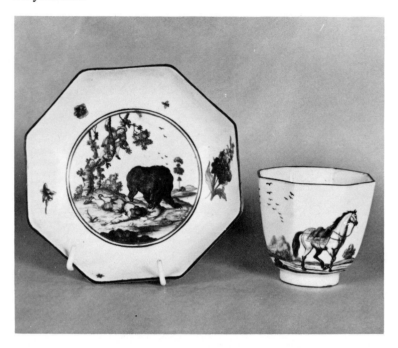

### Teabowl and Saucer c.1750-52
**Diameter of saucer 5¼in.  no mark**

A raised anchor period Fable-decorated teabowl and saucer superbly
painted by J.H. O'Neale. The decoration is in Vincennes style and the
subjects are taken from Aesop's Fables. Fable-decorated Chelsea of this
period is one of the most desirable classes of English porcelain. Very
rare.

*£850–1,100*

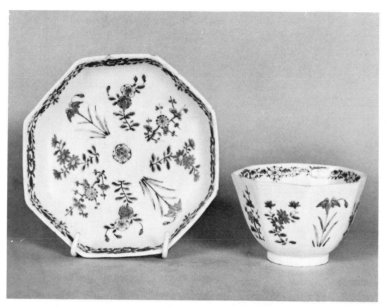

**Teabowl and Saucer c.1750-52**
**Diameter of saucer 5in. raised anchor mark**

A raised anchor period octagonal teabowl and saucer decorated in Kakiemon style. The Japanese influence at Chelsea was very strong in the early 1750's. The majority of the raised anchor period teawares are octagonal in shape. Rare.

*£220–300*

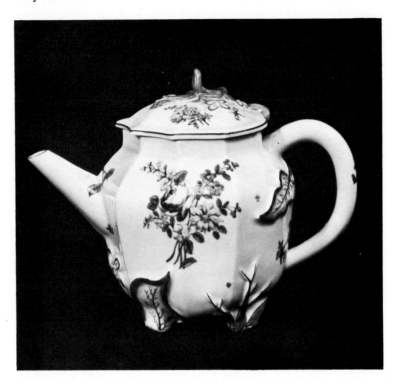

**Teapot c.1755**
**Height 5in. red anchor mark**

A superb strawberry leaf moulded widely-fluted red anchor period tea-pot painted with fine floral sprays. As well as being extremely rare, this teapot is of altogether exceptional quality and such pieces are almost impossible to evaluate with any degree of accuracy.

*It fetched 2,300 guineas in 1968*

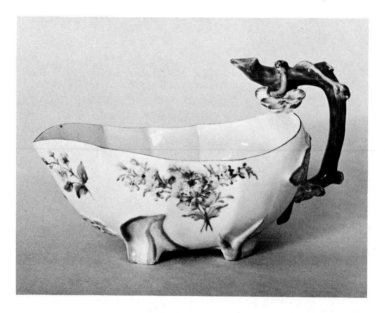

### Sauceboat c.1755
**Length 6½in.  red anchor mark**

A moulded strawberry leaf sauceboat on four feet painted with flower sprays. The amount of floral decoration on these well-known Chelsea sauceboats varies and affects their price. In silver, sauceboats together with many other shapes are worth considerably more in pairs, sometimes up to half as much again. In porcelain, pairs of articles are worth little if anything more than double the singletons. The exceptions to this include figures and some of the more elaborate vases.

*£180–240*

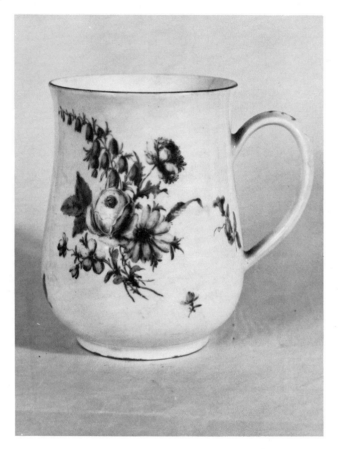

**Mug c.1755**
**Height 4½in. red anchor mark**

A red anchor period bell-shaped mug attractively painted with sprays of English flowers. The predominating influence at Chelsea in this period was that of Meissen.

*£170–220*

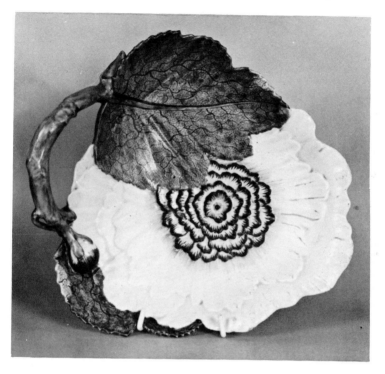

**Dish c.1754-56**
**Diameter 9in.  red anchor mark**

A fine red anchor period Chelsea dish moulded in the shape of a peony and painted in fine strong colours. The fashion for leaf-moulded wares which was derived from Meissen, was at its height in the mid-1750's and its influence was strongly felt at Chelsea, Longton Hall and Derby.

*£230–290*

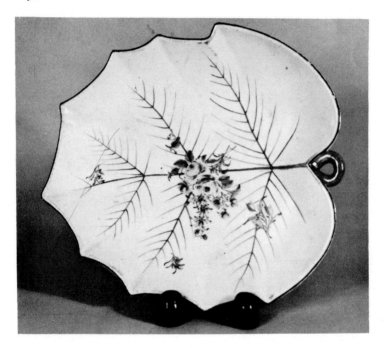

### Leaf Dish c.1755
**Length 9in.  red anchor mark**

This dish is in the form of a strawberry leaf and is supported on moulded stalk feet joined by tendrils and leaves. It was perhaps intended as a stand for a sauceboat of the type illustrated on page 11 . The decoration is typical of the period.

*£125–160*

**Dish c.1754-56**
**Length 9½in. no mark**

A red anchor period silver shape dish. The shape is characteristic of Chelsea as is the carefully done but sparse floral decoration. Chelsea footrings are often ground.

*£85–110*

### Plate c.1754-55
**Diameter 9½in.  red anchor mark**

A fine Chelsea 'Hans Sloane' plate painted in botanical style with a plant with star-shaped dark green leaves and globular seed-pods. Botanical plates vary enormously both in quality and in price; the better specimens such as the one illustrated, are very desirable.

*£700–900*

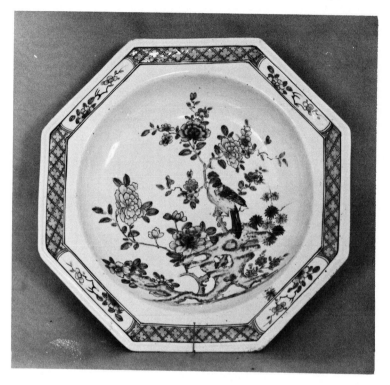

### Plate c.1753-55
**Diameter 9¼in. no mark**

This fine red anchor period octagonal plate is decorated in soft pale colours in the style of the Chinese 'famille rose'. This decoration is perhaps slightly unusual in a period when the main influences on Chelsea were those of Meissen and of Japanese porcelain.

*£140–180*

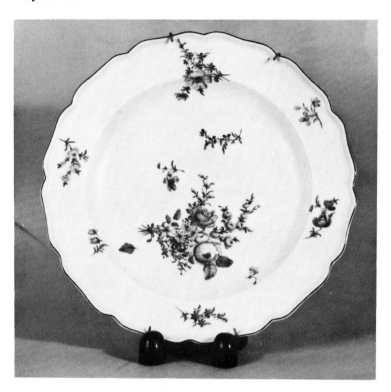

## Plate c.1755-57
### Diameter 9½in.  red anchor mark

A typical Chelsea red anchor plate painted with a bouquet of garden flowers and other scattered sprays. Plates with this decoration are the most common Chelsea wares of the red anchor period.

*£85–110*

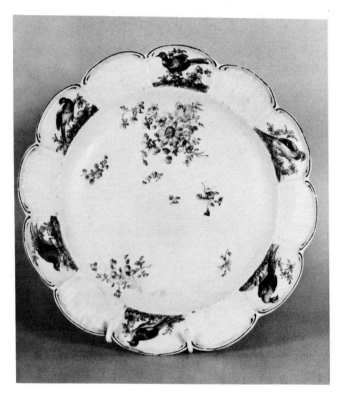

### Plate c.1756-58
**Diameter 8¾in.  red anchor mark**

This plate is decorated with floral sprays and birds; a rather odd combination. It dates from the end of the red anchor period. Any 'rubbing' on a plate of this type greatly reduces its value.

*£85–115*

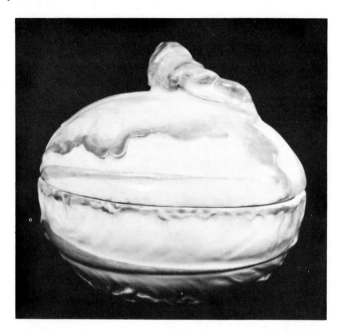

**Tureen c.1755**
**Width 5in.  red anchor mark**

A fine Chelsea lettuce tureen and cover moulded with puce stalked leaves edged in green, the edge of one leaf scrolled upwards to form the finial. All leaf-moulded forms of this type are rare and very desirable.

*£900–1,200*

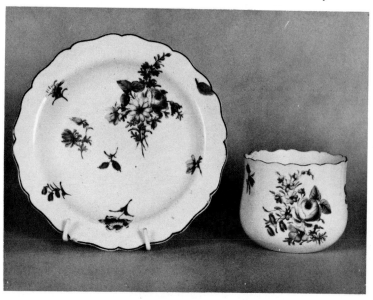

### Finger Bowl and Stand c.1755
**Diameter of stand 5½in.  red anchor mark**

A fine Chelsea finger bowl and stand painted with sprays of garden flowers. These rather scarce articles were also produced at Worcester in both blue and white and polychrome during the period c.1754-1765.

*£160–200*

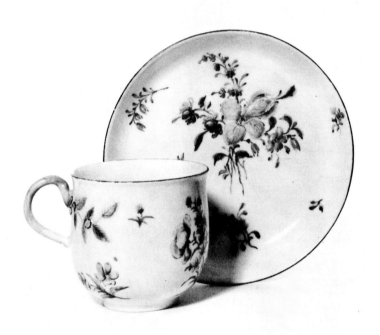

### Coffee Cup and Saucer c.1755
**Diameter of saucer 4¾in. red anchor mark**

A very typical coffee cup and saucer of the red anchor period showing good quality flower painting and the characteristically bell-shaped cup. Teawares are much less common than plates and dishes in this period, creamjugs and sucriers being particularly scarce.

*£115–140*

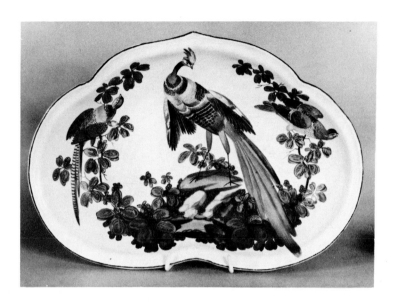

**Dish c.1758-60**
**Width 11½in.  brown anchor mark**

A fine kidney-shaped dish painted with exotic birds, possibly by James Giles. Some of the wares of the period c.1758-60 are totally unlike the usual Chelsea in both their paste and their translucancy. These heavily potted pieces are almost opaque to transmitted light and most of them bear a brown anchor mark.

*£135–175*

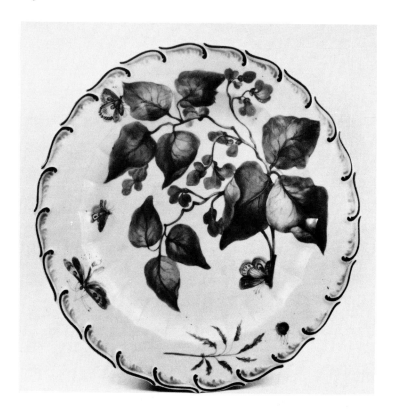

### Plate c.1762-65
#### Diameter 8½in.  gold anchor mark

An attractive gold anchor period Chelsea plate with its feather-moulded rim picked out in turquoise and brown. The centre is well-decorated with leaves and insects. A typical specimen of its period.

*£175–220*

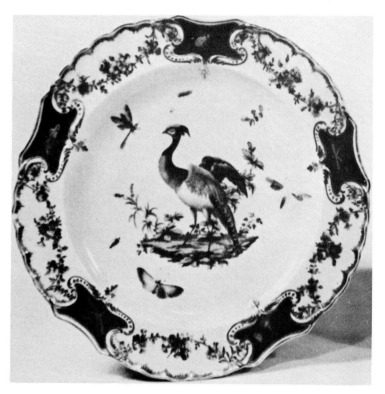

**Plate c.1764-65**
Diameter 8¾in.  gold anchor mark

A fine Chelsea plate decorated in the style of the Mecklenburg-Strelitz service with an exotic bird, insects and floral swags. The mazarine blue panels on the original service are convex and not concave as on this plate. The service was presented by George III and Queen Charlotte to her brother, the Duke of Mecklenburg-Strelitz in 1763.

*£140–180*

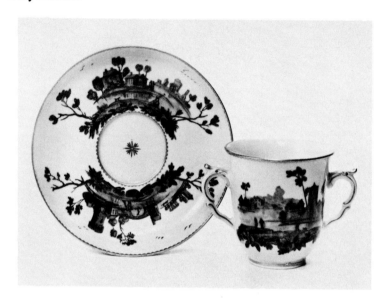

## Cup and Saucer c.1765-68
### Diameter of saucer 5¾in. gold anchor mark

An outside-decorated Chelsea double-handled cup and saucer finely painted by James Giles in tones of green, with a European style river scene. The decoration is very unusual. A rare article.

*£110–145*

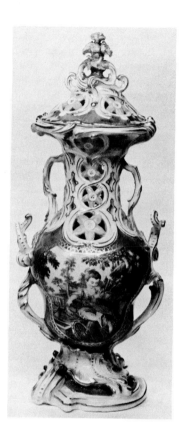

### Vase c.1762-65
### Height 13in.  gold anchor mark

A superb claret ground rococo vase and pierced cover. The elaborate shape and sumptious decoration are derived from Vincènnes and Sevrès. A very fine and rare piece but it has a strictly limited appeal to collectors.

*£450-650*

# BOW 1749-1776

When one considers the importance and the size of the output of the Bow factory, it is surprising that not more specimens have survived. Whilst Chelsea produced a considerable number of purely ornamental items, Bow concentrated chiefly on useful wares. The output of blue and white porcelain in particular, was enormous; probably the largest in Europe between 1755-1765.

## Polychrome Wares

It seems that very little porcelain was produced until 1751 or thereabouts, at any rate, very few specimens have survived. Amongst those that have are a few mugs and several shell salts. The decoration is usually in vivid 'famille rose' colours which stand out strongly against the greyish paste.

Decoration in 'famille rose' style was used extensively right up until the early 1760's when it seems to have fallen out of fashion. It appears frequently on teawares, coffee cups, coffee cans, bowls, mugs, plates, dishes and sauceboats. Another popular form of decoration in the pre-1763 period was in imitation of Fukien blanc de Chine. These are usually not painted, but have instead decoration applied in relief, usually sprigs of prunus blossom. Coffee cups are quite common in this style and so to a lesser extent are teabowls and saucers, coffee cans, bowls, sauceboats and plates; most other shapes are scarce. A design especially associated with the factory is the 'quail' pattern. This is one of several patterns of the period derived from Japanese (Kakiemon) porcelain. It is very common on plates and dishes, but it occurs much less frequently on tea and coffee wares. Decoration in underglaze blue and overglaze iron red and gilt is found mainly on teawares and mugs; many of these specimens date from before 1755. After about 1760, floral designs in European style and Chinese Mandarin patterns appear; they occur chiefly on teawares. Other forms of decoration at this time include exotic bird patterns, botanical designs and some which include fruit and vine leaves. The elaborate vases in rococo style date from after about 1762 and seem rather crude and ungainly beside the elegant gold anchor Chelsea specimens. From about 1755 onwards, overglaze transfer printing appears in various colours including black, red and purple. Prints occur on plates, mugs and vases, but less often on teawares; all examples are fairly scarce. All Bow coffee pots and pickle leaf dishes

are scarce in polychrome and one might find thirty or more coffee cups for every one saucer. Staining occurs sometimes, either on rims, foot-rings or around cracks. No factory marks were used, although the anchor and dagger mark occurs on pieces decorated in the workshop of James Giles in Kentish Town.

### Blue and White Wares

The early blue and white wares of the period 1749-54 tend to be thickly potted and therefore heavy, and painted in a vivid cobalt blue. The glaze is often thick and the painting tends to run, sometimes making it difficult to determine the intended pattern. Most pieces from this period are comparatively scarce but amongst those most often found are sauceboats which were quite a speciality of the factory. These occur in a number of different shapes, many of them influenced by contemporary silver such as the examples on three lion paw feet. Other shapes include mugs, coffee cups, plates, bowls, coffee cans, creamjugs and knife and fork handles. Teapots, saucers, creamboats, pickle leaf dishes and coffee pots are scarce, the latter particularly so. Most of the early designs are in Chinese style, many of them being blurred as if out of focus. Teaware shapes have a slightly clumsy but distinctly simple and functional appearance which is in contrast to the splendour of some of the sauceboats. Some pieces are marked with a capital R which is in-cised in the base. A few painted workman's marks occur, such as a cross and a capital B.

During the middle period (1755-63) the wares became less thickly potted, although many specimens are almost opaque to transmitted light. This was a successful time for the factory and the output of blue and white was fairly large, as was the range of objects produced. Flat-ware was a great speciality of the factory, possibly because Worcester were not serious rivals in this field at the time. Other comparatively common shapes include mugs, sauceboats, bowls, pickle leaf dishes, creamboats, patty pans, vine leaf dishes and knife and fork handles. Tea-wares, whilst hardly rare, were not produced in the same quantities as at Worcester, Lowestoft or Caughley. Coffee pots and saucerdishes are scarce, and tea caddies and teapot stands seem not to have been produced at all. Miniature teawares can still be found, although they are rarer than the Caughley examples. Two-tier shell centrepieces are more common in Bow than in any of the other factories, as are powder blue wares. This attractive form of decoration was used extensively on Bow from about 1758 until the mid-1760's. It is found mainly on

flatware and less often on teawares, bowls and mugs. The quality of the decoration varies but at its best it easily outshines the much rarer examples made at Worcester, Lowestoft and elsewhere. A number of specially attractive designs were produced in the late 1750's. Amongst these are the 'Image' pattern, the 'Jumping Boy' pattern and a harbour scene design which would seem to be a Bow version of a Chinese copy of a European scene. The 'dragon' pattern spans a rather longer period and specimens might vary in date from 1753-1765. Transfer printing in undergalze blue was done from about 1760 onwards, but it does not appear on useful wares to the same extent as at Worcester or Lowestoft. Painter's numerals sometimes occur, usually on bases, but occasionally inside footrings as on Lowestoft examples.

From about 1764 onwards, the quality of the porcelain deteriorated, until by the 1770's some specimens are hardly recognisable as porcelain at all. Much of the painting is rather slapdash and the porcelain is often completely opaque to transmitted light. Many pieces show signs of black pitting in the glaze and staining frequently occurs, particularly around cracks. Plates continue to be the most commonly found shapes and sauceboats remain a speciality, although their shapes are now much less elaborate. Some of the designs used are close copies of Worcester patterns but decoration in the Chinese style continues to predominate. After about 1770, the factory's output decreased considerably.

For many years Bow has been slightly undervalued in comparison with most of the other factories. This is probably because there are not as many specialist collectors of the factory as there are of Chelsea, Worcester, Derby and Lowestoft, and although Bow has increased in price recently, it has still not really quite caught up. For this very reason, it should be a good factory to invest in as the competition for fine specimens is not quite so keen as in other factories.

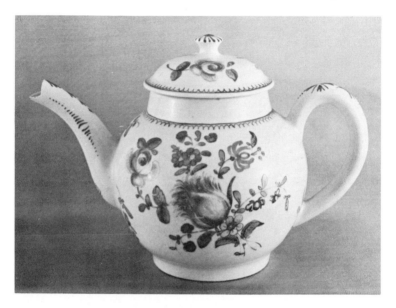

### Teapot c.1762
#### Height 4½in.  no mark

Bow teapots are rarer than Worcester or Lowestoft examples in both colour and blue and white. This is a typical example of the 1760's although the tip of the spout is a little unusual. Similar teapots have oriental figure decoration instead of flowers.

*£72–90*

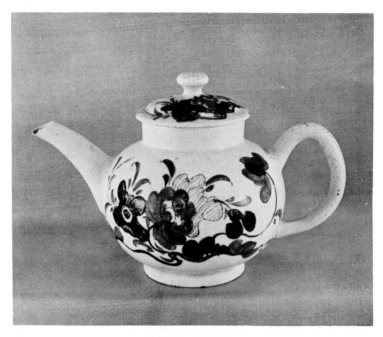

**Teapot c.1754**
**Height 4in.  no mark**

Early Bow teapots are fairly scarce but often less expensive than later specimens because of their decoration. This example is painted in underglaze blue and overglaze red and gilt, never a popular form of decoration with collectors. The simple elegant shape is typical of the period.

*£58–72*

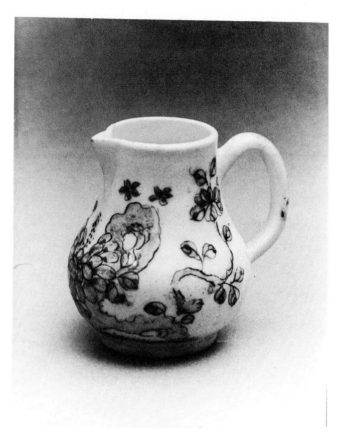

**Creamjug c.1753**
**Height 2½in.  no mark**

Early Bow creamjugs are typically squat and dumpy, often having handles which seem too large in proportion. The decoration is derived from the Chinese 'famille rose'. Early Bow wares have a tendency to stain particularly on rims, footrings and around cracks.

*£45–60*

**Creamboat c.1762**
**Length 4¼ in.  no mark**

The shape of this creamboat is typical of Bow although the decoration is slightly reminiscent of Lowestoft. The colours are sometimes 'muddy' and this has an adverse effect on the value. This shape is common in blue and white.

*£45–58*

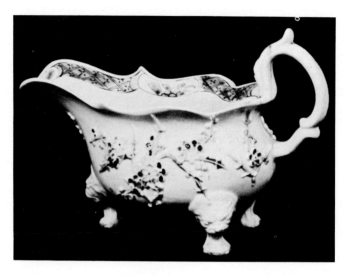

### Sauceboat c.1754
**Length 9 in.  no mark**

The shape of this sauceboat is derived from contemporary silver and the raised decoration is in imitation of Fukien blanc de Chine. These sauceboats are more commonly found without the polychrome decoration. Quite rare.

*£75–100*

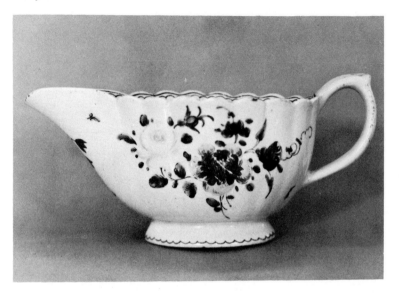

### Sauceboat c.1765-68
**Length 7¼ in.  no mark**

This fluted sauceboat is a typical Bow form of the 1760's. The decor-
ation, however, is rather strange and was probably done outside the
factory. The poor decoration detracts from its value. Sauceboats of a
similar shape occur with underglaze blue decoration.

*£38–48*

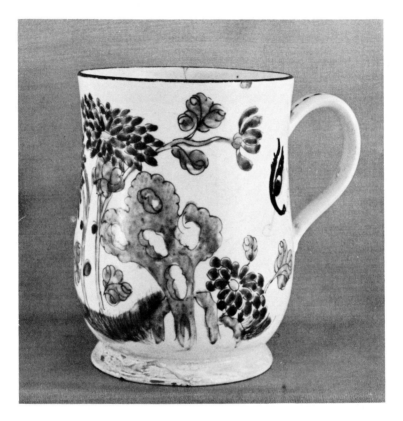

**Mug c.1756-58**
**Height 4¾ in. no mark**

A typical bell-shaped mug with decoration in Chinese 'famille rose' style. The colours are thickly applied and very bright in tone. There is a characteristic heart-shaped terminal at the base of the handle.

*£95–115*
*in a damaged state as above £18–25*

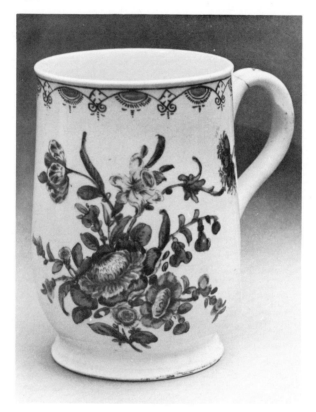

### Mug c.1760-62
**Height 4½ in.  no mark**

A typical Bow mug attractively painted with European flowers. The quality of the painting and the colours tend to vary on such pieces. Mugs of this period can be either bell-shaped or straight-sided.

*£78–98*

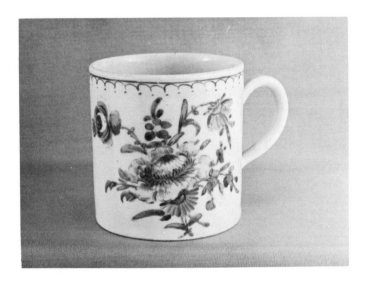

### Coffee Can c.1760
**Height 2¼ in. no mark**

Unlike the earlier specimens, coffee cans of this period have glazed bases, grooved handles and footrings. Examples are not always as well painted as this one. A very common Bow pattern of the 1760's.

*£35–45*

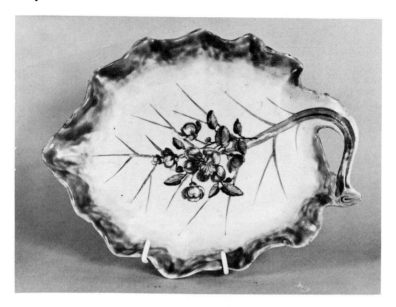

### Leaf Dish c.1765
**Diameter 9¼ in.  anchor and dagger mark**

This typical Bow leaf-shaped dish looks rather crude when compared with its Chelsea or Longton Hall counterparts. It is, however, pleasantly decorated and has a certain unsophisticated charm. The shape was also made with underglaze blue decoration.

*£90–115*

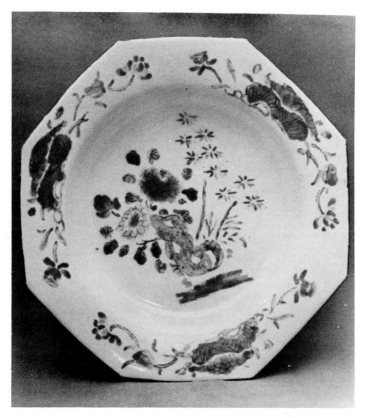

**Plate c.1758**
**Diameter 9 in. no mark**

An octagonal Bow soup plate painted in the popular 'famille rose' style. These are less common than the ordinary dinner plates but their value is about the same.

*£40–48*

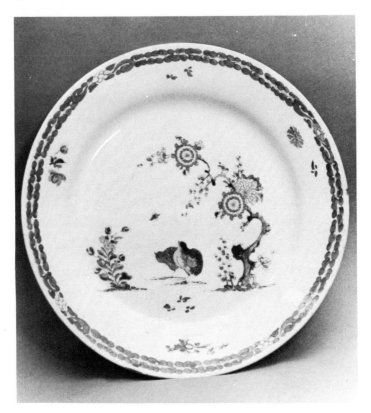

**Plate c.1760-62**
**Diameter 7½ in.  no mark**

The popular 'quail pattern' is very common on Bow, particularly on
plates and dishes. This pattern, which is derived from Japanese porcelain,
was also used on Chelsea, Worcester and Longton Hall. Octagonal Bow
plates are often found in this design.

*£42–55*

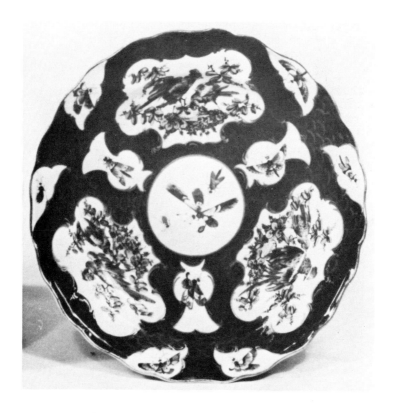

### Plate c.1768-72
**Diameter 8¼ in.  anchor and dagger mark**

This plate was decorated in the atelier of James Giles in imitation of the Worcester scale blue. It was probably intended as a replacement in a Worcester service. Although very much rarer than a Worcester example, it is worth if anything, rather less.

*£125–160*

Bow
Undecorated

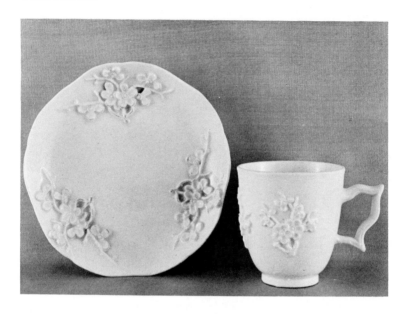

## Coffee Cup and Saucer c.1755
**Saucer diameter 4½ in. no mark**

The raised decoration on this cup and saucer is applied and not moulded like that on many early Chelsea examples. Most Bow specimens with this form of decoration date from the period c.1750-1763. Care should be taken to distinguish the Bow examples from the 'creamier' St. Cloud ones.

*£42–55*

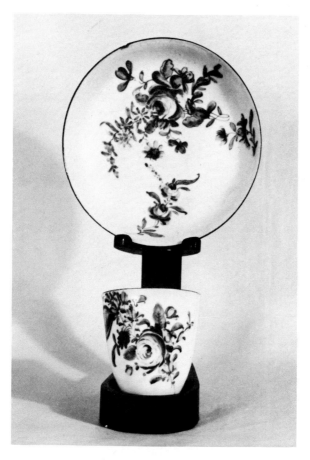

**Beaker and Saucer c.1762-65**
**Diameter of Saucer 4¾ in. no marks**

A beaker and saucer well-decorated with European flowers. The floral painting is typical of the period. A beaker is a fairly rare shape in all of the eighteenth century English factories.

*£40–52*

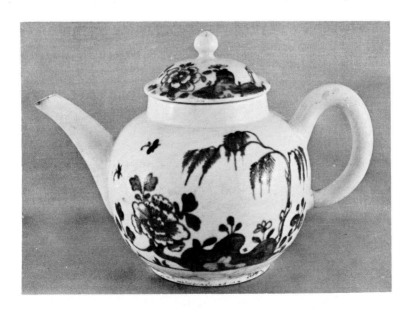

## Teapot c.1752
### Height 4¾ in.  no mark

The shape of this teapot is typical, particularly the angle of the spout and the rather thick handle. The underglaze blue is a characteristically bright, vivid tone. Specimens from this period are usually surprisingly heavy. All early Bow teapots are scarce, especially the blue and white examples.

*£68–85*

**Creamjug c.1762-65**
**Height 3 in.  no mark**

This is the standard Bow 'sparrow beak' creamjug form of the post-1758 period and it is painted with a typical Chinese scene. These creamjugs tend to be a more bulbous and less elegant shape than their Worcester and Lowestoft counterparts.

*£32–40*

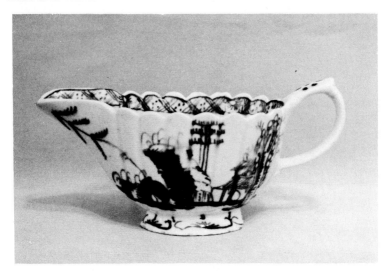

## Creamboat c.1762-65
### Length 4½ in. no mark

This typical Bow fluted form is more or less a miniature version of a full-sized sauceboat of the same period. The decoration is invariably of scenes copied from Chinese porcelain. A similar shape occurs in polychrome. Fairly common.

*£32–42*

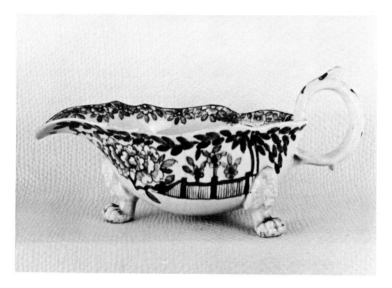

**Sauceboat c.1753-4**
Length 7¾ in.  no mark

This is one of several types of Bow sauceboat on three lion paw feet all of which are based on contemporary silver shapes. This particular form also occurs with underglaze blue and overglaze red and gilt decoration. A similar shape was also produced at William Reid's factory in Liverpool. Sauceboats of this shape are especially desirable in pairs.

*£78–92*

## Sauceboat c.1762
### Length 7¼ in.  no mark

These attractive moulded sauceboats were also produced at Derby and Lowestoft. This particular example is moulded with pears and cobnuts. The Lowestoft version is painted in a darker tone of underglaze blue and is rarer.

*£48–58*

**Mug c.1751**
**Height 4½ in.  no mark**

This fine early mug could almost be mistaken for an Oriental one. The painting is very free and in a vivid tone of blue. Mugs of this period tend to be thickly potted and are consequently heavy. Very rare.

*£75–90*
*in above condition £20–28*

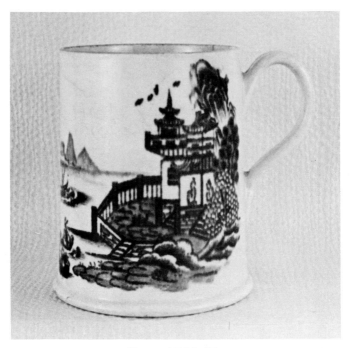

**Mug c.1762-65**
**Height 3½ in.  no mark**

This is quite a common form of Bow mug at this period. A heart-shaped
terminal at the base of the handle is a common and characteristic
feature.

*£55—68*

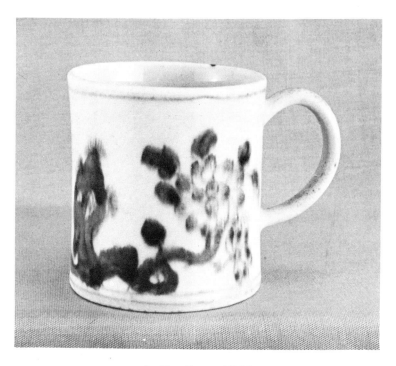

**Coffee Can c.1754**
**Height 2¼ in.  no mark**

This shows the Bow version of the 'prunus root' pattern which was so popular at Worcester. Early Bow coffee cans like Longton Hall and some Liverpool examples, have unglazed bases. The underglaze blue on early Bow is a bright vivid tone but by the late 1760's it had become a much darker colour.

*£30–36*

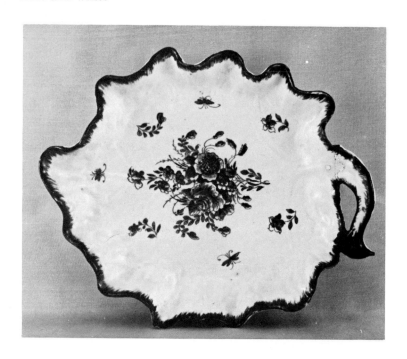

### Leaf Dish c.1765
**Diameter 10¼ in.  no mark**

Most of these leaf-shaped dishes date from the mid or late 1760's. They
are also found decorated with grape-vine patterns set against a dark
washy-blue background. A similar form is found in polychrome.

*£70–85*

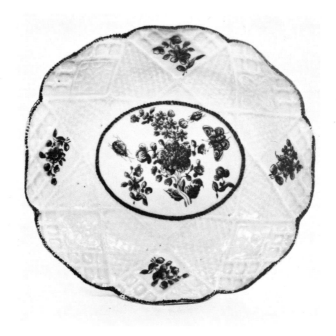

### Dish c.1760-65
**Diameter 7½ in.  no mark**

A blue and white Bow basket-moulded dish painted with flowers and insects. This is a fairly typical Bow shape of the period and it was also produced with polychrome decoration.

*£52–68*

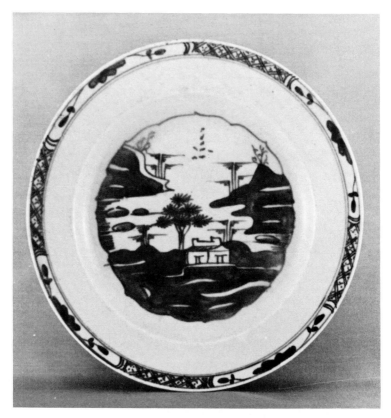

**Plate c.1753**
Diameter 9¼ in.  no mark

Bow plates of this period are usually thickly potted and therefore heavy, and often have countersunk bases instead of footrings. The glaze has a tendency to craze. Underglaze blue patterns at this period are nearly always derived from Chinese porcelain.

*£36—48*

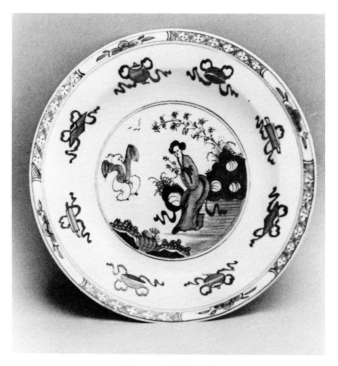

**Plate c.1760-62**
**Diameter 7 in.  Pseudo Chinese marks**

The 'Jumping boy' pattern appears on Bow flatwares and occasionally on teawares. The Chaffers' Liverpool version, however, is only seen on tea and coffee wares. The Bow examples of this design are slightly rarer. Very desirable.

*£62-78*

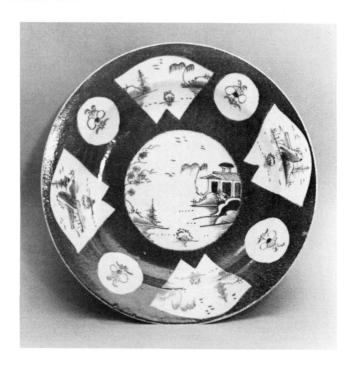

**Plate c.1760-65**
**Diameter 7 in.  Pseudo Chinese marks**

Powder blue decoration is fairly common on Bow in the period c.1758-1768. It occurs much more often on flatware than on any other shapes and the quality of the blue varies quite considerably. This form of decoration also appears on Worcester and more rarely on Lowestoft, Caughley, Longton Hall and some Liverpool wares.

*£35—42*

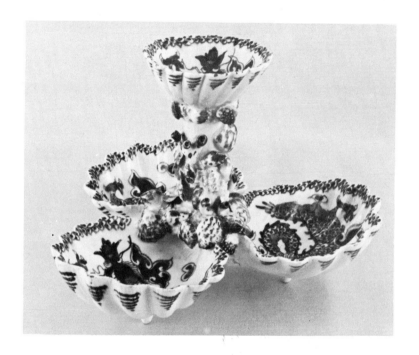

**Shell Centre-piece c.1758-60**
**Height 5 in.  no mark**

These shell centre-pieces are more common in Bow than in any other
factory. Rarer specimens have an upturned dolphin instead of the upper
shell. Examples occur in several patterns and occasionally with poly-
chrome decoration. They were produced in the period c.1758-1770.
Fairly scarce.

*£95–120*

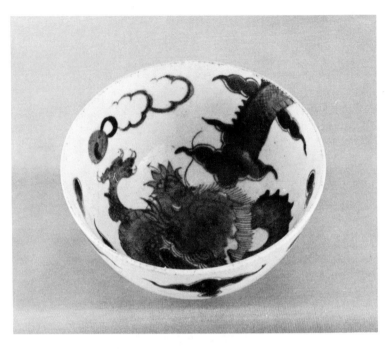

**Bowl c.1753**
**Diameter 4 in.  numeral 13**

A popular Bow pattern which is found more often on bowls than on any other shape. The design was also produced at Lowestoft, Worcester and at several of the Liverpool factories. The Bow version shows, appropriately enough, an arrow in the mouth of the dragon

*£40—48*

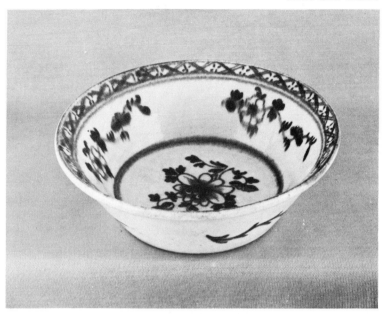

**Patty Pan c.1762**
**Diameter 4 in.  no mark**

Bow patty pans are slightly less common than Lowestoft examples and more robustly potted. The pattern and size of the specimen illustrated are typical. Patty pans were also made in Lowestoft, Worcester, Caughley and hard paste Bristol. It seems that this shape was never produced with polychrome decoration.

*£28–35*

### Pickle Leaf c.1758
**Height 3 in.  numeral 27**

These small pickle leaf dishes occur in various different patterns of which this is one of the most attractive. The blue is usually a lighter tone than that on the Lowestoft examples which they sometimes resemble. Polychrome specimens are very scarce.

*£30–36*

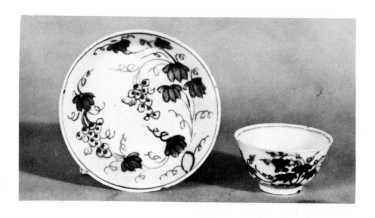

### Miniature Teabowl and Saucer c.1755-58
**Diameter of Saucer 3 in.  no mark**

This is easily the most commonly found pattern on Bow miniature tea-wares. A different design occurs on the earlier and rarer specimens which date from about 1753. Bow made polychrome miniatures but all examples are scarce. It is not certain whether these miniature wares were intended as toy services for children or as samples. The latter explanation seems the more likely.

*£35–42*

## Knife and Fork c.1758-60
### Handle lengths 3¾ in. and 3 in. no mark

These are considerably more common than the Worcester examples and were made in a number of different patterns, some of which were moulded, during the period 1752-1770. If the handles are without blades, or if the blades are of a later date, the value is reduced. Polychrome decorated examples are very scarce. It is all too easy to confuse the Bow examples with the blue and white French soft paste St. Cloud ones. A useful hint is that the metal hafts of most French specimens pierce right through the handle to the butt end; this is not the case with most English examples.

*£18–25 for a matching pair*
*one handle alone £4–6*

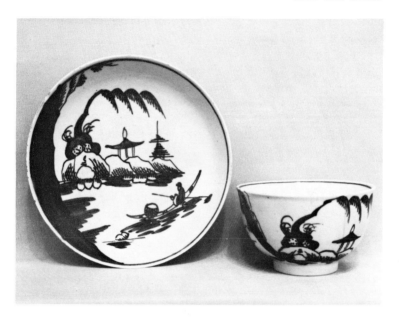

## Teabowl and Saucer c.1758
**Diameter of Saucer 4½ in.  no mark**

Bow made far fewer teabowls and saucers than most other factories, but although they are consequently comparatively scarce, they are usually no more expensive than comparable Worcester or Lowestoft examples.

*£26–32*

# POLYCHROME WORCESTER 1752-76

Worcester had by far the largest output of any of the eighteenth century English porcelain factories. Although it is consequently comparatively common, it is also both the most collected of all the early factories, and one of the most expensive. This is because of the vast range of objects produced, the enormous variety of different forms of decoration and the consistently high standards of potting and painting.

A certain amount of polychrome porcelain was produced at the Lund's Bristol factory, but it is not known for certain just how much. It is probable that many of the shapes traditionally considered to have been made at Bristol in fact date from the very early years of the Worcester factory. The most commonly found shapes in the Bristol group are sauceboats, which are usually of silver-shape, creamboats and vases. The decoration on these pieces is invariably in Chinese style and the paste is very white and often shows signs of fire cracks near foot-rings and handle terminals. All pieces of Lund's Bristol are extremely scarce.

The decoration on the Bristol/Worcester group (i.e. the earliest productions at Worcester c.1752-53 which resemble Lund's porcelain) is also mainly in Oriental style. The shapes are graceful, sometimes being taken from Chinese 'famille verte' originals, and the painting is very fine. The potting is rather finer than on the earlier pieces but the glaze has a tendency to stain, a fault soon to be rectified. Teawares are usually either widely fluted or hexagonal like the small bottle-shaped vases. Other shapes of the period are elegant lobed creamjugs, small shell-shaped dishes, vases, bowls, sauceboats, creamboats and the beautiful tall quatrefoil lobed cups with silver-shape handles. All shapes of this group are very rare, with the exception of the octagonal coffee cups.

The wares of the 'scratch cross' group (1753-56) on the other hand, tend to be rather thickly potted and the colours used are stronger than before. The decoration consists mainly of oriental figures, landscapes and Chinese emblems. The most common shapes are large mugs, which can be bell-shaped or waisted, bowls, large jugs and sauceboats on pedestal feet. The shapes of these robustly potted pieces are nearly always derived from contemporary silver. Teawares are of simple practical form, the teabowls and saucers being thinly potted and having low footrings. Coffee pots, which like mugs have 'strap' handles, are particularly scarce. All flatware of this group is extremely rare. The colour of the paste varies, but it is usually of a greyish tone.

The wares produced from 1755-1765 have an elegance of form, a subtlety and restraint of decoration and an individuality somehow lacking in the succeeding period with its colourful splendour. The decoration is for the most part derived either from the Chinese or from Meissen. The oriental figure painting is charmingly, if rather naively, done, but in contrast the flower painting has a sophistication not often seen on English porcelain of this period. Other forms of decoration include oriental flowers, Kakiemon patterns, 'pencilled' decoration, the rare European landscapes and fine bird painting in more restrained style than was used later. Some pieces, particularly sauce-boats, creamboats, and thinly potted teawares are moulded, often having painted scenes within small rococo reserves. Teawares are fairly common as are creamboats, bowls, leaf dishes, jugs, baskets, mugs and sauceboats. The latter occur in various shapes, some having two handles, others being moulded in the shape of a Cos lettuce leaf. The small pickle leaf dishes so common in underglaze blue, are scarce, as are ordinary plates until after about 1760. No factory marks were used until after about 1765.

Transfer printing in overglaze 'jet' black is comparatively common in the period 1757-1776; earlier specimens are scarce. These prints, most of which were engraved by Robert Hancock, fall into two main categories, European scenes, i.e. 'l'Amour' and 'the tea party' and commemorative prints, the most common of which is 'Frederick of Prussia'. The value of these pieces depends upon the rarity of the subject and of course the object upon which it appears. The commemorative prints are most often found on mugs and jugs, but the other prints occur on a variety of shapes, including teawares, mugs, jugs, plates, saucerdishes and coffee pots.

From about 1765 until the end of the first period in 1776 the output of the factory was enormous and a quite astonishing range of patterns was produced. Nearly all the standard forms were made including teawares, leaf dishes, mugs, bowls, plates, dishes, baskets, coffee pots, cider jugs, sacueboats, creamboats and coffee cans. During this period, throughout which an extremely high standard of potting and painting was maintained, the range of colourful patterns was produced for which the factory is so famous. The main forms of decoration were:—

1) SCALE BLUE. A speciality of the factory. The reserves are usually filled with either exotic birds or flowers.

2) GROS BLEU. A 'wet' underglaze blue ground colour. The circular central reserve is usually filled with birds or flowers.

3) COLOURED GROUNDS. All ground colours are rare with the exception of the two mentioned above. The main colours used in ascending order of value are: Turquoise, apple green, claret and yellow.

4) DRY BLUE. An overglaze monochrome blue which is often accompanied by gilding.

5) BIRD DECORATION. Various different styles of bird painting appear, including exotic birds, dishevelled birds and water fowl.

6) EUROPEAN FLOWERS. Examples vary considerably in quality from fine painting in Meissen style to rather sparse and poorly done sprays.

7) ORIENTAL FLOWERS. More common and less sought-after than European flowers.

8) CHINESE FIGURES. Usually quite attractively painted but with less individuality than in the earlier period.

9) 'JAPAN' PATTERNS. Many of these are standard patterns and quite common. Some of the more colourful ones however, are expensive.

10) PATTERNS DERIVED FROM SÈVRES. These include many of the most expensive of the standard patterns, such as the 'hop-trellis' pattern.

11) OUTSIDE DECORATION. Some pieces were decorated in the workshop of James Giles in Kentish Town. This by no means detracts from their value.

Other rarer forms of decoration are: European figures, European landscapes, 'famille verte' type, fruit painting, Fable decoration, armorials, coloured transfers and animal painting. Slightly over half the porcelain of this period is marked, including most of the 'Japan' patterns and all of the 'scale blue' and 'gros bleu' designs. Easily the most often found mark is the fretted square in underglaze blue. Other marks include the crossed swords of Meissen, the script W and a crescent either in underglaze blue or less often in gold.

Over the last ten years or so, polychrome Worcester has risen steadily in price and shown itself to be the most popular of all the English porcelains with both collectors and investors. The enormous interest in the factory, together with the size and quality of its output should ensure that this trend continues.

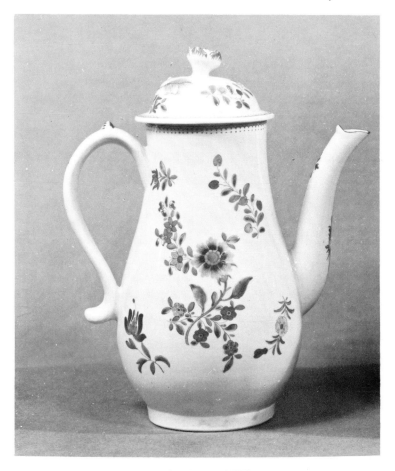

**Coffee Pot c.1770**
**Height 8in.  no mark**

A fairly typical Worcester coffee pot shape of the early 1770's. Although nothing about this coffee pot is exceptional it is nevertheless a desirable object particularly if in good condition. Worcester coffee pots of the pre-1765 period are scarce.

*£140–185*

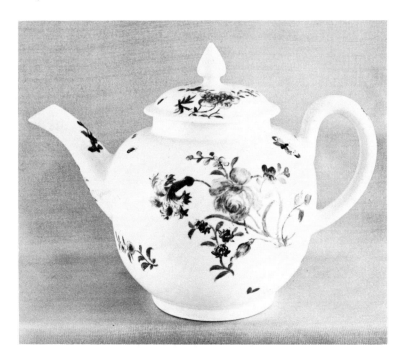

**Teapot c.1765**
**Height 5¼in.  no mark**

This is a good example of floral decoration of the 1760's. The shape of this teapot is almost identical to that of the blue and white specimen on page 118. Polychrome wares of this period are seldom marked. From about 1768 until the end of the First Period, Worcester teapots are relatively common.

*£100–135*

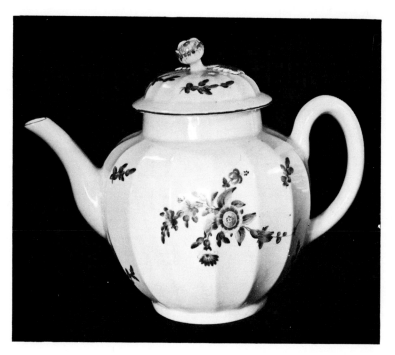

**Teapot c.1770**

**Height 7¼in.  no mark**

An attractively fluted teapot painted with flower sprays. Although the rather sparse decoration is against it, the shape is quite a desirable one.

*£70–85*

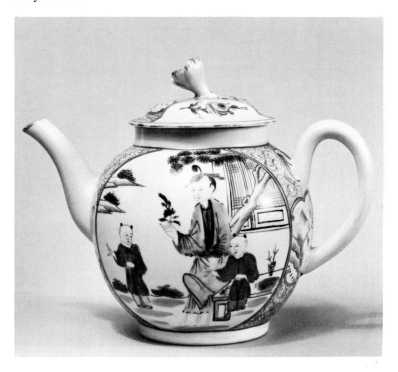

### Teapot c.1770-72
**Height 5½in.  no mark**

Chinese Mandarin decoration of this type is very common on Worcester
of the early 1770's. Restoration is sometimes hard to detect on these
densely decorated specimens. Most Worcester teapots of the post-1768
period have floral finials. This teapot is a particularly fine example of
its type.

*£82–105*

**Cream Jug c.1754-56**
**Height 2¾in.  no mark**

The 'Red Bull' pattern. This attractive little cream jug is transfer-printed in overglaze black and then coloured in with enamels. This standard Worcester pattern invariably occurs on early pieces and spans the period c.1753-1765. The shape of the cream jug is typical of the 'scratch cross' period and the form also appears in blue and white.

*£68–85*

### Cream Jug c.1765-68
**Height 3 in.  no mark**

A Worcester 'sparrow beak' cream jug attractively painted with sprays
of flowers. The shape and the grooved handle are absolutely typical of
the mid-1760's. This is a fairly common piece but nevertheless quite a
desirable one.

*£52–68*

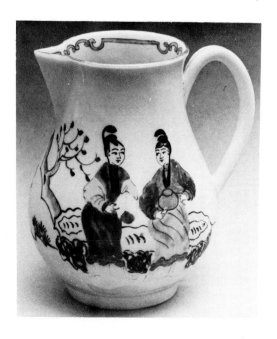

### Cream Jug c.1768
**Height 3¼in. no mark**

The shape is typical of the period. A well-painted floral example of the same period would be worth slightly more. Cream jugs are at the moment more popular with collectors than teapots, probably because of their size. Consequently cream jugs seem rather expensive in comparison.

*£48–65*

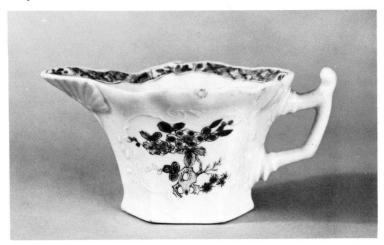

### Creamboat c.1751
**Length 4¼in. no mark**

This hexagonal creamboat was almost certainly made at Bristol before the transfer to Worcester in 1752. It is not always easy to distinguish the Lund's specimens from the slightly later Worcester examples of the same shape. The Lund's paste is whiter and pieces are much more prone to fire cracks particularly near footrings and around handle terminals. All pieces of Lund's Bristol whether polychrome or blue and white are extremely scarce.

*£125–175*

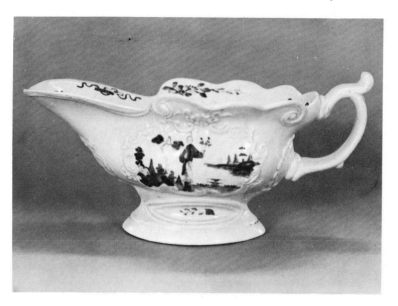

### Sauceboat c.1753-55
**Length 7¾in.  no mark**

This fine moulded silver-shape sauceboat is painted with Chinese figures
and landscapes in a very similar style to that found on pieces of the
'scratch cross' family. The slight firing faults which are sometimes
found on these sauceboats do not affect their value to any large extent.
The shape was also produced at the earlier Bristol factory but examples
are usually much less well-moulded and extremely scarce.

*£135–185*

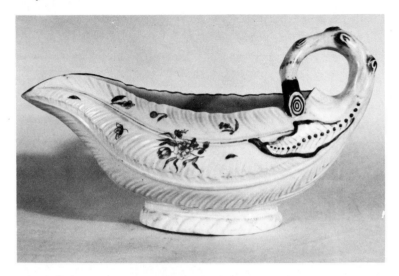

## Sauceboat c.1760
### Length 9in. no mark

This standard Worcester sauceboat shape was produced from the mid-1750's until about 1768. The amount of decoration varies considerably and affects the value. Polychrome examples are comparatively common but blue and white specimens are extremely rare. Other leaf-shaped sauceboats were produced at Derby and Longton Hall.

*£85–110*

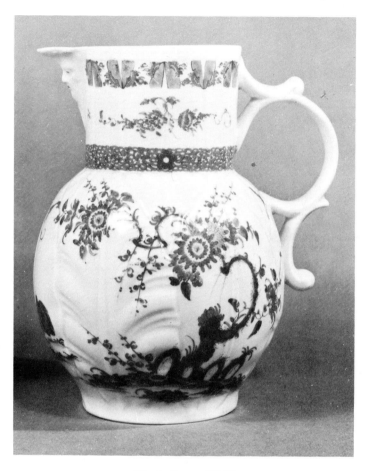

**Mask Jug c.1765**
**Height 7½in.  no mark**

A fine moulded cider jug decorated with the 'quail' pattern which is
considerably rarer in Worcester than in Bow. Polychrome jugs of this
type are very desirable despite their size.

*£125–165*

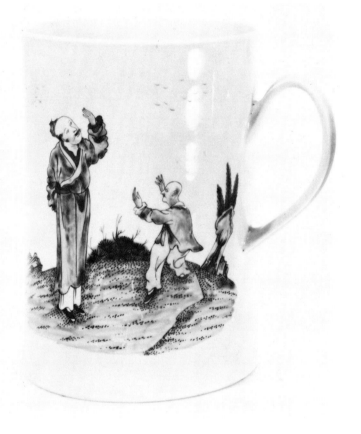

### Mug c.1756-58
#### Height 5½in. no mark

The 'Beckoning Chinaman' pattern. This mug is well painted in bright 'famille rose' colours and shows on the reverse side an exotic flowering branch. Most examples of this pattern, which appears mainly on mugs, jugs and teapots, date from the period 1755-1765.

*£175–235*

**Mug c.1756-60**
### Height 3¼in.  no mark

A typical bell-shaped mug of the late 1750's with fine quality floral decoration. Bell-shaped mugs tend to be slightly more desirable than cylindrical ones.

*£100–135*

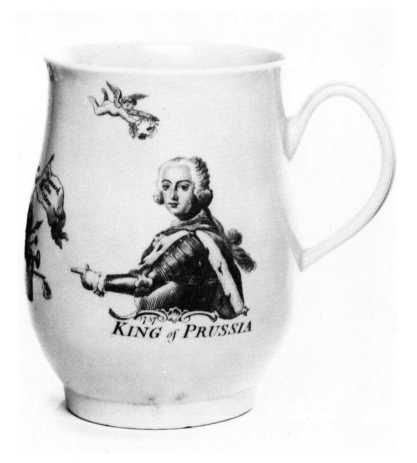

**Mug c.1760-62**
**Height 4¾in. no mark**

The 'King of Prussia' is easily the most common of Hancock's transfers
with historical subjects. The print, which appears mainly on mugs and
jugs, often includes the date 1757, but most specimens were made in
the period 1760-1770.

*£90–115*

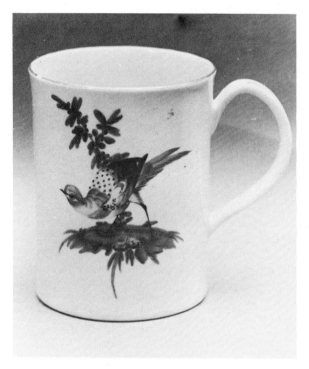

**Mug c.1770-72**
**Height 3½in.  no mark**

Bird decorated specimens even when a little sparse, are always desirable
and fairly expensive. The grooved handle of this mug is typical.

*£90–115*

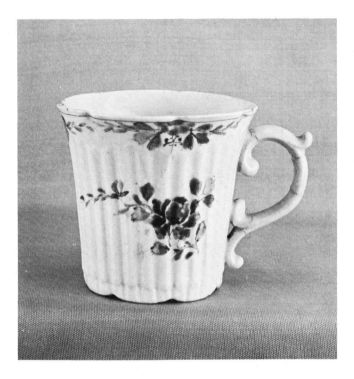

### Coffee Can c.1752-54
**Height 2¼in.  no mark**

These fluted coffee cans might possibly have been produced at Bristol but it is more likely that they date from the first few years of the Worcester factory. They are at any rate both earlier and rarer than their blue and white counterparts.

*£35−45*
*in above condition £11−16*

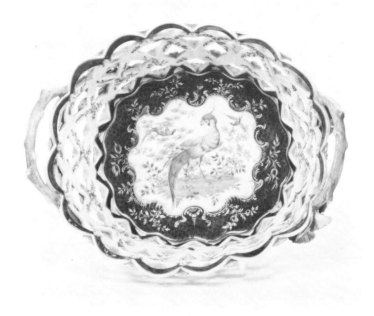

### One of a Pair of Baskets c.1770
**Length 11¾in.   square mark**

One of a fine pair of two handled baskets with blue scale decoration and exotic birds in landscapes. These baskets are of exceptionally fine quality and such pieces will always be in great demand. A pair would be worth slightly more than double a single example.

*£950–1,250 the pair*

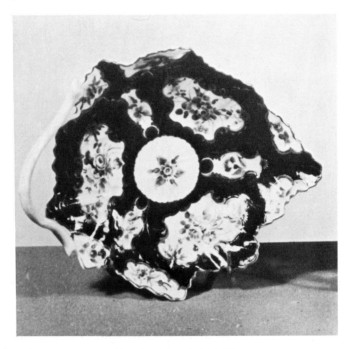

### Leaf Dish c.1770-72
**Length 7½in.  square mark**

A fairly common Worcester shape with scale blue decoration and European flowers in the shaped reserves. Dishes of the same shape and period occur in a variety of different patterns and also, less often, in blue and white.

*£155–195*

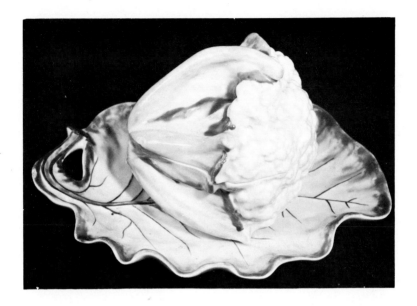

**Tureen and Stand c.1758-65**
**Width of stand 8¼in.  no mark**

This fine cauliflower tureen and stand is painted in shades of green and the veining is picked out in puce. All tureens and other forms moulded in the shapes of fruit or vegetables are very desirable and tend to be expensive. Copies of many of those shapes were done at Coalport but all of these are in hard paste and therefore should be easily distinguishable.

*£650–850*

### Dish c.1770-72
**Width 7½in.  no mark**

A fine claret ground shell-shaped dish from the 'Hope Edwards' service decorated in the atelier of James Giles. Worcester wares with claret ground decoration are scarce and very desirable. On some pieces the ground colour is a later addition but careful examination of these pieces will show signs of re-firing. The later decorated pieces are not very valuable and have little interest for collectors.

*£500–650*

### Plate c.1760-62
#### Diameter 7½in.  no mark

The so-called 'Blind Earl' pattern. A well painted plate moulded with leaves and rose buds. These plates although not particularly rare, are very desirable. They were traditionally supposed to have been made for the blind Earl of Coventry so that he could feel the moulding. In fact the Earl of Coventry did not become blind until 1780 and these plates were first produced twenty years earlier.

*£220–290*

**Plate c.1768-70**
### Diameter 8½in. gold crescent mark

The 'Brocade' pattern. This is a very decorative design painted in a fine
range of colours including green, orange, mauve, yellow, blue and gilt.
Colourful patterns of this type tend to be fairly expensive.

*£120–155*

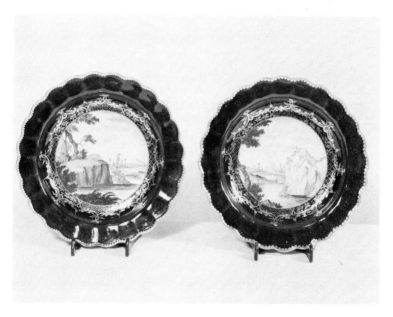

## Pair of Plates c.1768-70
### Diameter 7½in.  square mark

A pair of superb gros bleu plates painted by J.H. O'Neale with subjects taken from Aesop's Fables. One shows 'the Fox and Wolf' and the other shows 'the Fox and the Hedgehog'. Fable-decorated plates are one of the most desirable and sought-after classes of Worcester wares. Examples are nowadays rare and always expensive.

*£1,050 – 1,350 the pair*

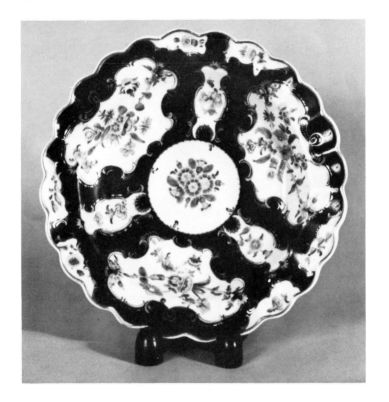

### Plate c.1770-72
#### Diameter 8¼in.  square mark

Scale blue decoration. This is a typical example of a very common form of decoration at Worcester. The quality of the blue scale ground, the gilding and the flower painting all affect the price. If this plate was decorated with birds instead of flowers it would be worth about 75% more.

*£90–115*

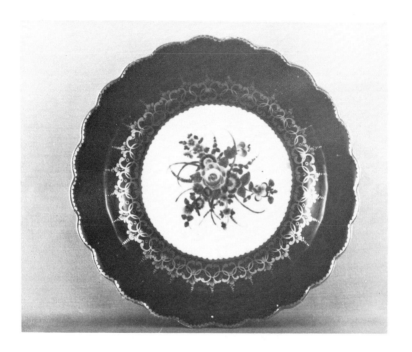

## Plate c.1772
### Diameter 7½in.  W mark

Gros bleu decoration is less highly valued than scale blue designs. The quality of the flower painting tends to be less fine although the gilding is often quite elaborate. The gilding is sometimes rubbed and this reduces the value considerably. Quite common.

*£75–95*

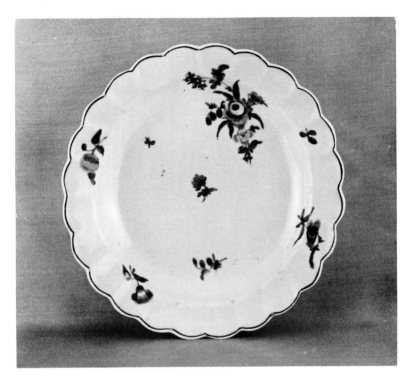

**Plate c.1772**
**Diameter 6¾in.  no mark**

A fairly common type of Worcester plate with pleasant but rather sparse
floral decoration. This is probably the least expensive sort of Worcester
flatware. Any rubbing of the decoration reduces value considerably.

*£40–48*

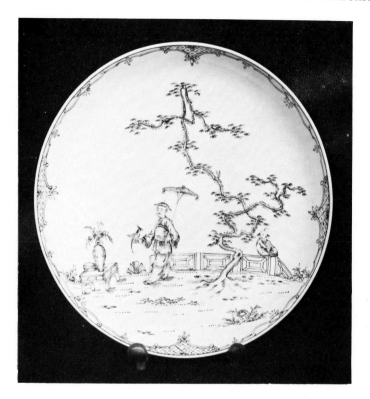

**Saucerdish c.1755-58**
**Diameter 8½in. no mark**

This fine saucerdish is 'pencilled' in black enamel with a scene which shows a Chinaman in a garden. The term 'pencilled' refers only to the effect of the fine brushwork on these pieces. Rarer and more desirable than overglaze black transfer-prints.

*£140–190*

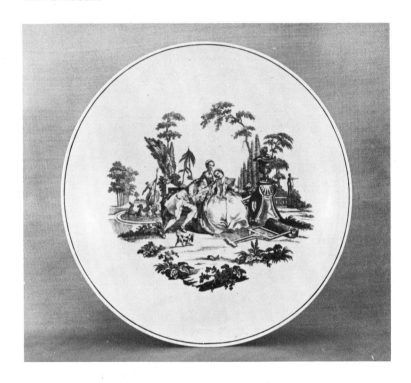

### Saucerdish c.1770
#### Diameter 7in. no mark

'L'Amour' is one of the most common of Hancock's transfer-prints. It is seen to particularly good effect on a saucerdish which is of course one of the rarer teaware shapes. When a signature (the initials R.H.) appears in the print, the value is increased by up to about 25%.

*£48–60*

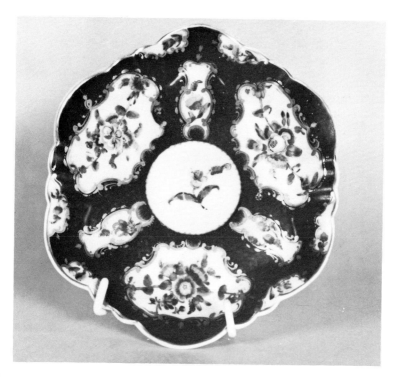

### Teapot Stand c.1770
#### Diameter 5¾in. square mark

A comparatively rare form. This is decorated with a scale blue ground and European flowers in reserves. European flowers are always more desirable than oriental flowers. The painting and gilding on teapot stands is often rubbed and this reduces their value.

*£85–115*

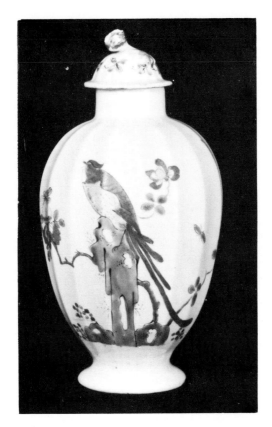

**Tea Caddy c.1768**
**Height 5¾ in.  no mark**

The 'Sir Joshua Reynolds' pattern. This attractive standard factory
pattern is invariably painted in bright clean colours. Most examples of
this design date from the period 1760-1772 but it was sometimes used
on pieces of the early 1750's. The pattern also occurs on flatware with
wide gros bleu borders.

*£140–185*

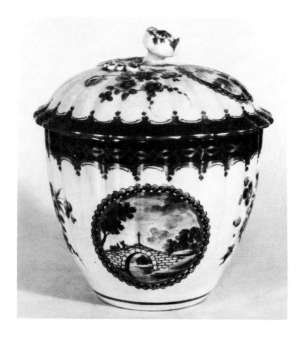

**Sucrier and Cover c.1770**
**Height 5¼ in.  crescent mark**

This fluted sucrier and cover is decorated with a variant of the 'Lord Henry Thynne' pattern. The influence of the Sèvres factory can be seen in the shape and decoration of this piece. Patterns of this type appear mainly on tewares but occasionally on mugs and jugs. Very desirable and quite rare.

*£180–230*

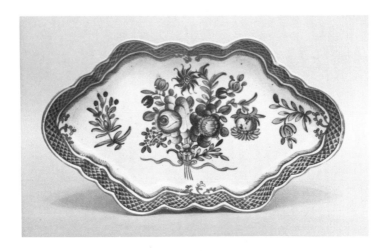

### Spoontray c.1775-78
**Length 6¼in.   no mark**

A typical Worcester spoontray form of the 1770's. The decoration is derived from 'Chinese Export' porcelain. Until recently the wares decorated in this style were considered to have been made at Caughley but it now appears that most of them are of Worcester origin. The underside is unglazed. Spoontrays are a comparatively rare shape in all the early English factories. A desirable form.

*£55–72*

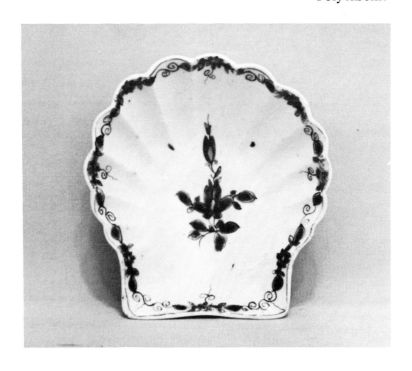

**Shell c.1752-54**
**Height 3in. no mark**

This small shell-shaped dish probably dates from the first few years of the Worcester factory rather than from the Lund's Bristol period. Examples are fairly scarce and often very attractively decorated. A similar shape was made with underglaze blue decoration but specimens are usually slightly later in date.

*£75–90*

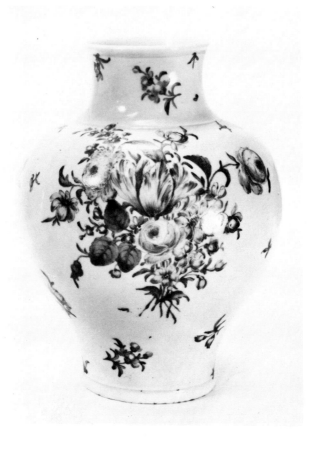

### Vase c.1758
**Height 7¼in.  no mark**

This vase is superbly painted in a soft palette with bouquets and sprigs of tulips, roses, lilies and other flowers. It is an example of Worcester floral decoration at its best and shows the influence of Meissen at that period. All Worcester vases are scarce.

*£160–200*

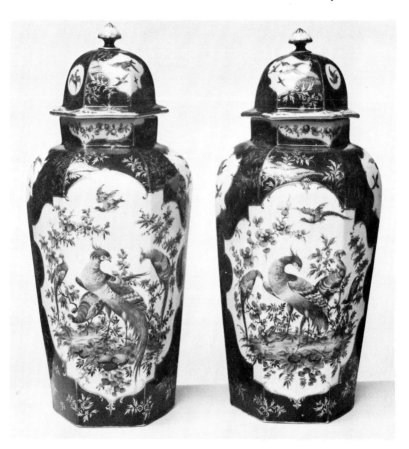

### Pair of Vases c.1770
**Height 11½in.   square marks**

A magnificent pair of hexagonal vases decorated with exotic birds on a scale blue ground. Vases of this shape are especially desirable in pairs. Extremely rare.

*£1,800–2,500 the pair*

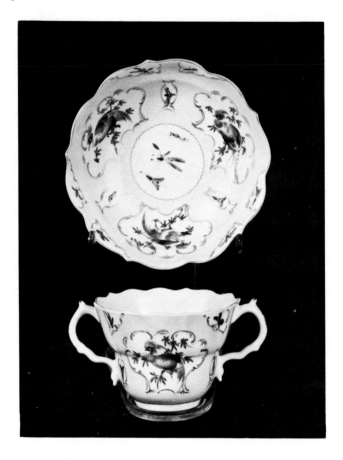

### Caudle Cup and Saucer c.1768-70
**Diameter of saucer 5¾in.  no mark**

A very fine two-handled caudle cup and saucer decorated with dishevelled birds on a yellow scale ground. This is one of the rarest and certainly the most desirable of all the ground colours. In combination with this shape and the dishevelled birds, it makes a very costly piece of porcelain indeed. Extremely rare.

*£1,400–2,000*

## Cups and Saucers c.1770-72
**Diameter of saucer 5¼in. crossed sword marks**

Apple green decoration. These coffee cups and saucers are decorated in
the style of the Marchioness of Huntly's service. This is not one of the
rarest or most valuable of the Worcester ground colours but the more
important shapes such as mugs, mask jugs and coffee pots can be
very expensive. Ironically the rarest and most expensive of the ground
colours today are the ones which were least popular in the eighteenth
century. Beware of later decoration.

*£150–200 each*

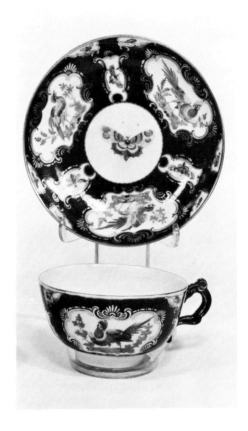

**Coffee Cup and Saucer c.1768-70**
**Diameter of saucer 5in.  square mark**

A cup and saucer decorated with exotic birds on a blue scale ground. Although these pieces must originally have been produced in large quantities, they are no longer common and have now become fairly expensive. The quality of the blue scale ground varies and great care should be taken to ensure that the painting and gilding on the cup matches that on the saucer.

*£115–150*

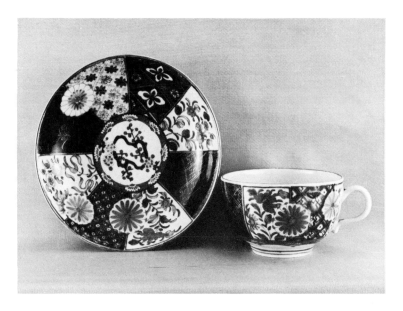

## Coffee Cup and Saucer c.1770
**Diameter of saucer 5in. pseudo Chinese marks**

The 'Old Mossaik' pattern. This standard pattern of the 1770's appears mainly on tea and coffee wares and flatwares. It is nearly always marked with pseudo Chinese numerals. Fairly common.

*£58–72*

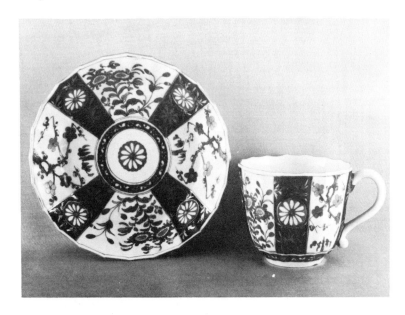

### Coffee Cup and Saucer c.1770
**Diameter of saucer 4¾in.  square mark**

This is the most common of the Worcester 'Japan' patterns. Fluted examples are more desirable and slightly more expensive than plain ones. Beware of the Derby replacements which also bear square marks.

*£48–62*

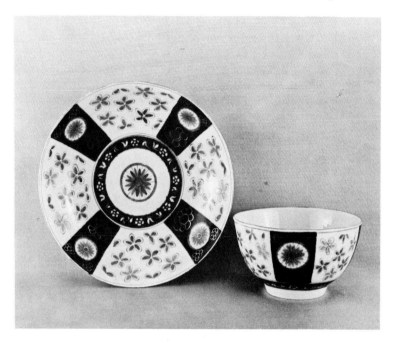

**Teabowl and Saucer c.1770-72**
**Diameter of saucer 4¼in. square mark**

A typical and very common Worcester 'Japan' or 'Imari' pattern. This is probably the least expensive of all the designs of this type. If the gilding is rubbed, the value is reduced.

*£42–55*
*Teabowl alone £8–11*

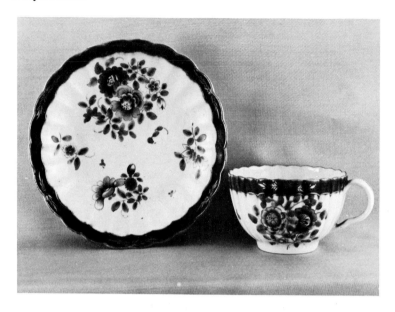

### Coffee Cup and Saucer c.1770
**Diameter of saucer 5½in.  crescent mark**

A fairly common pattern decorated in 'famille rose' style. Wares painted
with oriental flowers are less desirable than those with European flowers.
The quality of the decoration and gilding on such pieces seldom varies.

*£50–65*

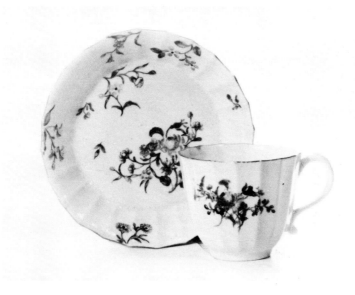

**Coffee Cup and Saucer c.1768**
**Diameter of saucer 4½in.  square mark**

An attractive fluted coffee cup and saucer with carefully painted sprays of garden flowers. This particular pattern seems only to occur on fluted tea and coffee wares.

*£52–68*

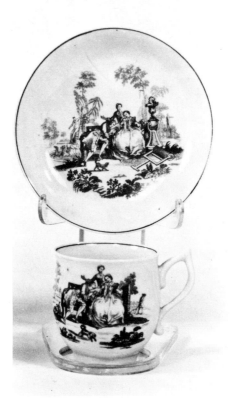

**Coffee Cup and Saucer c.1765**
**Diameter of saucer 4½in.  no mark**

A cup and saucer printed in overglaze black with the common Hancock
subject, 'L'Amour'. Coffee cups with peaked scroll handles are worth up
to three times as much as ordinary cups and this would of course
increase the value of this cup and saucer.

*£50–65*

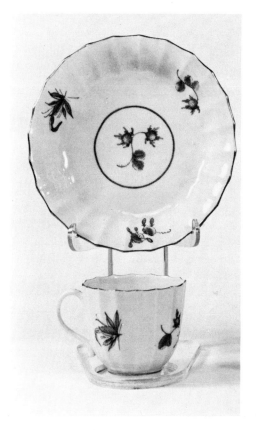

**Coffee Cup and Saucer c.1770**
**Diameter of saucer 4¾in.  no mark**

A fluted coffee cup and saucer decorated in the atelier of James Giles in green camaieu with leaves and sprays. Not a very desirable form of decoration.

*£30–38*

# BLUE AND WHITE WORCESTER 1752-1776

Throughout the early period at Worcester, blue and white porcelain formed a large and very important proportion of the factory's output. Undoubtedly these wares were the finest blue and white soft paste porcelains produced in Europe in the eighteenth century. Although it is true to say that as far as blue and white is concerned, there is almost as much Worcester as all the other factories put together, it is nevertheless comparatively expensive. This apparent paradox is explained by the quality and range of the wares made. It is quite simply an interesting and aesthetically rewarding factory to collect.

The blue and white wares made at Bristol before the transfer to Worcester in 1752 are extremely scarce. In the last six years only seven examples have appeared in the main London salerooms compared with literally thousands of pieces of blue and white Worcester. The output of the Lund's Bristol factory seems to have been confined mainly to sauceboats, creamboats, coffee cans and pickle leaf dishes. A few patty pans, teapots, small baskets, bowls and scallop shells are known, but no more than half a dozen of each at most. Teabowls, coffee cups and saucers are all unrecorded.

Most pieces from the early period at Worcester of 1752-65 are rather expensive and, with a few exceptions, relatively scarce. Of the tewares, teabowls are slightly more common than coffee cups, teapots and cream jugs are scarce and coffee pots and spoon trays rarer still. Tea caddies and sucriers seem not to have been made until about 1765. All flatware is rare and in fact Worcester produced very few plates or dishes until after about 1768 when they became very common. By the way of contrast, between 1752 and 1770 the Bow factory specialised in flatware, while making comparatively few teawares. Worcester produced a fine range of sauceboats including two-handled examples which occur in three sizes. Nearly all the sauceboats of this period are moulded and have rococo reserves containing Chinese style fishing scenes. The finely-potted teawares similarly decorated are particularly sought-after by collectors. Mugs of this period, although not especially rare in comparison with some other shapes, are usually expensive, particularly the early examples with spreading bases. Many of the finest early Worcester specimens belong to the 'Scratch Cross' group (1753-56) and these include the superb jugs, coffee pots and large mugs which have in the past been mistakenly attributed to Liverpool. Easily the most common de-

sign of the pre-1765 period is the 'prunus root' pattern which appears frequently on teawares, bowls, coffee cans, mugs and the rare early mustard pots. Factory marks were not regularly used until the late 1760's, but most of the early pieces bear a workman's or painter's mark of some kind.

From 1765 until the mid-1780's blue and white porcelain was manufactured at Worcester in very large quantities, particularly in the 1770's. In this period objects became more standardised in both shape and decoration. After about 1768, flatware became very common, leaf dishes, baskets, plates and shaped dishes being produced in great numbers. Many of these were transfer printed with the popular 'pinecone' pattern. All teawares are common, with the exception of spoon trays and teapot stands. Other standard shapes at this time are cabbage leaf jugs, mugs, coffee cans, pickle leaf dishes and small hors d'oeuvre dishes. Coffee pots, whilst more common than the earlier specimens, are still hard to find in good condition. Transfer printed wares became increasingly common and by the mid-1770's some 80% of the porcelain was printed rather than painted. Comparatively few printed designs were used and consequently the wares of this period lack the variety of some of the other factories. The standard of the potting and the quality of the porcelain, however, continued to be extremely high.

In the period from 1776 until about 1785, a group of printed wares was produced which until very recently was thought to be of Caughley origin. The standard of potting is a little below usual for Worcester, and the blue is a rather unattractive almost violet tone. Pieces are marked with either a hatched crescent or with pseudo-Chinese numerals. One of the designs used at this time was the well-known 'fisherman' pattern which also appears on Caughley and Pennington's Liverpool. It will be some time before we know how the re-attribution of these wares has affected their value.

Blue and white Worcester is very popular with collectors, the earlier pieces being especially highly esteemed. It is probably the soundest factory in which to invest and specimens have risen in price considerably during the last eight or ten years.

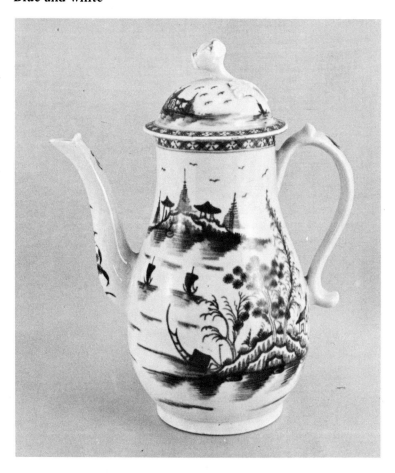

### Coffee Pot c.1772
#### Height 8½in. Crescent mark

A typical Worcester shape of the 1770's. Pre-1768 coffee pots are rather scarce. Painted coffee pots of this period are worth about 30% more than transfer-printed ones.

*£90–120*

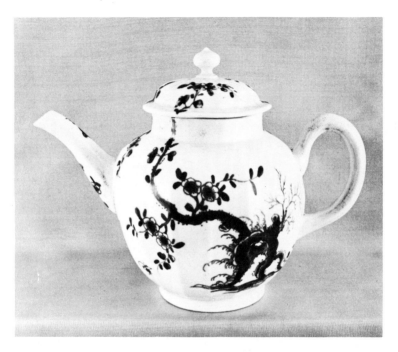

**Teapot c.1756-58**
**Height 5¾in. Workman's mark**

The 'prunus root' pattern is easily the most common design found on pre-1760 Worcester wares. This attractively fluted teapot is slightly larger than usual for its date. All blue and white Worcester teapots of this period are scarce, especially if in good condition.

*£95–125*

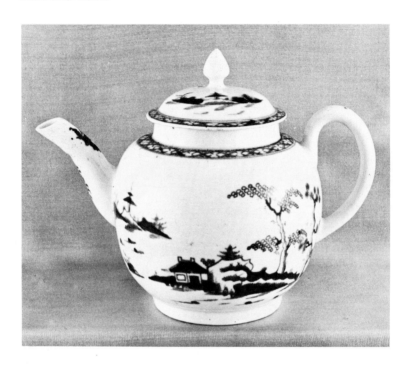

### Teapot c.1768
**Height 5½in. Crescent mark**

An absolutely typical Worcester teapot painted with one of the most common designs, the 'blue rock' pattern. This pattern was first used in the mid-1760's but most examples date from the period 1768-1780. The design was also used at Bow, Caughley, Liverpool, Derby and Plymouth.

*£55–72*

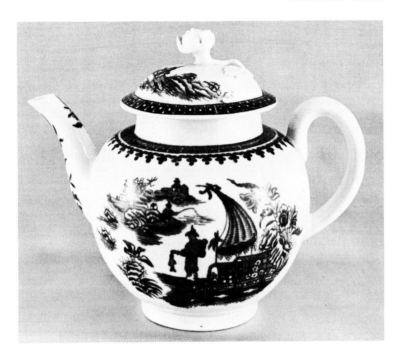

**Teapot c.1775-78**
**Height 5in. Crescent mark**

A typical Worcester teapot shape of the late 1770's although it is below average in size. The 'fisherman' pattern is printed on this teapot in a lighter tone of underglaze blue than would usually be found on Caughley. The inside flanges on Worcester teapot lids are always unglazed.

*£40–50*

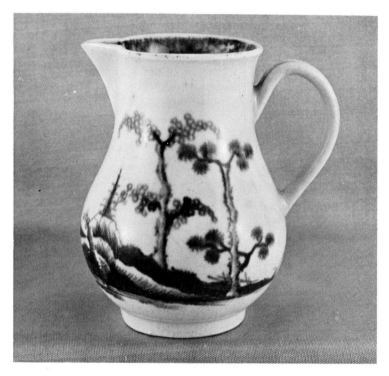

**Creamjug c.1768**
**Height 3¼in. No mark**

A typical Worcester creamjug of the period in both its shape and its
pattern. Creamjugs are very popular with collectors as they are easy to
display and do not take up much space. Quite common.

*£35–45*

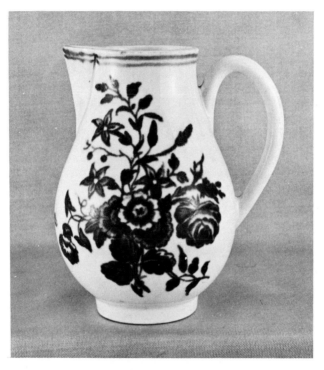

**Milk Jug c.1775**
**Height 3¾in. Crescent mark**

A very common floral transfer-print. Unlike creamjugs, milk jugs would originally have had covers and a complete specimen would be worth up to 30% more than an example without its lid. The shape is typical of the late 1770's.

*£28–35*

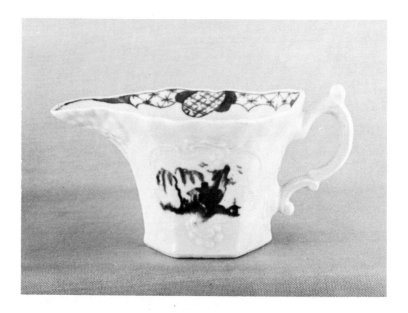

### Creamboat c.1765
**Length 4¼in. Crescent mark**

These very attractive moulded creamboats are much sought-after and nowadays fairly scarce. Some examples are less well painted and therefore not as valuable. Earlier creamboats of a similar shape were produced first at Bristol and then at Worcester. The handles of these specimens tend to be 'squared' and the painting is more freely done.

*£70–85*

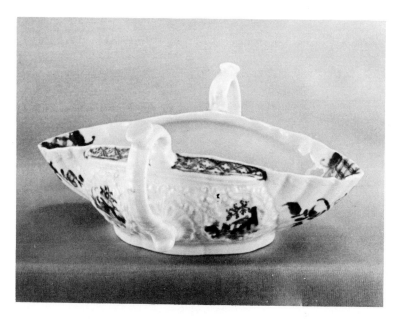

## Sauceboat c.1756
### Length 7¾in. Workman's mark

These fine two-handled sauceboats were produced at Worcester in three sizes of which the one illustrated is the smallest. The larger examples sometimes have thumb rests moulded in the form of monkey heads and these are worth up to 25% more. All two-handled sauceboats are now fairly scarce. Bow and Chelsea also made sauceboats of this type.

*£95–120*

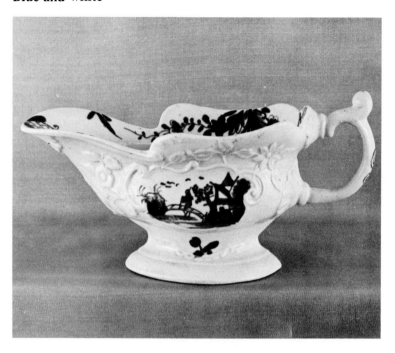

**Sauceboat c.1755-56**
**Length 6in. Workman's mark**

These fine moulded sauceboats were made in three sizes and vary in date between 1753 and about 1758. Their value varies according to their date, size and the quality of their moulding. The largest examples tend to be the best painted and are nowadays the rarest. This form was also produced in polychrome over roughly the same period.

*£80–100*

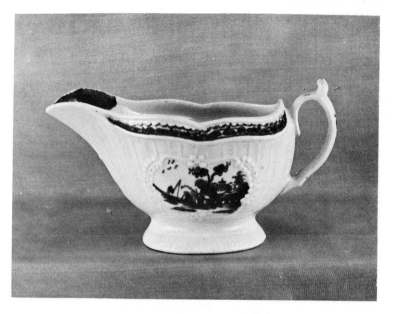

### Sauceboat c.1768
**Length 5¾in. Workman's mark**

This is the most common form of Worcester sauceboat. Most examples date from the period 1768-1778 and have a crescent mark. The moulding seldom varies. Polychrome specimens of this shape are considerably less common.

*£45–60*

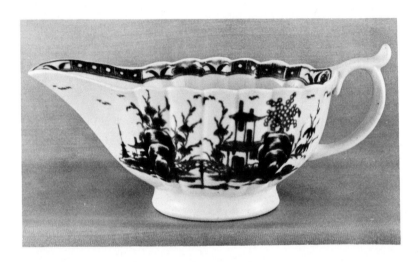

**Sauceboat c.1768**
**Length 7in. Crescent mark**

The combination of the fluting and the Chinese scene is pleasing.
Some rather similar (but usually larger) sauceboats were made in the
late 1750's but these tend to have 'squared' handles. This sauceboat
form was not produced in polychrome.

*£50-65*

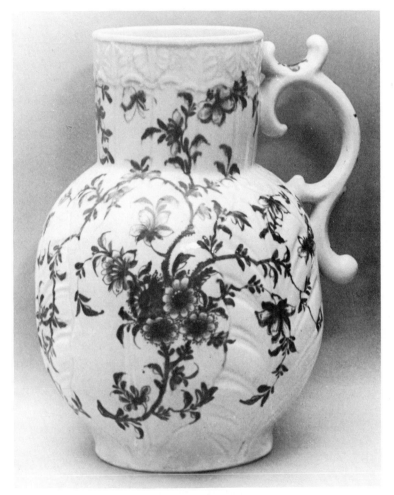

**Cider Jug c.1756**
**Height 10½in. Crossed swords mark**

These moulded jugs were produced in three sizes of which the one
illustrated is the largest. Imposing though they are, their size tends to
count against them as they are difficult to display.

*£100–130*

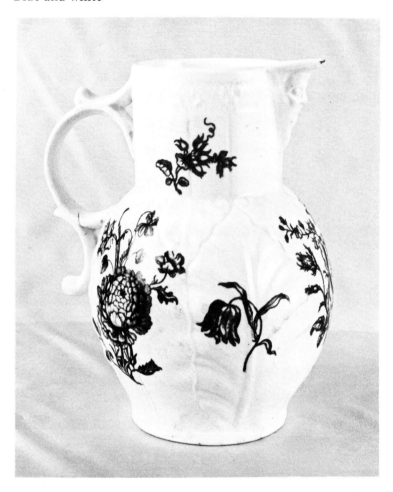

### Mask Jug c.1770
**Height 8in. Crescent mark**

Most examples of this standard Worcester form are printed, usually with floral sprays. The shape was also produced at Caughley and at Pennington's Liverpool factory. Quite common.

*£70–88*

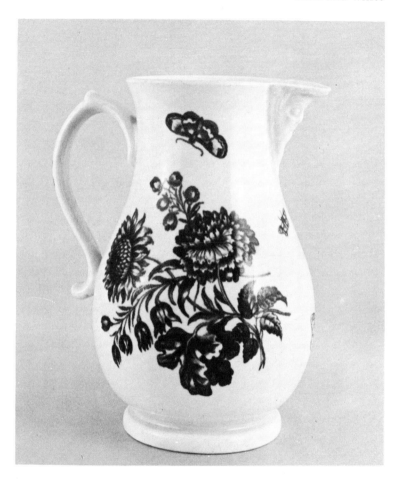

**Mask Jug c.1770**
**Height 7½in. Crescent mark**

Quite a graceful shape which is remeniscent of some silver examples.
The floral print is a common one but this jug has the advantage of not
being too large.

*£65–82*

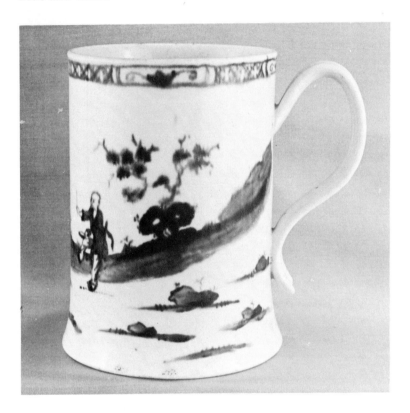

**Mug c.1756**
**Height 4¾in. Workman's mark**

The 'Tambourine' pattern is one of the fine range of early Worcester designs, most of which are now rather scarce. The shape of this mug is typical of the 1750's with its spreading base and grooved handle. Patterns which include Chinese figures tend to be particularly desirable.
*£95–130*

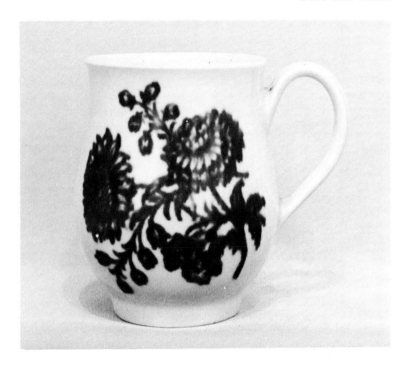

**Mug c.1770**
**Height 3½in. Crescent mark**

Mugs with this common floral print were produced in three sizes and in two shapes; one bell-shaped and the other cylindrical. The largest size is less desirable. Smudgy or runny transfers reduce the value somewhat. Fairly common.

*£45–60*

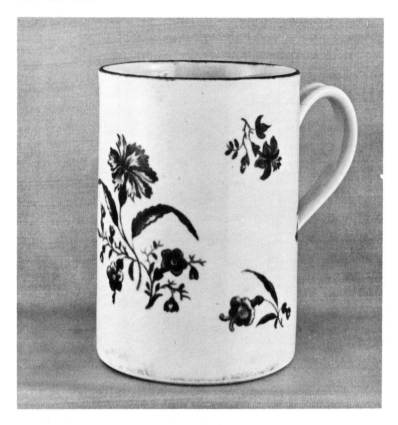

**Mug c.1775-78**
**Height 3¾in. Crescent mark**

This common type of Worcester mug is usually rather sparsely decorated. The transferprint also appears on plates and dishes but is rare on tea and coffee wares.

*£40–50*

**Coffee Can c.1755-56**
**Height 2¼in. Workman's mark**

These fluted coffee cans were all made at Worcester although they are often described as Lunds' Bristol. The flared rims and silver-shape handles are typical. It is doubtful whether they were intended to have saucers; at any rate, saucers of this pattern seem to be extremely rare.

*£30—38*

**Coffee Can c.1765**
**Height 2¼in. No mark**

The 'Plantation' pattern was one of the earliest underglaze blue transfer-prints to be used at Worcester. The pattern, which is sometimes found in a painted version, occurs mainly on mugs, coffee cans and teawares. Most specimens of this pattern are not marked.

*£21–28*

### Basket c.1770-75
**Diameter 7¾in. Crescent mark**

This standard Worcester form was produced in several sizes. Most examples were transfer-printed, usually with the 'pine cone' pattern. A slightly larger, deeper basket has two handles and these would be worth about 20% more. Worcester produced baskets painted in underglaze blue in the period c. 1765-1772, but specimens are comparatively scarce.

*£78—98*

**Salad Dish c.1772-5**
**Diameter 10in. Crescent mark**

A fairly common Worcester form in the period 1765-80. Printed speci-
mens are roughly three times as common as painted ones and worth
about 30% less. These salad dishes were also produced at Lowestoft
and Caughley.

*£62–78*
*In above condition £10–14*

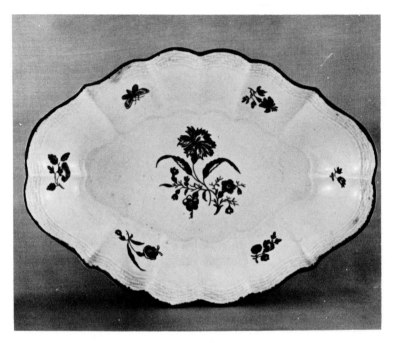

### Dish c.1775
**Length 9¾in. Crescent mark**

A very common transfer-print known as the 'Chantilly Sprig' pattern. It occurs mainly on plates and dishes but also sometimes on cylindrical mugs. There is a painted version of this pattern but it is less common. Dishes of this shape were also made at Caughley.

*£35—45*

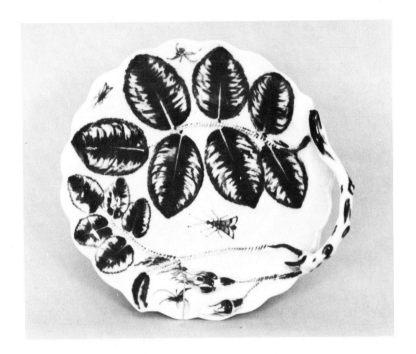

### Small Dish c.1765-68
#### Diameter 6in. Crescent mark

The so-called 'Blind Earl' pattern. These attractive little dishes are moulded with rose leaves and buds and are very desirable. They all date from the period 1765-70 and are considerably rarer than their polychrome decorated counterparts. The pattern also occasionally appears on full-sized plates but specimens are scarce.

*£95—130*

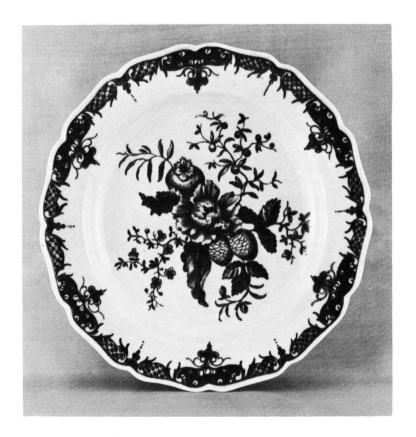

**Plate c.1770**
**Diameter 8¾in. Crescent mark**

The 'pine cone' pattern is easily the most common transfer-print found on blue and white Worcester flatware. Plates of this type were made between about 1770 and 1780. The pattern was also used at Caughley and Lowestoft. This design never occurs on tea or coffee wares.

*£30—40*

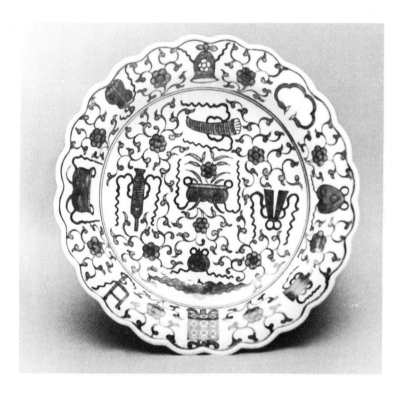

## Plate c.1775
### Diameter 7½in. Pseudo Chinese marks

The 'Hundred Antiques' pattern appears only on flatware of the post-1770 period. Specimens are not particularly rare but they tend to vary in price considerably. All blue and white Worcester plates of the pre-1765 period are scarce.

*£35—48*

**Saucerdish c.1768**
**Diameter 7in. Crescent mark**

This fluted saucerdish is painted with a fairly common form of decoration which was probably derived from the early French factory at St. Cloud. Fluted patterns of this type appear almost exclusively on tea and coffee wares.

*£30–38*

### Tea Caddy c.1768
**Height 5in. Crescent mark**

This is the standard Worcester tea caddy shape in the pre-1775 period. It appears that few, if any, blue and white caddies were produced before about 1762. This caddy should of course have had a cover and this would increase its value by up to about 35%. The quality of the moulding of this example affects its price.

*£30–40 (without cover)*

**Sucrier and Cover c.1772**
**Height 5in. Crescent mark**

This sucrier and cover is printed with a very common Worcester floral transfer. Similar pieces were produced at Caughley and Lowestoft. It seems that hardly any blue and white Worcester sucriers were made before about 1762.

*£35–45*

## Bowl c.1770
### Diameter 7¼in. Crescent mark

A fairly typical Worcester bowl of the period, with a Chinese scene painted all the way around it. Painted bowls are worth about 40% more than transfer-printed ones. Quite common.

*£38–45*

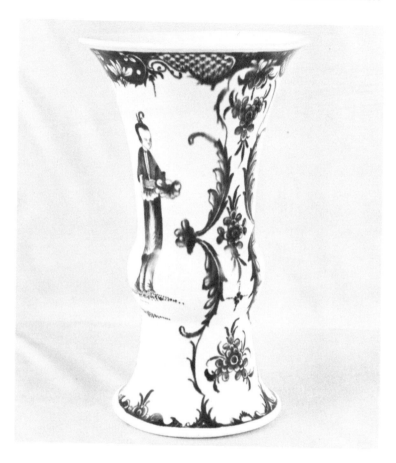

**Vase c.1770-72**
**Height 7¾in. No mark**

This vase was originally one of a garniture of five, but nowadays even single examples are scarce and expensive. This shape occurs in at least three sizes, of which this one is the tallest.

*£100−125*

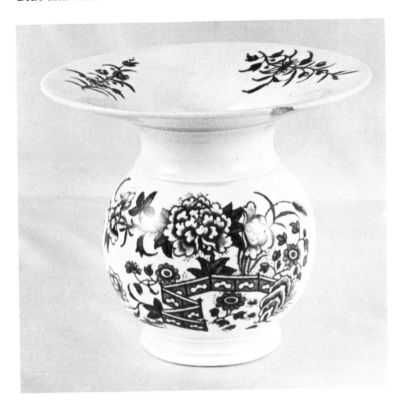

### Spitoon c.1775
#### Height 4¼in. Crescent mark

Worcester made more spitoons than any other factory. Nearly all of them date from the period 1768-1780, and the vast majority are transfer-printed. Similar forms were made at Lowestoft and Caughley, although the former examples are scarce.

*£35–45*

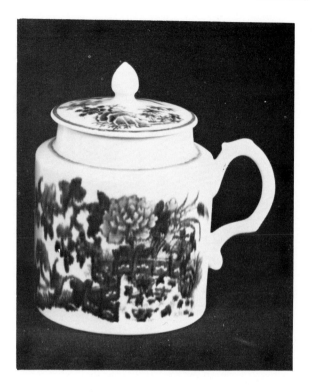

**Mustard Pot c.1770**
**Height 4¾in. Crescent mark**

This mustard pot is transfer-printed with the 'zig-zag fence' pattern.
Most Worcester mustard pots of the period 1768-1780 are printed;
earlier specimens are scarce. Polychrome decorated examples are rare in
all factories.

*£45−60*

## Spoon c.1770
### Length 5¼in. Crescent mark

Worcester blue and white spoons are fairly scarce although more common than the Bow and Lowestoft specimens of a similar shape. They occur in several patterns of which the one illustrated is by far the most common. This shape seems not to have been made in polychrome.

*£48–68*

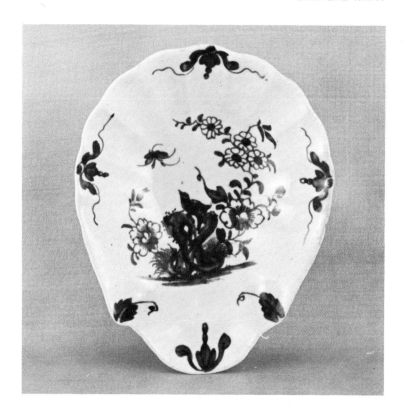

**Shell-Shaped Dish c.1758**
Length 4¼in. Workman's mark

These shell-shaped dishes were produced at Worcester in the period
1756-65. The pattern illustrated is very common on early leaf and shell-
shaped dishes but is seldom seen on any other shape. Polychrome decora-
ted examples of this shape were made from c.1752 until about 1760
and are fairly scarce.

*£38—55*

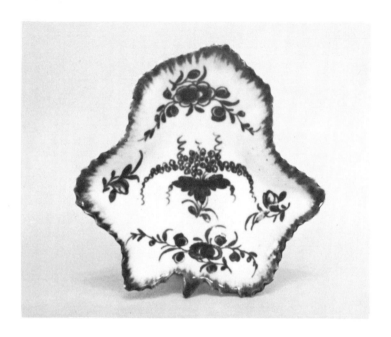

### Pickle Leaf c.1768-70
#### Height 3¼in. Crescent mark

These Worcester pickle leaf dishes are fairly common in the period c.1765-1778. Most Eighteenth century factories produced them but each type can be recognised by its distinctive shape. Worcester made polychrome decorated pickle leaf dishes but they are extremely rare.

*£26—32*

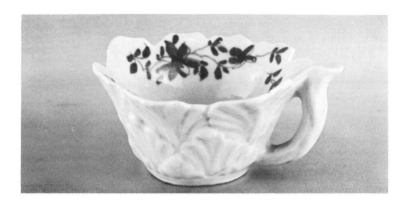

## Pickle Leaf c.1760
### Length 3in. Workman's mark

This attractive pickle leaf dish is moulded in the form of a geranium leaf. It was perhaps intended as a butter boat. These were produced at Worcester in the period c.1758-1775 and vary considerably in the quality of their decoration and moulding. The shape was also produced in polychrome but specimens are scarce. Similar forms were made at Derby, Bow, Lowestoft and Caughley. Quite common.

*£30–40*

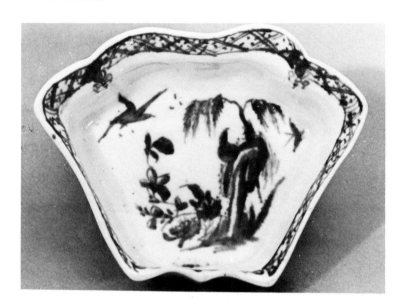

## Hors-D'Oeuvre Tray c.1765
### Height 2¾in. Workman's mark

This little tray is one of a set of six which fit around a central star-shaped dish. These trays vary in date from about 1762-1775, but the pattern is nearly always the same. Complete hors-d'oeuvre sets are now extremely rare but the individual trays are relatively common. No polychrome decorated examples of this shape are known.

*£27—35*

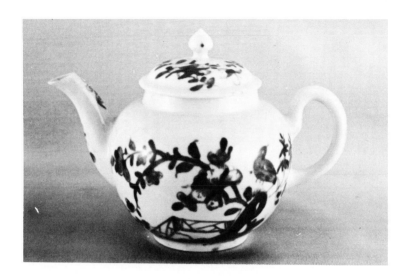

**Miniature Teapot c.1756**
**Height 3in. Workman's mark**

This is an exact replica in miniature of a full-sized Worcester teapot of
the mid-1750's. Worcester miniature wares are considerably rarer than
those made at Caughley, Bow and Lowestoft. The pattern is a standard
one of the period. The extreme popularity of these miniature wares,
combined with their comparative rarity, has caused them to be rather
expensive even by the standards of today.

*£80–115*

## Knife and Fork c.1765
### Handle lengths 4in. 3½in. No mark

Blue and white Worcester knife and fork handles appear in four different patterns, none of which are moulded. They are considerably rarer than the Bow examples and are the sort of objects which might vary enormously in price according to circumstances. A few polychrome decorated examples and some undecorated ones are known but these are rare. Blue and white handles were also made at Bow, Lowestoft, William Ball's Liverpool factory and Newhall.

*£28–45*

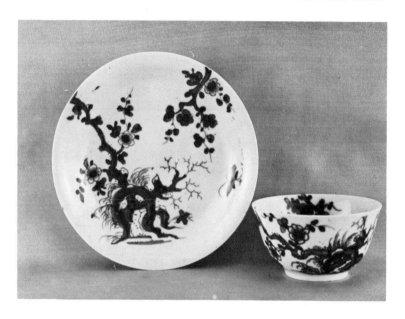

## Teabowl and Saucer c.1755
### Diameter of Saucer 4¾in. Workman's mark

Although the 'prunus root' pattern is quite a common one, it is also a popular design as it usually appears on early pieces. This teabowl and saucer is attractively painted and thinly potted. A specimen of fifteen or so years later would be less well-painted, more thickly potted, crescent marked and less valuable.

*£32–40*

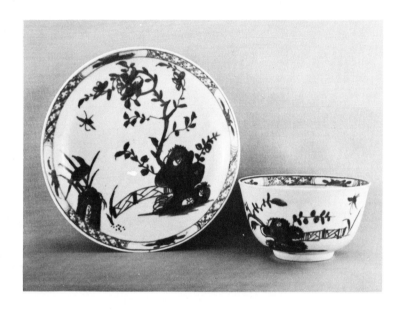

### Teabowl and Saucer c.1756
**Diameter of Saucer 4½in. Workman's mark**

The 'Warbler' pattern is a fairly scarce design which occurs on Worcester tea and coffee wares in the period 1754-1762. Teabowls and saucers of this quality are nowadays hard to find. The so-called 'glaze shrinkage', traditionally found on all Worcester wares with footrings in fact is rarely seen on pieces of before about 1758.

*£40–48*

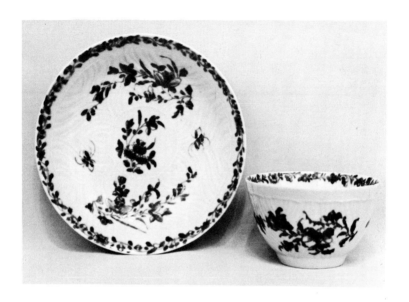

## Teabowl and Saucer c.1770
### Diameter of Saucer 4½in. Crescent mark

'Feather-moulded' or 'herring bone' decoration. This moulded pattern occurs on Worcester blue and white tea and coffee wares in the period c.1755-1772. Specimens bearing workman's marks are worth slightly more than the crescent marked examples. Fairly common.

*£25−32*

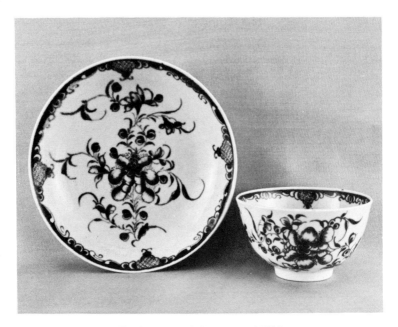

## Teabowl and Saucer c.1775
### Diameter of saucer 4¾in. Crescent mark

The 'Peony' pattern is one of the most common Worcester painted designs. It was used from the mid-1750's right through until about 1778, but most examples date from the 1770's. The pattern was also used at Lowestoft, Caughley and elsewhere. Very common.

*£20–25*
*teabowl alone £5–7*

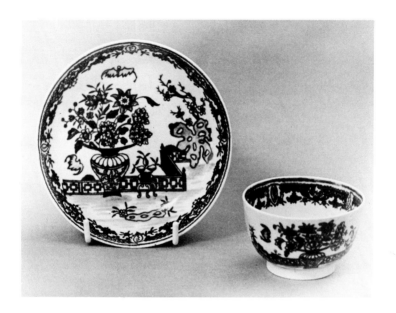

## Teabowl and Saucer c.1780-85
### Diameter of saucer 4¾in. Pseudo Chinese numerals.

This teabowl and saucer is transfer-printed with the 'bat' or 'vase' pattern in a bright and deep tone of underglaze blue. Wares with disguised numeral marks were until recently thought to be Caughley. Quite common.

*£14–18*
*Saucer alone £7–9*

# LONGTON HALL c.1750-1760

This small factory was not only the first in Staffordshire to manufacture porcelain, but one of the first two or three to do so in the entire country. Perhaps understandably its output for the first four years or so consisted mainly of wares which were somewhat primitive and crude in appearance. Thereafter, the standard of potting and of decoration improved and some of the most attractive and delightful pieces to be found in English porcelain were produced.

The earliest products of the factory seem to have been the so-called 'Snowman' figures and the group of useful wares decorated in 'Littler's' blue. The exact date and place of origin of the latter group has not yet been established for certain. This group consists mainly of mugs, plates, dishes, teabowls and saucers, teapots and sauceboats. The underglaze blue, which is often runny and unevenly applied, has a peculiar brightness which was presumably intended to simulate the ground colour used at the famous Vincennes factory. Indeed, the remains of the unfired gilding can sometimes be seen. Most pieces have an unfinished appearance caused by the empty reserves which are often found on mugs, coffee pots and tea wares. In the cases where overglaze decoration does occur in these reserves, it was possibly added ten years or so later at West Pans in Scotland. The potting of these wares is clumsy and thickly done and the handles add to the general rustic appearance. Other even rarer forms of decoration are floral designs, 'Japan' patterns and some bird painted patterns.

In the brief transitional period from 1753-54, the potting becomes slightly better and the shapes more sophisticated. The painting still has a rather primitive, experimental look to it and the glaze tends to craze at times. Teapots sometimes have dragon-head spouts and sauceboats are of silver-shape; teawares are comparatively rare. The very scarce powder blue vases, bottles and teapots also date from this period.

The middle period (1754-57) includes many of the finest and most famous of the factory's products and in fact some of the most beautiful porcelains ever produced in this country. Amongst these are the fine range of leaf moulded wares in the Meissen style, which were in fashion in the mid-1750's. These include teapots, sauceboats, tureens, dishes, cream jugs, bowls and the beautiful openwork baskets. All these wares are very expensive and have been so for a long time. Other relatively common shapes at this time are large jugs, strawberry plates and dishes, mugs and the finely-decorated teapots which were pro-

duced in a variety of remarkable shapes with recurring leaf, fruit and vegetable motifs. In fact, a large proportion of the Longton Hall output of this period was moulded in some way. Some pieces are decorated by the 'Castle painter' who specialised in attractive European scenes, others by the 'Trembly Rose' painter whose fine flower sprays are similar to some found on red anchor period Chelsea. The bird painting often reached a standard hardly equalled by any other eighteenth century English factory.

The later polychrome wares (1758-60) are for the most part rather less elaborate but still finely decorated. Teawares become more common and their shapes more simple and practical. The group of Longton Hall wares transfer printed in black by Sadler date from this period. They are much rarer than their Worcester counterparts but not always very much more expensive.

The blue and white porcelain made from 1754 onwards is somewhat rarer than the polychrome products. Sauceboats, creamboats, bowls and mugs are slightly more common than teawares; plates, dishes and coffee pots are particularly scarce. Footrings are usually low and the paste often has slight tears which are particularly apparent when seen through transmitted light. Handles are very often of rustic twig form and patterns tend to be derived from the Chinese. The blue is a pleasant tone, resembling that on Worcester wares of the 'Scratch Cross' period.

All Longton Hall wares are now very scarce, but the blue and white in particular is not always quite as expensive as one might expect. It is a difficult factory to collect because a large proportion of the surviving specimens are either in large private collections or in museums. This means that an even smaller percentage than usual of the factory's output remains in circulation.

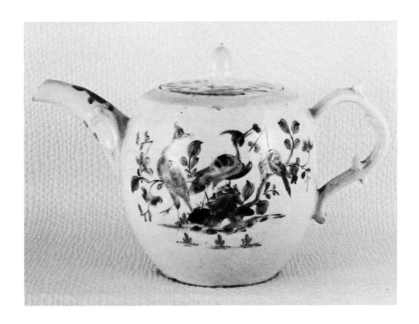

**Teapot c.1758**
**Height 4½in. No mark**

Most Longton Hall barrel-shaped teapots date from the period 1756-60.
This example is typically decorated in bright colours. The moulded
spout and double scroll handle are characteristic of the factory. All
Longton Hall teapots whether polychrome or blue and white are scarce.

*£150–200*

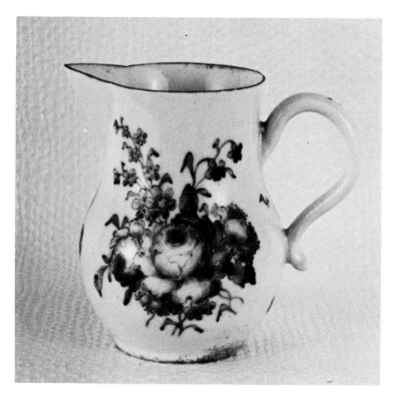

**Creamjug c.1756-57**
**Height 3in. No mark**

A charmingly decorated Longton Hall creamjug painted with a large
bouquet of garden flowers. The brown-edged rim and simple scroll
handle are typical. A fairly rare article.

*£72–90*

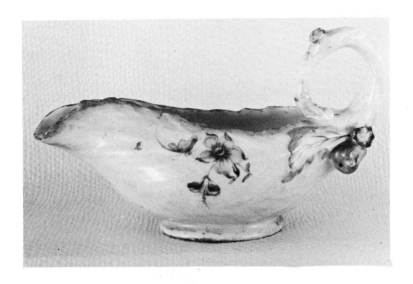

### Sauceboat c.1753-54
**Length 7½in. No mark**

Leaf-shaped sauceboats were produced in both blue and white and poly-
chrome. Most of the latter date from 1753-57, have green edges and are
decorated with flower sprays painted in soft colours. A comparatively
common Longton Hall form. Sauceboats of a similar shape were
produced at Worcester and Derby.

*£105–135*

**Mug c.1758**
**Height 3½in. No mark**

This is the most common Longton Hall mug form. Bird decoration in this manner is peculiar to the factory. Rare.

*£145–190*

**Mug c.1758-60**
**Height 3½in. No mark**

All Longton Hall wares with overglaze transfer-prints were bought 'in the white' by Sadler and printed at Liverpool. Many of these prints bear a signature and this increases their value.

*£110–140 (unsigned)*

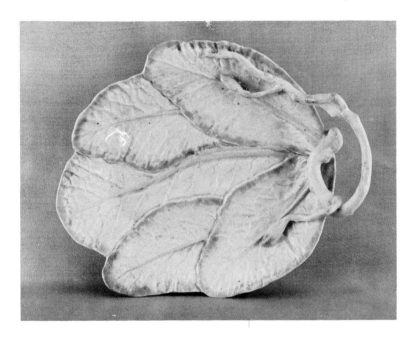

**Leaf Dish c.1754-56**
**Height 8½in. No mark**

This cos-lettuce leaf-shaped dish is moulded with overlapping leaves and painted in tones of yellowish green with pink veining. Leaf forms of this type were very popular at Longton Hall in the period 1754-57.

*£180–250*

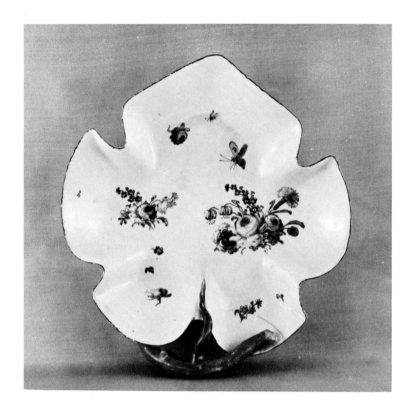

### Leaf Dish c.1756
**Height 8¼in. No mark**

This standard Longton Hall leaf form is painted in a style similar to that found on red anchor period Chelsea by the 'Trembly rose' painter. These dishes would originally have had leaf-shaped basins to go with them.

*£200–275*
*In above condition £55–70*

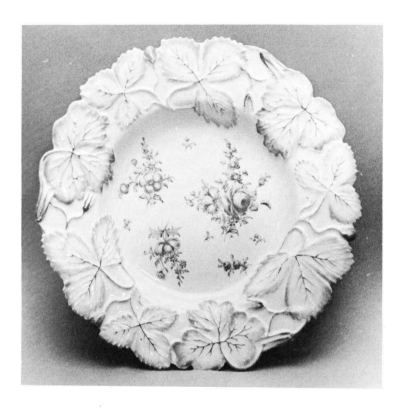

**Plate c.1755-57**
**Diameter 8½in. No mark**

A fine plate moulded with strawberry leaves and painted with sprays of flowers. Plates of this type were one of the most common forms produced at Longton Hall. Virtually all polychrome decorated wares of this factory will be expensive if in good condition.

*£165—220*

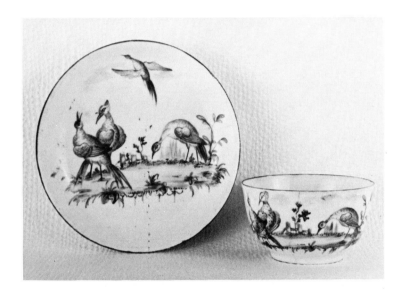

### Teabowl and Saucer c.1756-58
**Diameter of Saucer 4¼in. No mark**

A well-potted teabowl and saucer beautifully painted with birds in a landscape setting. Longton Hall bird decoration at its best will stand comparison with any done in this country. Specimens of this quality are now scarce and expensive.

*£150–195*

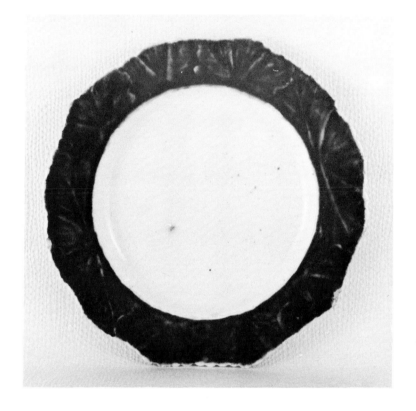

### Plate c.1752
**Diameter 8¼in. Crossed L's mark**

This plate is a typical specimen from the early period at Longton Hall. The border is moulded with strawberry leaves and painted in the rich ultramarine 'Littlers blue'. The edges have unfired gilding but any decoration that there might have been in the centre has now rubbed off, leaving an unfinished appearance about this rather crude piece.

*£52–68*

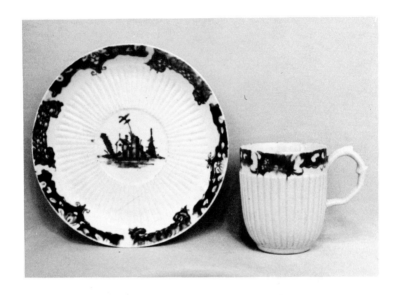

## Coffee Cup and Saucer c.1755
### Diameter of Saucer 4¾in. No mark

The decoration on this ribbed cup and saucer is derived from the French factory at St. Cloud. The shape of the coffee cup and its handle are typical. Longton Hall saucers tend to be particularly shallow and their footrings rather wide.

*£48–60*

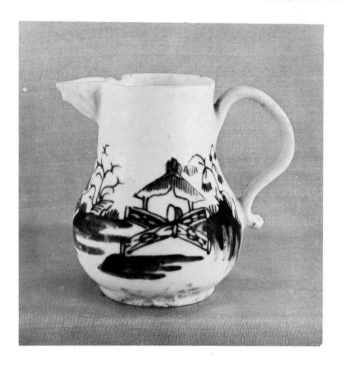

**Creamjug c.1755-57**
**Height 3in. Indistinct mark**

This is a standard Longton Hall pattern but the shape of the creamjug, especially its lip, is unusual. As can be seen, not all Longton Hall handles are of the characteristic double scroll form. No transfer-printing in under-glaze blue was done at the factory.

*£55–68*

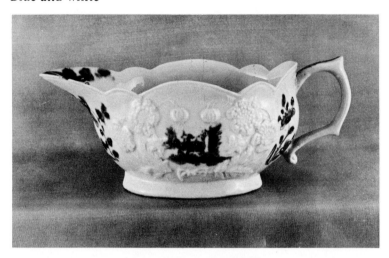

## Sauceboat c.1757-58
**Length 6¾in. No mark**

An attractive sauceboat with moulding of good quality. The tone of
underglaze blue is similar to that found on Worcester of about the same
period. Sauceboats are amongst the most common forms produced at
Longton Hall in underglaze blue. This shape does not occur with poly-
chrome decoration.

*£75–95*

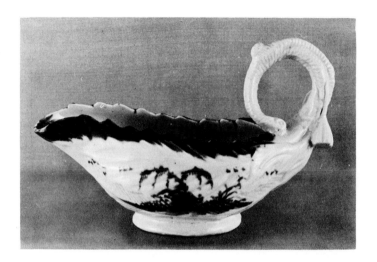

**Sauceboat c.1758-60**
**Length 5¾in. No mark**

These cos-lettuce leaf sauceboats are copies of a Meissen prototype. They were produced throughout the factory's life, the early examples being poorly potted and decorated in Littlers' blue. This is easily the most common Longton Hall sauceboat form.

*£80–100*

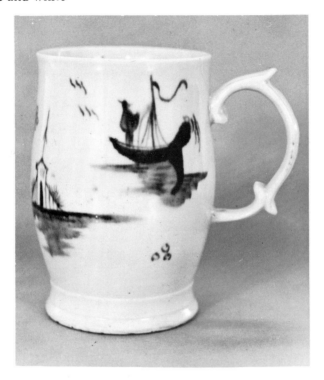

**Mug c.1758**
**Height 3¾in. No mark**

A typical example in its shape, handle and style of decoration. Other less attractive mugs of this period are taller and straight-sided. Most of the Longton Hall patterns are Chinese scenes.

*£75–100*

# EARLY DERBY 1750-1775

For the first twenty years or so of its existence, the Derby factory was chiefly preoccupied with the production of figures. Consequently, useful wares were not produced with the customary profusion of the other eighteenth century factories.

The wares of the pre-1760 period have a slightly primitive appearance which is in marked contrast to the predictable perfection of most of the post-1770 output. Much of the early potting is rather thick and heavy and flatware in particular is often mis-shapen. The decoration on these early pieces is for the most part of fine quality and subjects include flowers, birds, butterflies, moths and other insects. Shapes show an emphasis on ornamental wares rather than on the purely functional forms produced at other factories. Openwork baskets, pot-pourris, pierced dishes and plates, leaf-moulded plates and frill vases were produced as well as the more mundane objects such as tea and coffee wares, mugs, creamboats and sauceboats. Amongst the shapes particularly associated with the early years of the factory are rectangular butter tubs, covered salts, bottles and leaf-moulded sauceboats. The tea and coffee wares painted with Chinese figure subjects are especially fine. Three or four unglazed patches are often found under the bases of pieces and these are known as 'patch marks' and help to identify these early porcelains, none of which bear a factory mark.

Many of the potting shapes of the late-1750's continue well into the 1760's and these include leaf-shaped sauceboats, frill vases, openwork baskets and butter tubs. As in the earlier period, many flatwares have 'moons' or patches in the paste which look especially bright when held up to the light. These 'moons' can also be seen on some Chelsea and Longton Hall wares. 'Patch marks' continue to be found and footrings are often ground.

In 1770 the Chelsea factory was taken over by Derby and this event coincided with the beginning of the neo-classical style in English porcelain. At first, William Duesbury the proprietor of the Derby factory, continued to make porcelain at both factories but after a few years Chelsea became no more than a decorating establishment. By the early 1770's, after years of experiment, the difficulties in producing a really perfect porcelain body had been overcome at Derby and the output of useful wares increased both in quality and elaboration. Indeed, such was the degree of technical perfection achieved that most other eighteenth century porcelains seem crude and primitive by comparison.

## BLUE AND WHITE

Unlike most of the early English factories, Derby made comparatively little blue and white. The output was curiously uneven and many standard shapes are unaccountably scarce. Very few teawares for example seem to have been produced and hardly any before about 1765. Sauceboats on the other hand are fairly plentiful in several shapes and sizes. Mugs, creamboats and flatware can still be found but bowls, jugs, coffee cans and coffee pots are rare. Some small objects are surprisingly common; these include pickle leaf dishes, asparagus butter boats, asparagus servers and small wine tasters of a type which are only otherwise found in Caughley. The proportion of ornamental wares produced is higher than in any of the other factories. Apart from openwork baskets and shell centrepieces. Derby was the only factory to produce pot-pourris in underglaze blue. The decoration on Derby blue and white mainly consists of Chinese scenes which are usually painted with particular care. A feature of the decoration are the elaborate and detailed borders which are often found on plates, dishes and baskets. Many of the Derby shapes are influenced by Bow and this is most noticable in the case of sauceboats. Some transfer-printing was done from the mid-1760's onwards but to begin with the process was used more often on mugs and flatwares than on ordinary teawares. The Derby paste is soft and glassy and the vivid underglaze blue looks an even stronger tone against the very white porcelain body.

Derby useful wares have always been a rather specialised field of collecting. The fine pre-1760 wares were somewhat undervalued up until a few years ago but they have now made up most of that ground. The post-1770 porcelains have a natural affinity with nineteenth century wares in that they are judged and valued by different standards from those of the earlier wares. Their quality and technical perfection is taken for granted and their decoration becomes of paramount importance both aesthetically and commercially. Derby porcelain should be a good sound investment, as it is perhaps equalled only by Worcester in its number of admirers and devotees.

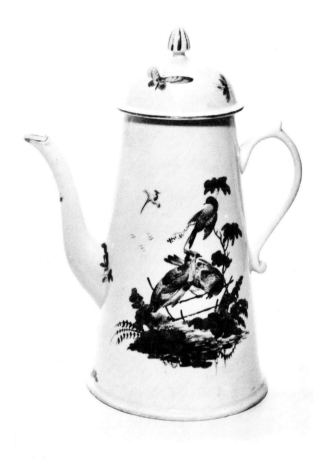

**Coffee Pot c.1758-60**
**Height 8¾in.   patch marks**

A fine early coffeepot with straight conical sides painted with birds.
This is a distinctive Derby shape which also occasionally occurs in blue
and white. Rare

*£180–230*

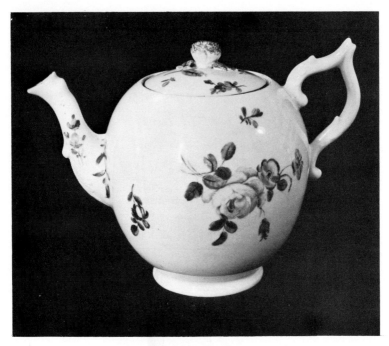

**Teapot c.1770**
**Height 4¼in.  no mark**

A Derby teapot painted in typically soft colours. The shape of this teapot is derived from Meissen. The Derby glaze is very soft and scratches easily. Not common.

*£58–70*

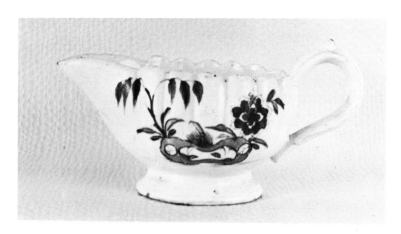

### Creamboat c.1758-60
**Length 5in.   patch marks**

An early fluted creamboat showing the characteristic Derby handle. It is fairly thickly potted for its size and is painted in oriental style. The Chinese influence on Derby wares became much less marked in the 1760's. A relatively common Derby form.

*£48–55*

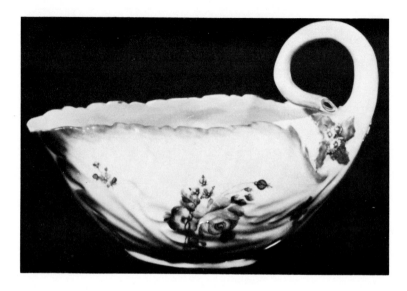

**Sauceboat c.1758-62**
**Length 7½in.  no mark**

A leaf shaped sauceboat with its edges painted in green and floral painting on its sides. Although leaf sauceboats were also produced at Worcester and Longton Hall, this particular shape is distinctively a Derby one. It does not appear in blue and white.

*£65–80*

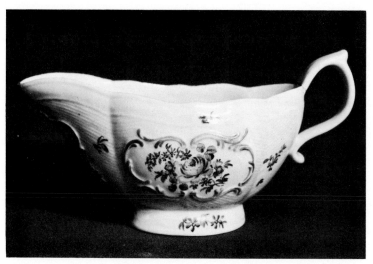

## Sauceboat c.1762-65
**Length 7¾in.  no marks**

An attractively moulded Derby sauceboat with good quality floral decoration. The handle form is characteristic of the factory, particularly the 'kick' at its terminal. A very similar shape was produced in underglaze blue.

*£55–72*

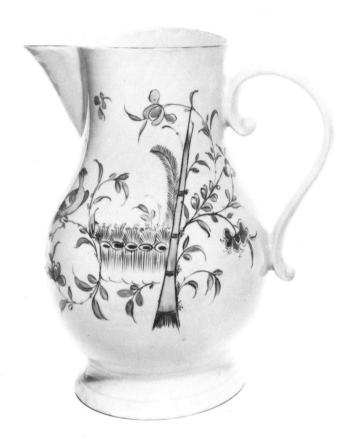

**Harvest Jug c.1765**
**Height 9in.  patch marks**

The decoration on this fine jug shows a Japanese influence. The shape and scroll handle are typical. Rare.

*£90–120*

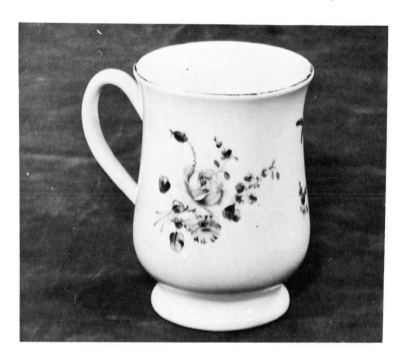

### Mug c.1762-65
**Height 4¾in. no mark**

A bell-shaped Derby mug pleasantly painted with floral sprays. Bell-shaped mugs tend to be slightly more desirable than cylindrical ones.

*£60–75*

### Mug c.1770-75
**Height 3¾in. no mark**

A typical Chelsea-Derby mug with a dark blue border and a floral spray painted in pale colours. Not a particularly desirable piece.

*£35–45*

### Basket c.1758
**Width 8¼in.  patch marks**

This fine openwork basket is decorated with fruit, butterflies and insects and has ropework handles. Elaborate shapes of this kind were a speciality of the factory in its early years. Early Derby wares were rather prone to having firing cracks and these faults were often disguised by being painted over with a leaf or insect.

*£125–175*

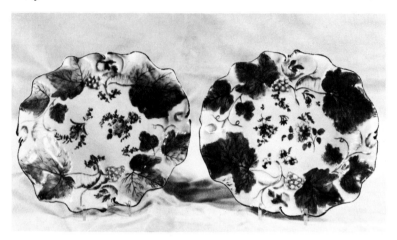

### Pair of Dishes c.1758-60
#### Length 11in. patch marks

A fine pair of early Derby vine leaf dishes with raised leaves picked out in tones of green and floral sprays painted in the centre. These dishes were also produced at Bow in both blue and white and polychrome.

*£150–190 the pair*

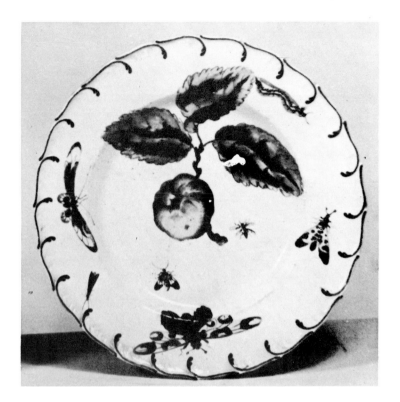

### Plate c.1758-62
#### Diameter 8¼in.  patch marks

A fine early Derby plate decorated with an apple, some leaves and various insects. The moulded border pattern also appears on Chelsea wares of the gold anchor period. The painted decoration is typical for the period.

*£78–92*

### Plate c.1770-75
**Diameter 9in.   blue mark**

A Derby shaped circular plate, the centre painted with a flower spray and the turquoise border enclosing floral swags suspended from gilt scrolls. This was possibly decorated in the atelier of James Giles.

*£75−92*

**Frill Vase c.1760-65**
**Height 9½in. patch marks**

These elaborate flower-encrusted vases were originally made in garniture sets of five. They are nowadays often found without their covers. This shape was also produced at Bow.

*£75–90*

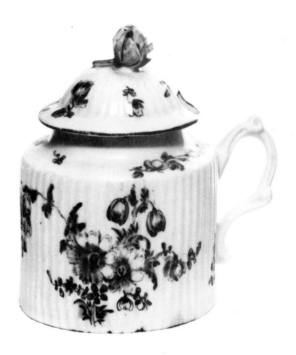

### Mustard Pot c.1758-60
**Height 3½in.  no mark**

An early Derby fluted mustard pot with a scroll handle decorated with
attractive sprays of garden flowers. The delicate colours combined with
the softness of the paste are reminiscent of some Ménnecy wares. Poly-
chrome decorated mustard pots are extremely rare in all factories.

*£85–115*

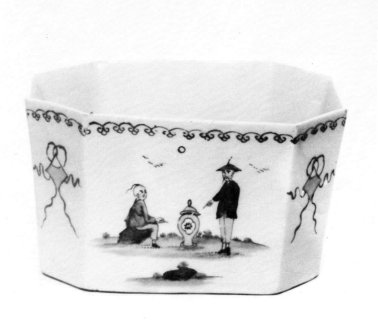

### Butter Tub c.1756-58
#### Diameter 5in.  patch marks

This butter tub is attractively painted with Chinese figures. Other examples are decorated with birds and the shape also occurs in underglaze blue. It seems that these butter tubs were not intended to have covers. The shape was not made at any other factory.

*£60–75*

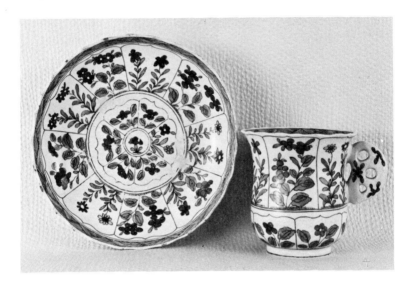

## Coffee Cup and Saucer c.1755-60
### Diameter of saucer 5in. patch marks

This rare early Derby cup and saucer is decorated in 'famille verte' style and appears to be a close copy of a piece of K'ang Hsi. Examples have in the past been wrongly attributed to Worcester.

*£100–135*

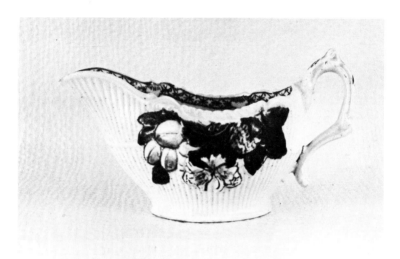

**Creamboat c.1760-62**
**Length 4¼in. no mark**

An attractive moulded and fluted creamboat with a slightly unusual handle. As can be seen in the illustration, the glaze is sanded with fine black specks, a fault which often occurred at this period.

*£38–45*

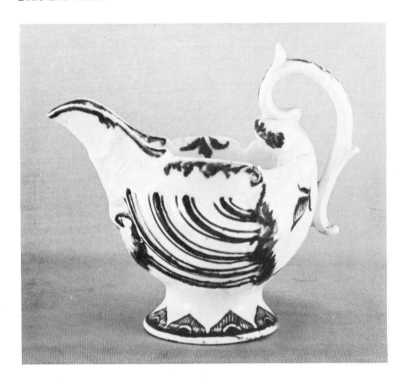

### Creamboat c.1762-65
**Length 3½in. no mark**

This is probably the most common Derby creamboat form. Some of these are shell-moulded whilst others of a similar shape are plain. Similar creamboats were made in polychrome at Derby and blue and white examples were produced at Worcester, Lowestoft and at Christian's Liverpool factory.

*£36—45*

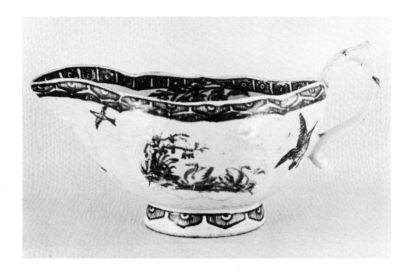

**Sauceboat c.1764**
**Length 7¾in.  patch marks**

A transfer-printed moulded sauceboat of typical Derby shape with a very glassy paste. The print is a re-engraving of a Worcester transfer. The elaborate border is painted. A similar shape was produced with poly-chrome decoration in the period 1762-70.

*£45–55*

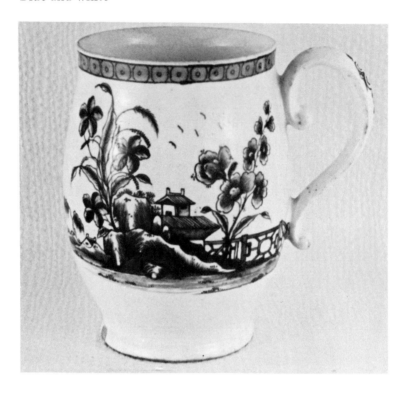

### Mug c.1762-65
**Height 4in. patch marks**

A bell-shaped mug pleasantly painted with a Chinese scene and showing
a typical Derby handle of the period. All blue and white Derby mugs
are fairly scarce.

*£58—68*

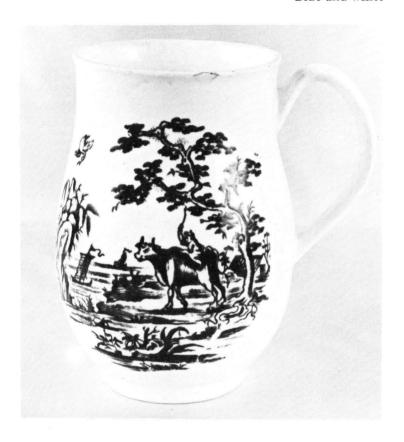

### Mug c.1765
#### Height 5in. no mark

This typical Derby mug is printed with the 'Boy on a buffalo' pattern which occasionally appears on Bow. This is a version of the better known 'red cow' pattern which is an overglaze print with added poly-chrome decoration. Fairly rare.

*£65–78*

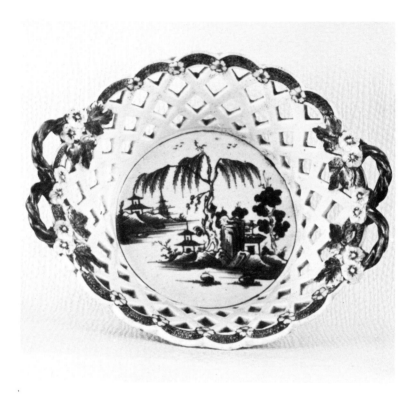

### Basket c.1758-62
#### Diameter 6¾in.  patch marks

A fine two-handled openwork basket painted in the centre with a typically carefully done Chinese scene. Blue and white baskets of this form were also produced at Bow, but the latter do not have handles. The Derby specimens are quite scarce.

*£82–98*

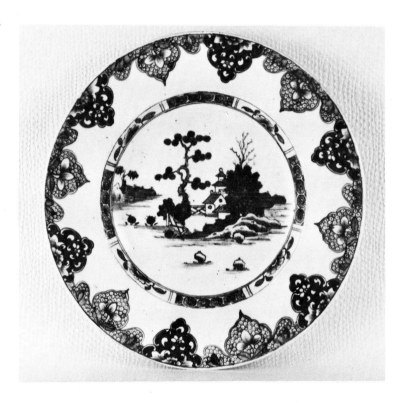

**Plate c.1756-60**
**Diameter 8¼in. patch marks**

A very attractive blue and white plate with a carefully painted Chinese scene. The elaborate and intricate border is a distinctive feature of early Derby. The underglaze blue is a strong vivid tone which contrasts startingly with the very white and soft paste. Quite rare.

*£45–58*

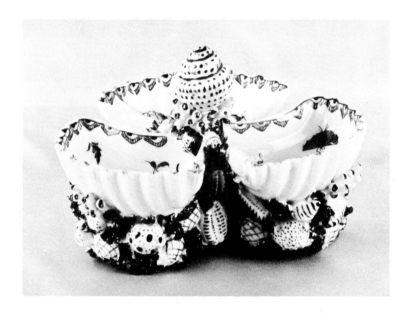

### Shell Centrepiece c.1758-62
**Diameter 6½in. patch marks**

Centrepieces of this type on shell-encrusted bases were also produced at Bow, Worcester and Plymouth. A much more elaborate Derby version has two tiers of shells surmounted by a kingfisher. The latter is very rare. Centrepieces were also produced in polychrome but the undecorated specimens are not very desirable.

*£85–120*

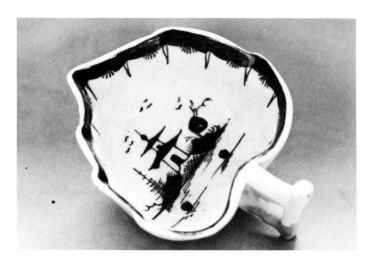

**Pickle Tray c.1758-60**
**Length 2¾in. patch marks**

These pickle trays (or asparagus butter boats) occur in several designs of which the one illustrated is by far the most common. Similar forms were produced at Worcester, Lowestoft and Caughley. This shape seems not to have been made in polychrome. Fairly common.

*£27–34*

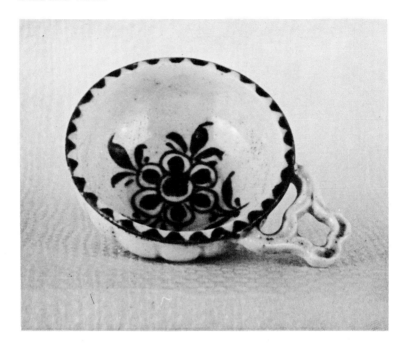

### Wine Taster c.1758-60
**Length 3in.  patch marks**

This wine taster is one of the numerous small objects which are sur-
prisingly plentiful in blue and white Derby considering its rarity. It
appears that Caughley was the only other factory to produce this
shape. No polychrome specimens are known.

*£28–36*

**Asparagus Server c.1770-75**
**Height 3in.  no mark**

Derby asparagus servers are not as common as Caughley ones but nothing like as rare as the Worcester examples. They occur in two or three different patterns of which the one illustrated is the most common. Slightly later Derby specimens are painted in overglaze 'dry' blue.

*£14–18*

# LIVERPOOL PART I

Of the seven porcelain factories in Liverpool in the eighteenth century, there are three, the Chaffers'-Christian's-Pennington's group, which can be regarded as the mainstream tradition from 1754-1799. These three factories form the conventional Liverpool group; conventional in influence, output and decoration. There is a definite and visible connection between these factories, the later ones being influenced by the earlier factory. It is possible to find most of the standard teaware shapes in this group, which is very far from being the case in several of the other Liverpool factories.

The Chaffers' factory (1754-65) made two different types of porcelain, first a bone ash and later a soapstone. These are often extremely difficult to tell apart, as in many cases identical shapes were produced in both pastes. The factory produced most of the standard shapes: mugs, large jugs, sauceboats, creamboats, teawares, bowls, coffee pots and coffee cans. Teacaddies, pickle leaf dishes, plates and dishes are all scarce.

The blue and white wares which comprise about two thirds of the factory's output, are influenced in shape and decoration by Worcester, particularly of the 'scratch cross' period. Coffee cups, coffee pots, mugs, jugs and some coffee cans, have plain strap handles, rather similar to those found on early Worcester specimens. Sauceboats and creamboats are often moulded and jugs have turned up lips; this is a very distinctive Liverpool characteristic. Much of the painting has a very pleasant freedom of style, not always found on Liverpool porcelains. Probably the most sought-after blue and white Liverpool is the group of well-potted octagonal teawares which are often decorated with the 'Jumping Boy' pattern, which also appears on Bow. These are almost always very expensive, although the quality of the painting, and indeed the paste, varies.

The decoration on polychrome pieces often reached a very high standard. Charmingly painted Chinese figure subjects occur on teawares and mugs, and many of the floral subjects are attractively done. There are noticeably fewer saucers than cups and creamjugs are rarer than teapots. Coffee cans and mugs are fairly common, but sauceboats and creamboats are rarer than the blue and white examples. As in other factories, some pieces are decorated in underglaze blue and overglaze iron red and gilt. These tend to be less valuable than either the poly-

chrome or the blue and white specimens. Overglaze transfer printing in black was done and this appears mainly on mugs.

The wares made by Philip Christian from 1765-76 are, generally speaking, rather better potted than most Liverpool porcelains. Examples have sometimes been considered to be too fine for Liverpool and therefore of Worcester origin. The decoration is at best quite competent and pleasant, but somehow lacking the freedom and spontaneity of the earlier factory. Most of the patterns and shapes are derived either from Chaffer's or from Worcester.

The majority of the blue and white, which is roughly twice as common as the polychrome, consists of teawares. Coffee pots are comparatively common, as are coffee cans which were produced in quantities by almost all the Liverpool factories. Most teawares are fairly common, with the exception of sucriers, teapot stands and spoontrays; some small vases may have been intended as tea caddies. All flatware is extremely rare, but bowls of all sizes are quite common. Footrings are undercut and usually deep, handles are often grooved but generally more generous in size than those on Worcester specimens. Some transfer printing was done in underglaze blue and most of the prints were used later by Pennington with less successful results.

The polychrome wares are usually pleasantly decorated with either floral or Chinese Mandarin subjects in the style of Worcester. Cream-boats and sauceboats are usually moulded and coffee pots have elaborate silver-shape handles and high domed covers. Coffee cans, bowls and most teawares are fairly common, but mugs and pickle leaf dishes are very scarce. A speciality of the factory was garniture sets of vases decorated with floral reserves on a rather naive simulation of a gros bleu ground. As in the Chaffers' factory, teawares were produced with red, blue and gilt decoration; sometimes overglaze colours were added to a standard underglaze blue design as if in an attempt to make the object more easily saleable.

A large part of the output of Pennington's factory (1769-99) was little more than a debased version of the Christian's wares. The standard of potting, painting, printing and moulding fell considerably, especially in the last years of the factory. Despite this, however, some pieces have a certain charm and any lack of artistic merit is usually reflected in the price.

The blue and white constitutes some 75% of the factory's output and is in fact the most common class of Liverpool wares. Teawares are common as are bowls, coffee pots, coffee cans and sauceboats. The

latter often have elaborate silver-shape handles in the form of a biting snake. Other common shapes are mugs, cider jugs, and scallop-shell pickle trays on three cone feet. Perhaps the finest articles made at the factory are the ship bowls which are sometimes named and dated. No other factory, with the exception of Lowestoft, produced as many dated or inscribed specimens. In the early years of the factory, the blue is a pleasant darkish tone, but by the 1790's it is usually a less attractive bright colour. Most of the ordinary wares are poorly finished and have a tendency to stain and some of the very late specimens have virtually no translucency and could almost be mistaken for earthenware.

The polychrome wares are of variable quality, the floral subjects usually being more attractively painted than the Chinese figure designs. Tea and coffee wares are quite common, teapots and creamboats sometimes being leaf-moulded with seven arched reserves. These teapots have often been mistakenly attributed to Longton Hall. Large jugs and massive punch pots were produced but these are now fairly scarce.

The value of the porcelains produced by these three factories is chiefly determined by the date and quality of each piece. They should prove to be a fairly sound investment as their price is often lower than comparable specimens from other factories.

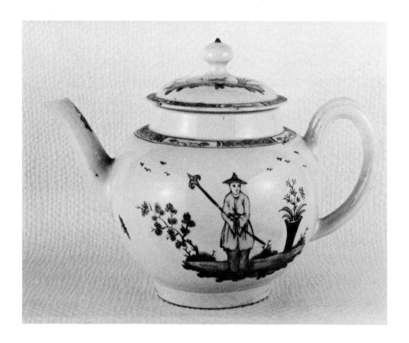

**Teapot c.1758-60**
**Height 4¾in. No mark**

A good example of the high standard of Chinese figure painting reached by the Chaffers' factory. The shape of this teapot is clearly influenced by early Worcester specimens. Quite scarce.

*£78–90*

**Sauceboat c.1760-62**
**Length 6½in. no mark**

A characteristic Chaffers' shape with typical well-painted floral decoration. All Chaffers' polychrome sauceboats are harder to find than their blue and white counterparts. This particular shape occurs in both polychrome and underglaze blue. Quite scarce.

*£55−68*
*in above condition £12−16*

**Jug c.1758-60**
**Height 10½in.  no mark**

A fine early Chaffers' Liverpool jug decorated in underglaze blue and overglaze red and gilt. The shape and strap handle are typical but the decoration detracts from its value.

*£72–85*

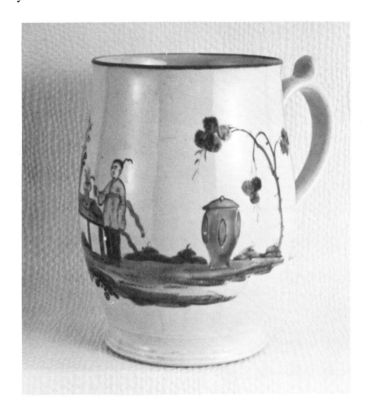

### Mug c.1758-60
**Height 5in.  no mark**

A standard Chaffers' shape with good Chinese figure decoration. Chaffers' polychrome porcelain is never marked. Mugs of this type are not common.

*£72–85*

### Mug c.1760-62
#### Height 4½in.  no mark

A mug transfer-printed in sepia with the arms of the Society of Bucks. Printed mugs of this type were a speciality of the Chaffers' factory. Fairly scarce.

*£65–78*

**Coffee Can c.1755-58**
Height 2½in.  no mark

This coffee can is decorated in underglaze blue and overglaze red and gilt. It is therefore not as valuable as a proper polychrome specimen, nor as desirable as a blue and white one. The base is unglazed. Note the typical early handle-form.

*£25−32*

## Coffee Cup and Saucer c.1760-65
### Diameter of saucer 4¾in. no mark

Attractively painted floral sprays of this type are the most commonly found decoration on Chaffers' polychrome wares. The shape of the cup and its handle are typical. Saucers tend to be rather shallow.

*£36–45*

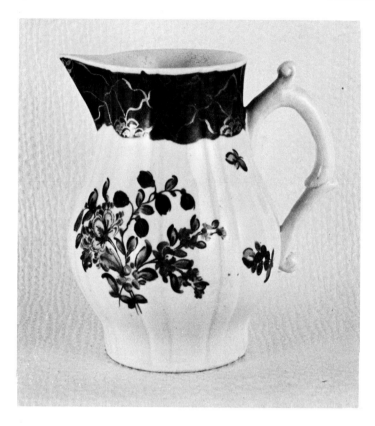

### Creamjug c.1772
**Height 3½in.  no mark**

The underglaze blue ground colour appears to good effect on this attractively painted creamjug. It was perhaps an attempt to imitate the Worcester 'gros bleu'. The handle of this jug is a little unusual.

*£38—48*

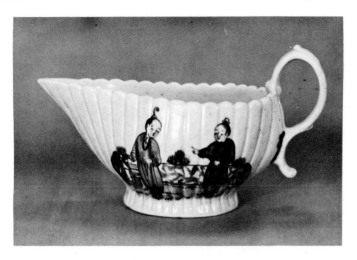

### Sauceboat c.1772-75
**Length 5½in.   no mark**

This is slightly unusual decoration to find on a sauceboat. A well-potted colourful example although by no means a common one. The shape of the handle is a characteristic Liverpool feature. This shape also occurs in underglaze blue.

*£45–58*

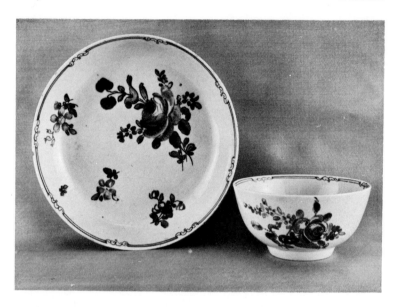

**Teabowl and Saucer c.1772-75**
**Diameter of saucer 4¾in.   no mark**

A typically well-potted example of Christian's porcelain with well executed floral decoration. The border is a popular one on Liverpool wares. Fairly common.

*£28–35*

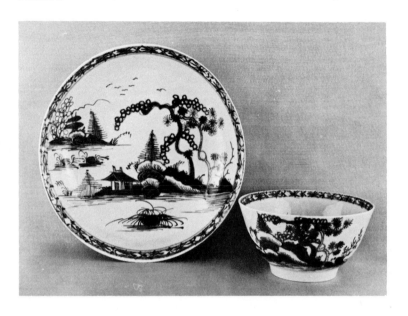

### Teabowl and Saucer c.1772
**Diameter of saucer 5in.   no mark**

This is a Liverpool version of the popular 'blue rock' pattern which has been 'clobbered' with overglaze decoration in iron-red and gilt. Although the overglaze decoration was done at the factory it nevertheless slightly reduces the value of this teabowl and saucer.

*£18–22*
*teabowl alone £4–6*

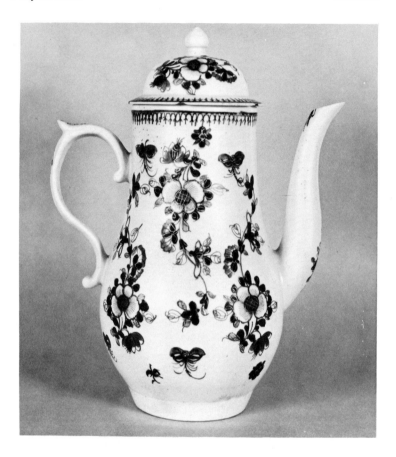

**Coffee Pot c.1780-85**
**Height 9¾in.   no mark**

A Pennington's coffee pot of typical shape decorated in underglaze
blue and overglaze red and gilt. Note the distinctively Liverpool border.

*£58–75*

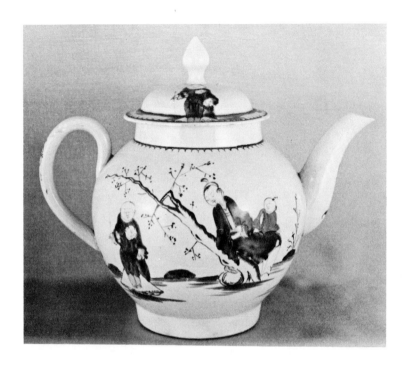

## Teapot c.1780-85
### Height 6¼in.  no mark

A characteristic Pennington's teapot shape showing Chinese Mandarin decoration of a slightly higher standard than usual. Polychrome decorated porcelain comprises a mere twenty-five per cent or so of the factory's total output.

*£38—48*

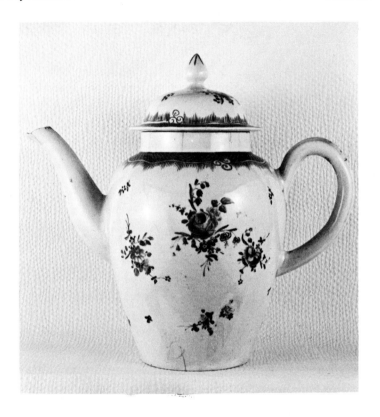

### Teapot c.1785-90
**Height 8¼in.  no mark**

An unusual shape although the decoration is typical. As a general rule post-1770 teapots tend to be of a larger size than the earlier ones. Polychrome wares from this factory are hardly ever marked.

*£35−42*

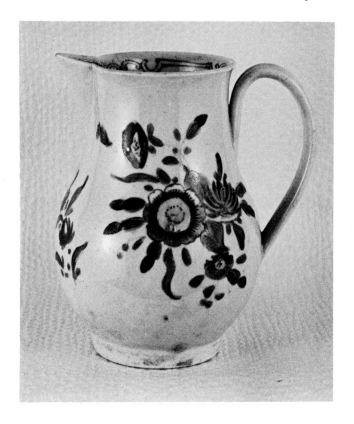

### Creamjug c.1780-85
#### Height 3½in.   no mark

A fairly ordinary creamjug of the period with a grooved handle of typical shape and a slightly up-turned 'sparrow beak' lip. The scummy effect which can be seen at the base often appears on Pennington's wares.

*£30–38*

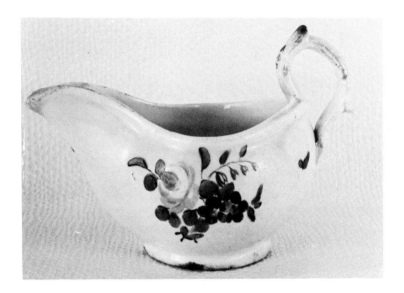

**Sauceboat c.1780-85**
**Length 5in.   no mark**

A typical Pennington's shape which is found more often in polychrome than in underglaze blue. The floral decoration is not of the same quality as in the Christian period. This sauceboat has a flat glazed base.

*£34–42*

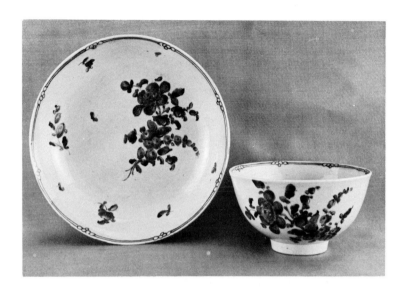

**Teabowl and Saucer c.1778**
**Diameter of saucer 4¾in.   no mark**

This teabowl and saucer is remarkably similar in conception and execution to the earlier example on page 218. The Pennington's colours, however, are harsher and the shape of the teabowl is slightly different.

*£25-32*

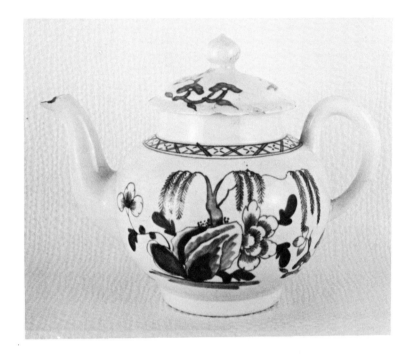

### Teapot c.1760-62
**Height 4¼in.   no mark**

A typical Chaffers' teapot in both its shape and its decoration. The blue tends to be a darker tone than that of Worcester but most of the Chaffers' shapes and some of their patterns are derived from that factory.

*£50–65*

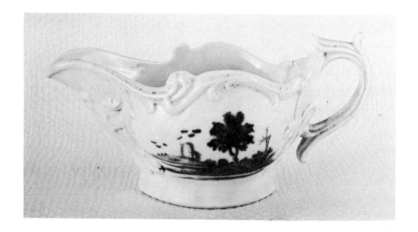

## Creamboat c.1758
### Length 5¼in.  no mark

A pleasantly moulded creamboat with a rococo handle. Sauceboats of a similar shape were made in both blue and white and polychrome. The creamboats are rarer than the sauceboats. A characteristic Chaffers' shape. Quite scarce. No transfer printing in underglaze blue was done at Chaffers' factory.

*£38−48*

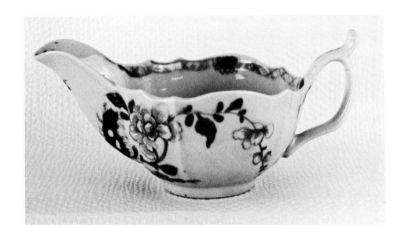

### Sauceboat c.1755-58
**Length 6in.  numeral 1**

A shape found only in Chaffers' porcelain. These sauceboats occur in two sizes of which the one illustrated is the smaller. Painter's numerals sometimes occur in the footrings of early pieces. This shape of sauceboat was made in both a bone ash and a soapstone paste but it is usually difficult to tell them apart. Quite scarce.

*£45–58*

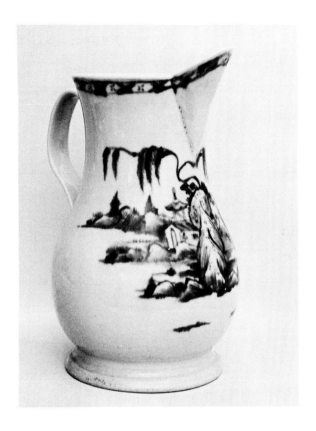

**Jug c.1762-65**
**Height 7¼in.   no mark**

This well-painted jug shows the distinctive broad raised lip, a recurring feature on Liverpool jugs of all sizes. Fairly scarce.

*£58–70*

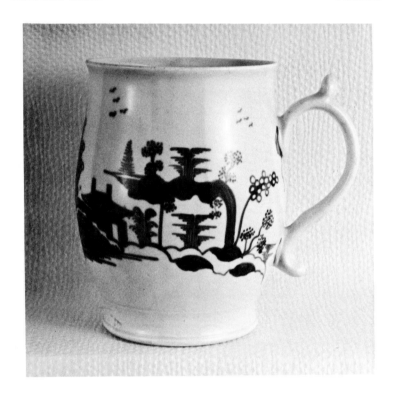

**Mug c.1756-58**
**Height 4½in.   numeral 2**

This is the standard shape for an early Chaffers' mug. The wavy 'comma marks' near the handle are only found on early pieces of this group.

*£58−72*

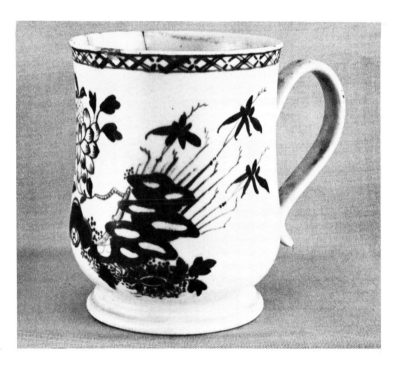

**Mug c.1762**
**Height 3¾in.   no mark**

A bell shaped mug showing the characteristic Chaffers' 'strap' handle.
The decoration is typical.

*£48—55*
*in above condition £12—16*

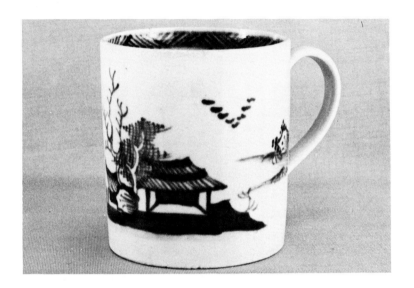

**Coffee Can c.1762-65**
**Height 2½in.  no mark**

Coffee cans are a comparatively common shape in most of the Liverpool factories. The majority of Liverpool coffee cans have unglazed bases; on this specimen the base is partly glazed.

*£26—34*

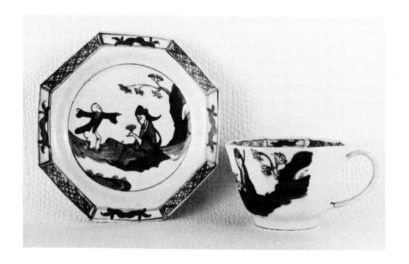

## Coffee Cup and Saucer c.1758
**Diameter of saucer 4¾in.   pseudo Chinese marks**

The 'Jumping Boy' pattern which also appears on Bow, is one of the most desirable of the Liverpool patterns. It appears mainly on tea and coffee wares of the late 1750's and early 1760's. The octagonal examples, some of which are very finely potted and painted, are particularly highly esteemed by collectors.

*£60–75*

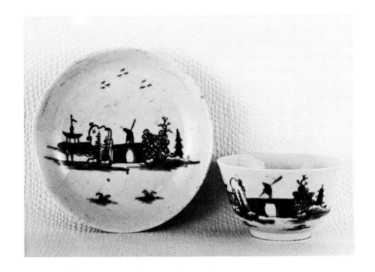

## Teabowl and Saucer c.1758-60
**Diameter of saucer 4½in.   numeral 1**

A fairly typical Chaffers' teabowl and saucer of the period. Some Chaffers' pieces have a glaze free ring just inside the footring as with many Worcester specimens.

*£25–32*
*Teabowl alone £5–7*

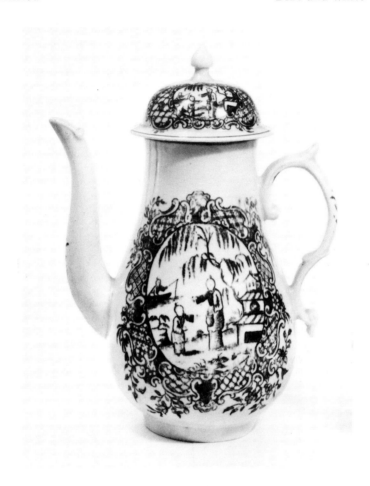

**Coffee Pot c.1775**
**Height 10in.   no mark**

A transfer-printed Christian's coffee pot of typical shape. The handle
form is especially characteristic of the factory.

*£85–110*

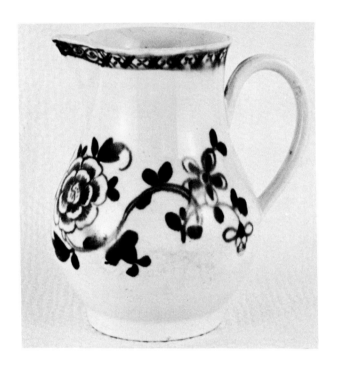

**Creamjug c.1775**
**Height 3¼in.   no mark**

A typical Christian's Liverpool creamjug in both its shape and its pattern, footrings tend to be high and nearly always undercut. Handles are usually grooved. This pattern was also used on the later wares made at Seth Pennington's factory. Quite common.

*£25–33*

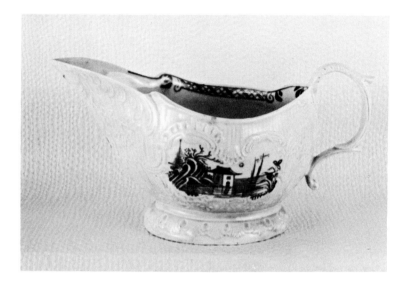

**Sauceboat c.1770-75**
**Length 6¾in.  no mark**

Sauceboats of a somewhat similar shape were produced at Pennington's factory but the painting and moulding is not as good. Christian's specimens are more common in blue and white than in polychrome.

*£35—45*

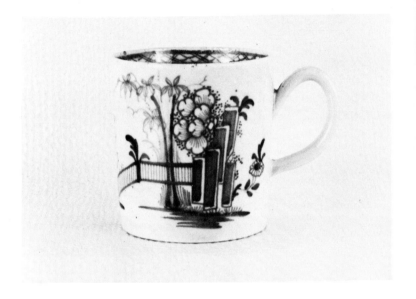

**Coffee Can c.1770**
**Height 2¼in.  no mark**

This common Christian's pattern is often painted in a paler tone of underglaze blue than is usual for Liverpool. The shape of the grooved handle is characteristic. As is the case with most Liverpool coffee cans, the base is unglazed. Fairly common.

*£18—24*

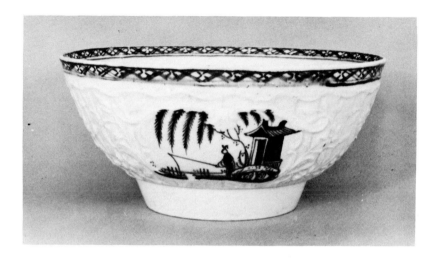

## Bowl c.1770-75
### Diameter 7¼in.  no mark

This pleasantly moulded pattern occurs mainly on Christian's teawares, bowls and coffee pots. Examples have occasionally in the past been wrongly attributed to Lowestoft. Christian's porcelains are almost never marked.

*£25–32*

**Pickle Leaf c.1772**
**Height 3¼in. no mark**

Christian's factory made more of these pickle leaf dishes than any of the other Liverpool factories. Even so, they are not as common as the Worcester Bow or Lowestoft examples. The pattern illustrated is typical. All polychrome decorated Liverpool pickle dishes are extremely scarce.

*£25–30*

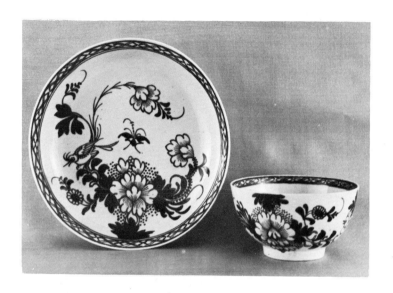

## Teabowl and Saucer c.1772
### Diameter of saucer 5in.  no mark

This very popular Liverpool pattern was not used elsewhere. Christian's specimens are almost invariably better painted than either the Pennington's examples or the much rarer Chaffers' ones. The style of painting and the border are useful guides to attribution. Fairly common.

*£20–27*

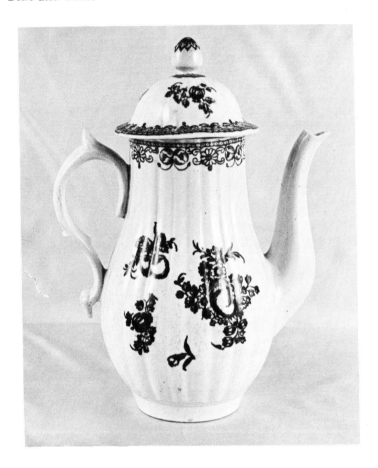

### Coffee Pot c.1782-85
#### Height 9½in.   no mark

A good and fairly typical example of its type; the handle is particularly characteristic. Pennington's factory produced a comparatively large number of blue and white coffee pots.

*£52—65*

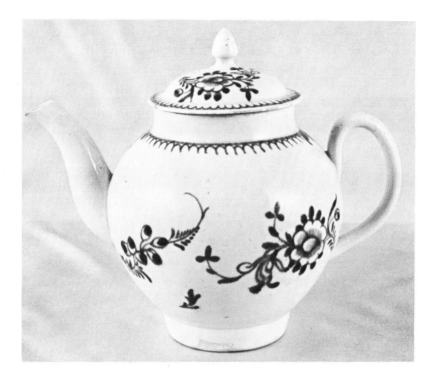

### Teapot c.1785-88
**Height 6¼in.   no mark**

A typical Pennington's Liverpool teapot of the 1780's. The design also appears on the earlier Christian's group but the shape is distinctively Pennington's. Again, the border is a pointer to a Liverpool origin. Quite common.

*£30–40*

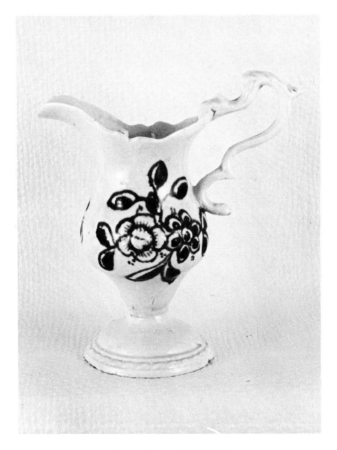

**Creamjug c.1780-85**
**Height 3¾in.  no mark**

This pedestal creamjug is a slightly crude version of a silver example of about ten years earlier. The elaborate handle in the form of a biting snake is often found on Liverpool porcelains of the period 1775-95.

*£22–30*

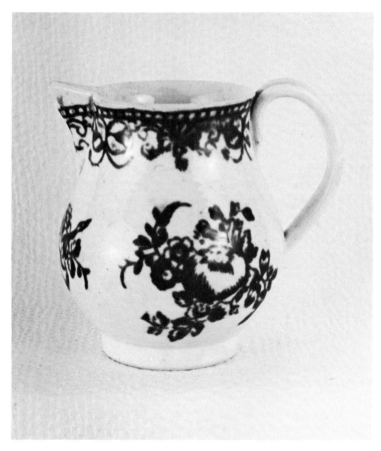

**Creamjug c.1785-90**
**Height 3¼in.   no mark**

A fairly typical late specimen from Pennington's factory. Underglaze blue transfer-prints were used quite extensively on Pennington's wares but the results were far from successful aesthetically. Fairly common.

*£12–18*

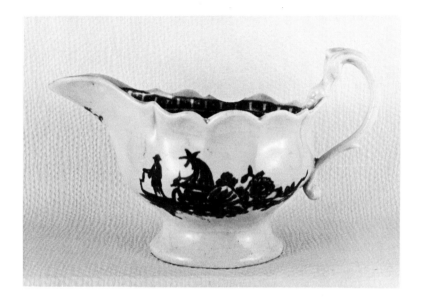

### Sauceboat c.1780-85
**Length 7¼in.   no mark**

A common Pennington's sauceboat form showing the influence of silver on contemporary porcelain shapes. The Pennington's glaze has a tendency to pool in places and the underglaze blue is often a bright rather unpleasant tone. The design is the Pennington's version of the well-known 'Fisherman' pattern. Quite common.

*£22–30*

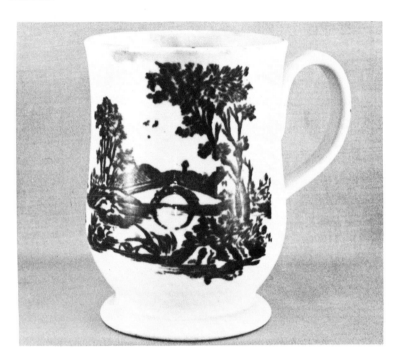

**Mug c.1780**
**Height 3½in.   no mark**

A mug of typical bell-shape but it is unusual in that it is printed with what appears to be a European scene. The staining which can be seen near the rim detracts somewhat from the value.

*£38–45 (unstained)*

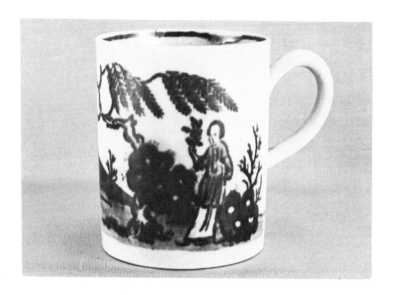

## Coffee Can c.1785
**Height, 2½in. no mark**

A fairly common Pennington's pattern and a typical handle. The base is unglazed. The basic difference between a coffee cup and a coffee can is that the latter is straight-sided, usually has no footring and is generally considered to be complete without a saucer.

*£11−15*

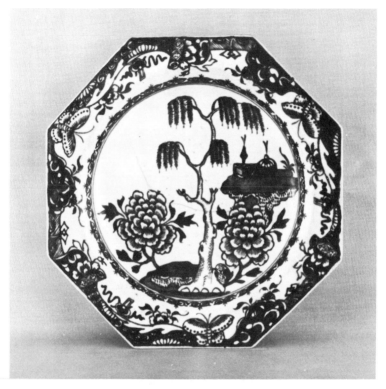

**Plate c.1775-78**
**Diameter 6½in.  no mark**

An unusually attractive Pennington's plate. Some similar but later examples are blurred so that it is not always easy to tell whether they are painted or printed. Many pieces from this factory, particularly in its later years, have virtually no translucency.

*£24–30*

### Ship Bowl c.1775-78
#### Diameter 7½in.  no mark

Bowls with shipping subjects were a speciality of several of the Liverpool factories and are nowadays quite rare. The illustrated example is transfer-printed but others are painted and sometimes inscribed and dated. The latter are especially desirable.

*£52–65*

## Bowl c.1790
**Diameter 6in. no mark**

A very ordinary late Liverpool bowl painted with rather sparse floral sprays. Not very desirable.

*£8–12*

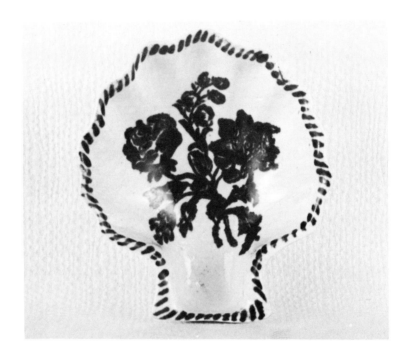

**Scallop-Shell c.1788-92**
Height 4½in.  no mark

These scallop-shell dishes usually have three cone feet and most examples
are of poor quality, whether painted or printed.

*£12–16*

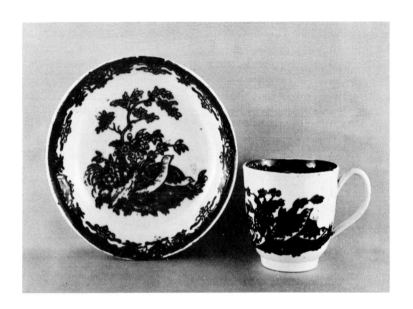

**Cup and Saucer c.1785**
**Diameter of saucer 5in. no mark**

A fairly common Pennington's transfer-print showing a pair of quails. Pennington's footrings tend to be tall and rather small in diameter. A similar painted version of this design appears on blue and white Bow and Worcester wares but specimens are scarce and tend to be expensive.

*£12–16*

# LIVERPOOL PART II

The group of porcelains attributed to the William Reid factory (1755-61) consist mainly of blue and white wares which are roughly equivalent in their rarity to blue and white Longton Hall. The porcelain is tin-glazed and nearly always very primitive in appearance, some examples being quite badly sanded. It is indeed quite remarkable that these wares were a commercial success at the time, considering that they were competing with some six or seven other factories (two of them in the same city) making blue and white porcelain of an altogether higher standard.

The most commonly found shapes produced in blue and white in this scarce group are pickle leaf dishes of various shapes and sizes and shell-shaped sweetmeat trays. Creamboats and sauceboats, some of which have lion masks and paw feet, occur occasionally, but all other shapes are extremely rare. This, strangely enough, also applies to tea-wares and in fact only one teabowl has so far been recorded and no coffee cups or saucers at all. Some potting shapes are derived from Lund's Bristol, others from Bow. Many of the moulded wares, sauce-boats in particular, are reminiscent of saltglaze pieces and some of the pickle leaf dishes have almost exact counterparts in Liverpool Delft. Most of the decoration is in Chinese style, but some rare specimens are painted with detailed European scenes. All polychrome examples are extremely rare. The decoration is nearly always of oriental designs executed in bright, bold colours which are similar to those found on saltglazed earthenware.

The small group of porcelains made at Samuel Gilbody's factory from 1754-61 is the rarest of all the Liverpool wares. The blue and white is especially hard to come by and harder still to recognise and attribute correctly. The glaze is soft and the paste sometimes has an almost pinkish tinge. The blue tends to be a dark tone and the style of painting is similar to some found on the Chaffer's group.

Amongst the polychrome wares, coffee cans, mugs and coffee cups are the most frequently found objects. The decoration and sometimes the shapes are similar to Bow, although the colours tend to be softer and to sink into the glaze more. The handles of some of the coffee cans are thin and elaborate, rather in the style of early Worcester. Some pieces are decorated in overglaze iron red with charming scenes often including pairs of geese. This form of decoration occurs particularly on

coffee cups and fluted coffee cans. The very rare early pieces of this group are decorated in underglaze blue and overglaze red and gilt and can easily be confused with early Bow specimens.

The blue and white porcelain made at William Ball's factory from 1755-69 is slightly more common than the wares of the other factories mentioned in this chapter. Whilst most Liverpool wares show the influence of Worcester, pieces from this group are inspired both in shape and decoration by Bow. The painting is often done with a pleasing freedom and a sketchiness which is reminiscent of Delft. Teabowls, coffee cups and sauceboats are comparatively common, as are mugs, creamboats, coffee cans and the fine range of sauceboats which appear in an almost bewildering variety of splendid and elaborate shapes. Coffee pots, plates and teacaddies are rare but vases are slightly more common than in most factories. Large objects such as sauceboats and vases are robustly potted but many teawares, teabowls and saucers in particular, have a thinness comparable to that of early Worcester specimens. Many shapes have exact counterparts in Delft and others show the influence of contemporary silver. Footrings are small and the blue has a characteristically bright vivid tone. The glaze is soft, resembling that of Longton Hall.

Teawares with Imari-style decoration are considerably more common than the proper polychrome decorated examples. Some of the latter are decorated with polychrome transfers overpainted with enamels. Bowls are probably the most commonly found shape in this rare group. Specimens of this factory, whether blue and white or polychrome, tend to be amongst the most expensive and sought-after of all Liverpool wares.

The porcelain made at Thomas Wolfe's factory from 1795-1800, often looks rather earlier in date than it really is. Shapes are confined almost exclusively to teawares, although some large cider jugs were made. Polychrome wares are usually decorated either with Chinese Mandarin subjects or with flowers and garlands in a similar style to that found on Lowestoft. Creamjugs are especially attractive and coffee cups sometimes have crude rustic handles. Teapots can be confused with Newhall specimens and I have seen cider jugs attributed to Longton Hall. Some teawares are decorated with monochrome transfer prints which occur in several colours including pink, brown, black and purple. Blue and white wares seem to be extremely rare, but it is quite possible that some pieces may lurk unrecognised in museums and private collections.

Specimens from these factories tend to be valued by collectors rather more for their aesthetic merits than for their rarity.

**William Reid's Factory**
**Painted**

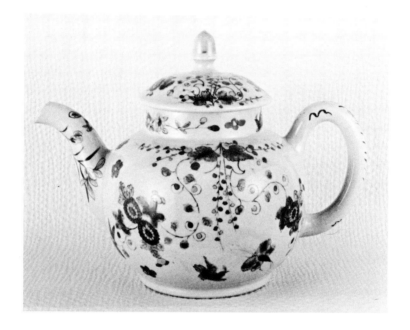

### Teapot c.1758-60
#### Height 4¾in. no mark

The decoration on this teapot is typical and the bright colours stand out vividly against the darkish body. Much of the decoration on this group is slightly reminiscent of saltglaze. All polychrome wares from this factory are extremely rare.

*£75–100*

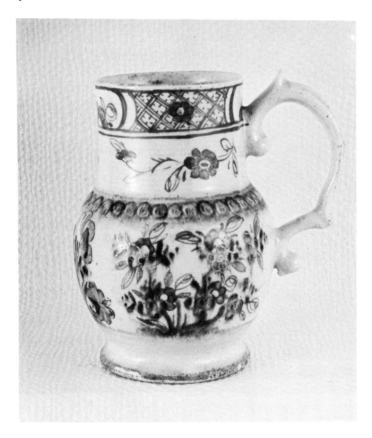

### Mug c.1755-56
**Height 4in.  no mark**

An early specimen from Gilbody's factory painted in underglaze blue and overglaze iron red and gilt. It could easily be mistaken for Bow. The extreme rarity of such pieces is not always reflected in their popularity or price.

*£60–85*

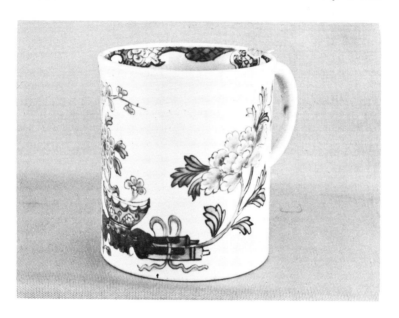

## Coffee Can c.1758-60
### Height 2½in.  no mark

A coffee can painted in Chinese 'famille rose' colours. It resembles a
Bow specimen, but the glaze is softer and the colours sink into it more.
All the colours are a less harsh tone than those of Bow. The base is
unglazed. Very rare.

*£48–58*

**Bowl c.1760-62**
**Diameter 3¾in. no mark**

This bowl has an overglaze transfer-print which has been enamelled over in very delicate colours. All polychrome decorated wares of this Liverpool group are very scarce.

*£38–48*

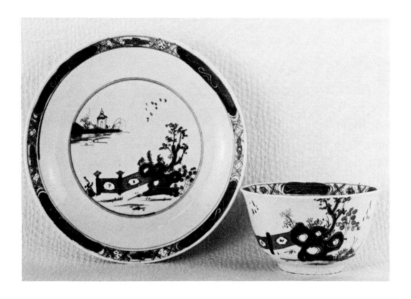

**Teabowl and Saucer c.1762-65**
**Diameter of saucer 4¾in. no mark**

This teabowl and saucer is attractively decorated in underglaze blue and overglaze red and gilt. For once the overglaze decoration seems to enhance the general effect. Not as rare as the proper polychrome decorated wares.

*£28–35*

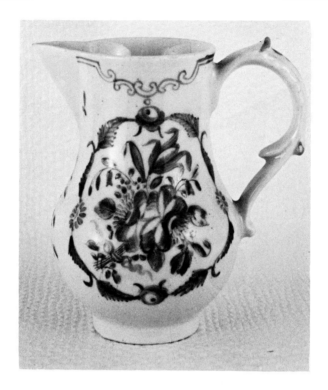

**Creamjug c.1795**
**Height 3¾in. no mark**

This very attractive creamjug shows a pattern, shape and handle which are very characteristic of this short-lived factory. Examples also appear with Chinese Mandarin decoration. The output of this factory was mainly confined to teawares and a few large cider jugs; blue and white specimens seem to be extremely rare.

*£35–48*

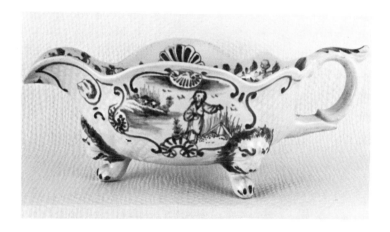

**Sauceboat c.1758-60**
**Length 8¼in. no mark**

A very elaborate and yet somehow rather primitive sauceboat. A similar shape was made at Bow. There is a theory that this group of porcelains was made not in Liverpool but in London, perhaps at the mysterious Limehouse factory. Although there are a number of factors which support this theory, an examination of the polychrome pieces must surely confirm the Liverpool attribution. The sauceboat illustrated is a rare one.

*£75−100*

**Shell-Shaped Dish c.1758**
Height 3½in.  no mark

A typical specimen in both its shape and its decoration. A few of these shell dishes are painted with Chinese figures and other even rarer examples have fine European landscape scenes. The latter is an extremely rare form of decoration and specimens would be expensive.

*£40–48*

### Pickle Leaf c.1760
**Height 3¾in.  no mark**

This is one of the most common shapes produced by this factory. Such was the curious output of the William Reid factory that all tea-wares are scarce and no teabowls, coffee cups or saucers are known at all. Some pieces are 'sanded' and this reduces their value by anything up to about thirty-five per cent. The shape illustrated also appears in Liverpool Delft.

*£30–38*

### Mug c.1760
**Height 3in. no mark**

A fairly typical example from this very scarce Liverpool group. The graceful silver-shape handle is characteristic as is the dark inky tone of blue. As with all extremely rare specimens, the price will vary considerably. Of the main factories only Chelsea produced less blue and white porcelain. Extremely rare.

*£55—80*

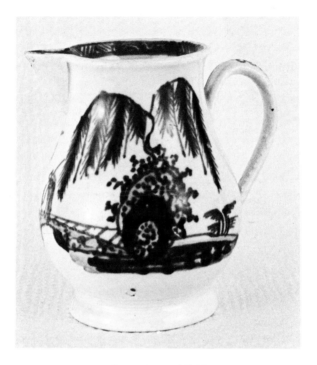

**Creamjug c.1765**
**Height 2¾in.  no mark**

This example is not as well painted as some specimens. The shape is less pleasing than that of the earlier creamjugs of this factory.

*£30–40*

**Creamboat c.1760-62**
**Length 4in.  no mark**

A very attractively painted example showing the influence of Bow. The blue is a very bright 'sticky' colour and the glaze is soft and scratches easily. Specimens from this factory tend not to have set prices but rather to derive their value from the individual merits of each piece.

*£40–50*

## Sauceboat c.1760
### Length 7¼in. no mark

One example of the fine range of sauceboats made at William Ball's Liverpool factory. This well-moulded specimen shows a typical handle form of the factory. Sauceboats of this shape were also made at Bow, Longton Hall and in saltglaze. Quite rare.

*£50–68*

### Mug c.1765
#### Height 3½in.  no mark

This mug is a more simple and less elegant shape than most of the earlier specimens. The rather slap-dash manner in which the border is painted is characteristic.

*£45–58*

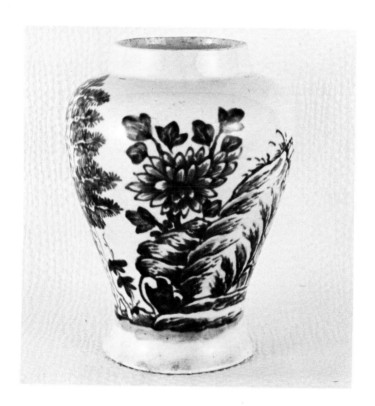

**Vase c.1762-65**
**Height 4½in.  no mark**

This is a rare form in any factory. Again the influence of Bow can be clearly seen in the shape and to a lesser extent, the decoration. Worth 30% more with a cover.

*£65–80*

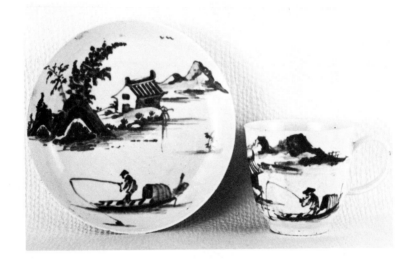

### Coffee Cup and Saucer c.1762
**Diameter of saucer 4½in.  no mark**

This coffee cup and saucer is attractively painted in a sketchy manner which is reminiscent of Delft. The bright tone of underglaze blue often has a wet appearance as if it had only just been applied. Although William Ball's factory is not one of the rarest of the Liverpool groups, it is probably the most popular one with collectors.

*£30–40*

# LOWESTOFT 1757-1799

The wares produced by this small Suffolk factory lack the sophistication of most of their main rivals. This very simplicity and lack of pretentiousness adds to their charm and is partly what appeals so much to collectors of the factory. The other great attraction of these wares is their local interest since so many pieces are inscribed with the names of East Anglian towns.

Very few examples from the early period of the factory (1757-61) have survived. All of these are blue and white and in fact little or no polychrome porcelain was produced at Lowestoft until about 1772. The early pieces have a somewhat primitive appearance and are painted in a dullish grey-blue in a manner reminiscent of Delft. The paste has a slightly pinkish tinge to it which is probably the result of underfiring. All pieces from this period are extremely scarce, but it is still occasionally possible to find some of the embossed coffee cups and bowls with moulding similar to that found on the slightly later 'James Hughes' teawares.

The middle period from 1761-1772 is also confined to blue and white. These highly attractive pieces are now fairly scarce and usually slightly more expensive than comparable later specimens. The most commonly found objects are mugs, bowls, moulded cider jugs, tea-bowls and saucers, sauceboats, creamboats and coffee cups. Teapots, creamjugs and plates are rarer than one might expect and sucriers, spoontrays and saucerdishes particularly so. Some embossed teawares have moulding which includes the initials 'I.H.' and the date '1761' or '1764'. The moulding is less sharp on the later examples and it is not always possible to detect the initials and date. Many shapes such as coffee cups, creamjugs and mugs show the characteristic Lowestoft 'kick' handle which remained a distinctive feature of the factory until its closure. The bases of such objects as spoontrays, coffee cans, inkpots and dishes are always glazed, as are the inside flanges of teapot lids. Most pieces of this period are attractively and individually painted in a pleasant, rather inky tone of underglaze blue. Many pieces bear a workman's or painter's mark which is usually a numeral, 1 to 17, on or near the footring.

After about 1772, the output of the factory increased considerably. Blue and white teawares became much more common and transfer printing was introduced. Of the twenty-five or so prints used at

Lowestoft, seven also occur on Worcester and Caughley, most others are unique to the factory. These include the small group of well-known prints, some of which have rather bizarre Chinoiserie subjects. The most common shapes of the period are tea and coffee wares, sauceboats, creamboats, straight-sided mugs, patty pans, bowls, pickle leaf dishes, moulded cider jugs and shell-shaped dishes. Spoontrays, coffee cans, plates, dishes and teapot stands are rare. Small objects such as eye baths, egg cups, bottles, caddy spoons and miniature teawares are expensive and in great demand because of their rarity and size. The underglaze blue tends to be a brighter, less pleasant colour and the painting and patterns less attractive than in the middle period. Some pieces show a tendency to stain, especially in cracks. Painters' numerals do not occur after about 1774 but some patterns are usually accompanied by an open crescent mark.

Polychrome wares were produced from about 1772 onwards, but the range of shapes made was much smaller than in blue and white. Teawares are quite common, although not many sucriers, teacaddies, spoontrays or teapot stands have survived. Bowls and creamboats are fairly easy to find, but mugs and coffee pots are scarce and always expensive. Amongst the shapes that are common enough in blue and white but extremely rare in colour are sauceboats, tea caddies, moulded cider jugs, pickle leaf dishes, patty pans and coffee jugs; all polychrome flatware is particularly scarce. The finest polychrome decoration to be found on Lowestoft appears on specimens decorated by the 'Tulip painter' who worked at the factory from about 1772-80. His work occurs mainly on large objects such as coffee pots and mugs, but occasionally on smaller pieces such as creamboats and coffee cups. All examples of his work are now rare, eagerly sought-after by collectors, and therefore expensive. Other forms of decoration are the various oriental figure patterns, a large range of floral and garland patterns and the designs in 'Chinese export' style. In the last ten years or so of the factory's life several 'sprig' patterns in the French style were used. The well-known 'Redgrave' patterns, with underglaze blue and overglaze enamel colours, appear throughout the polychrome period and are the most common designs to be found on Lowestoft.

Although a fairly large number of dated and inscribed specimens have survived, the vast majority of them are in museums and big private collections. Consequently, they very seldom come onto the open market except on the occasions when collections of Lowestoft are sold in one

of the big London salerooms. These pieces almost invariably command a high price even when damaged.

Lowestoft has risen sharply in price over the last four or five years. In fact many pieces have doubled in price, some articles increasing more than others. Although the factory has no international reputation, and is not collected to any extent outside this country, it has a very strong local interest. As one might expect therefore, prices tend to be slightly higher in East Anglia than elsewhere.

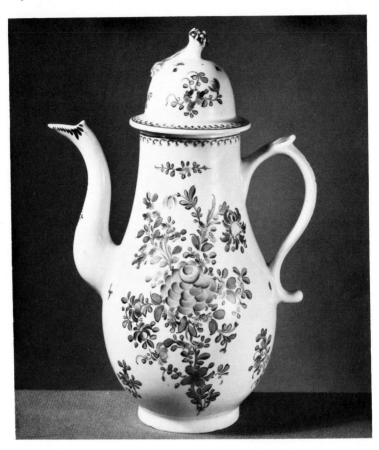

### Coffee Pot c.1785
#### Height 10½in. no mark

Polychrome coffee pots are scarce in Lowestoft even in the more common patterns. Specimens in good condition are especially hard to come by. The shape of the spout of this example is typical of the period as is the handle and the high domed cover.

*£120–160*

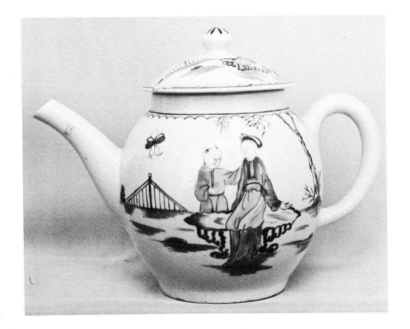

**Teapot c.1778**
**Height 5¼in. no mark**

This teapot is typical of its period and is a good illustration of the charming if rather naive Lowestoft Chinese figure decoration. The object between the two conversing Chinese is presumably intended to be a table, but it can resemble anything between a small animal and a jellyfish, according to the way it is painted.

*£75—92*

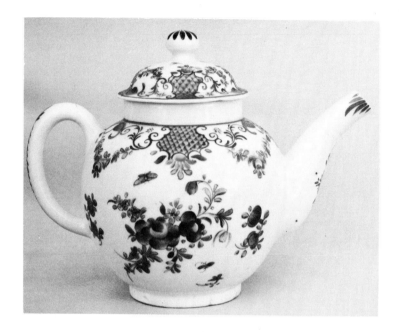

**Teapot c.1782**
**Height 5½in. no mark**

The 'Curtis' patterns were a standard form of decoration at Lowestoft in the period 1778-1790. The shape of this teapot is typical and the inside flange of the lid is glazed. This form of decoration occurs on tea and coffee wares, bowls, mugs and vases.

*£70–85*

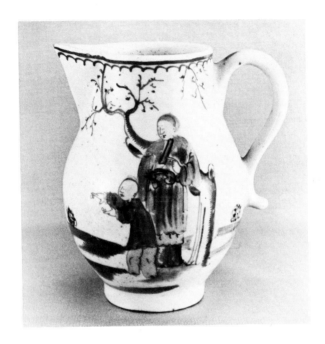

## Creamjug c.1780-1785
### Height 3½in. no mark

This is the standard shape for a Lowestoft 'sparrow beak' creamjug. The pattern is one of the most common of the twenty or so Chinese Mandarin designs which appear on Lowestoft. They are usually slightly more expensive than floral designs.

*£45–60*

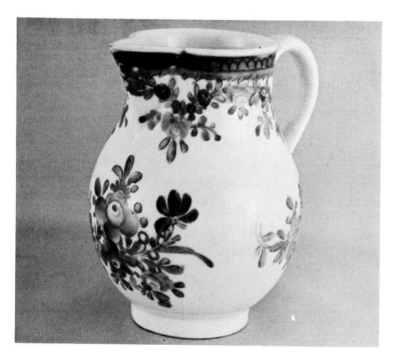

**Creamjug c.1780-1785**
**Height 3¼in. no mark**

This is slightly more 'stumpy' than the usual creamjug shape. Otherwise it is typical of the period and has the well-known Lowestoft 'kick' handle. Fairly common.

*£42–58*

### Creamboat c.1778
**Length 4in. no mark**

This moulded creamboat was painted by the anonymous 'Tulip painter' who worked at the factory between c.1774-1780. His fine work can be recognised by a tendency to use the undecorated background to form highlights and his fondness for 'turkshead lily' motifs. This is easily the best floral decoration produced at Lowestoft.

*£45–60*

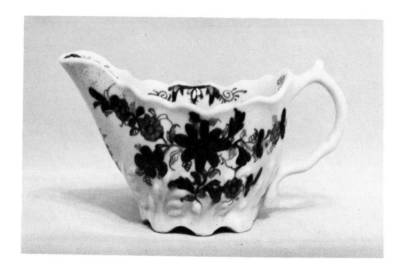

### Creamboat c.1775
**Length 4in. no mark**

These moulded creamboats were known in the eighteenth century as
'Chelsea ewers'. Lowestoft specimens were produced in polychrome,
blue and white and in Imari colours like the example illustrated. The
form was also made at Worcester, Caughley, Coalport and elsewhere.

*£35—45*

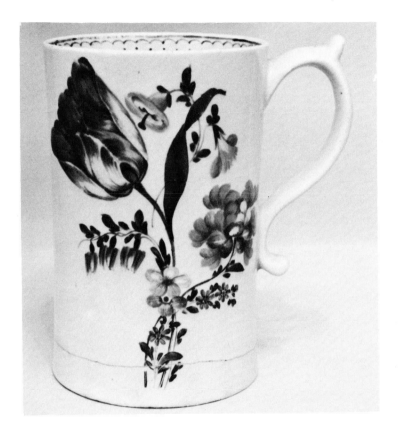

**Mug c.1775**
**Height 6in. no mark**

This early example of the 'Tulip painter's' work shows the full-blown tulip for which he was famous. Pieces bearing a tulip are very desirable and tend to be extremely expensive.

*£200–250*
*in above condition £45–60*

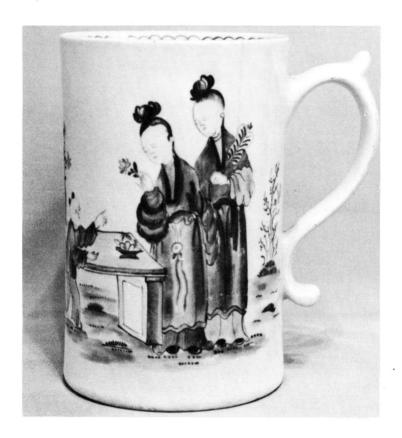

**Mug c.1778**
**Height 6in. no mark**

Lowestoft mugs decorated with Chinese Mandarin subjects are scarce
and sometimes very finely decorated. The one illustrated, although not
of exceptional quality, is nevertheless a good example and would be a
credit to any collection.

*£90–125*

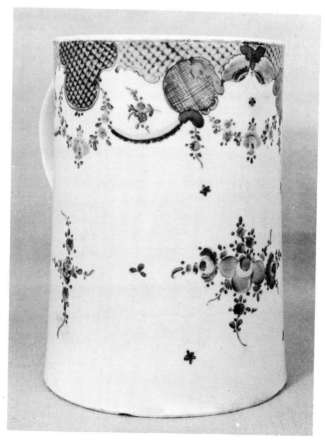

**Mug c.1785**
**Height 5¾in. no mark**

Polychrome Lowestoft mugs are considerably rarer than the blue and white specimens. This example is unusually wide and its sparse decoration has an adverse effect on its value.

*£75–100*

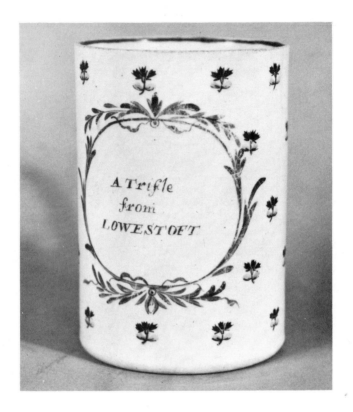

**Mug c.1790**
**Height 4¾in. no mark**

Mugs are easily the most common of the Lowestoft inscribed shapes.
Pieces bearing the inscription 'A Trifle from....' date from the last
fifteen years of the factory and are very scarce and much sought after.

*£220–280*

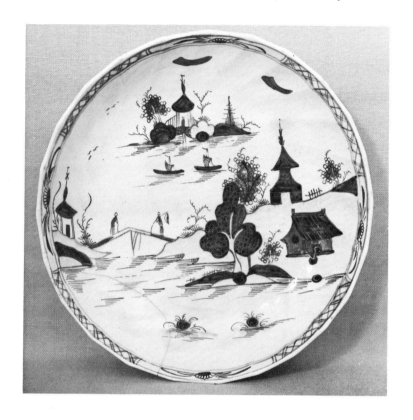

**Saucer Dish c.1785-1790**
### Diameter 8in. no mark

All polychrome Lowestoft flatware is scarce and therefore this saucer-dish is a desirable article, even though it is decorated with the very common 'Dolls House' pattern. The fluted version of this pattern is comparatively rare.

*£48–60*
*in above condition £20–28*

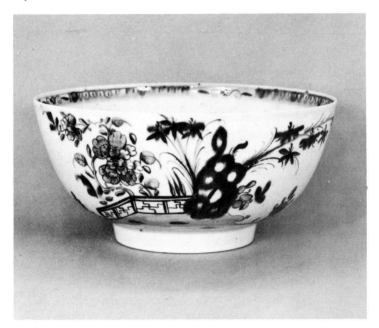

## Bowl c.1780-1785
### Diameter 6in. no mark

This 'Famille Verte' or 'Green Redgrave' pattern is one of the most common of the polychrome Lowestoft designs. It was produced from late 1770's onwards, and seems only to appear on tea and coffee wares. Polychrome Lowestoft is hardly ever marked.

*£28–38*

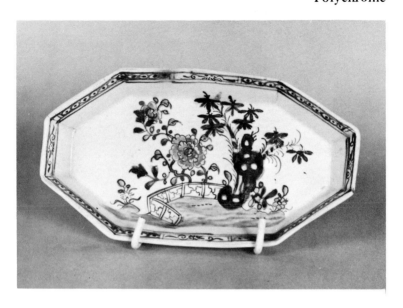

**Spoontray c.1780-1785**
Length 6¼in. no mark

All Lowestoft spoontrays are very rare, blue and white examples particularly so. Polychrome specimens nearly always appear in this shape which is seldom found in any other factory. Bases are flat and always glazed. Despite its comparatively ordinary design, this is a very desirable article.

*£65–85*

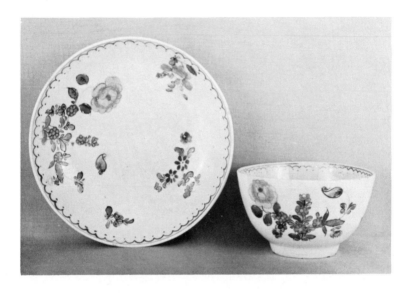

### Teabowl and Saucer c.1778
**Diameter of Saucer 4¾in. no mark**

Floral designs of this type appear mainly between 1774 and 1780. For the next ten years or so the majority of patterns have a very definite Chinese influence. Lowestoft saucers usually have three 'stilt' marks as do the Bow examples.

*£30–38*

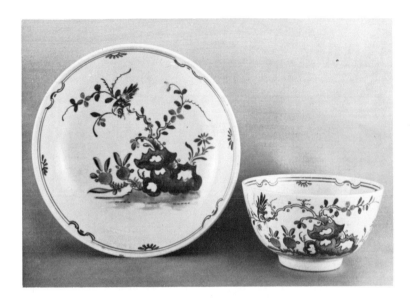

### Teabowl and Saucer c.1782
**Diameter of Saucer 5in. no mark**

This attractive teabowl and saucer is rather different in both its colours
and its subject from the usual run of Lowestoft polychrome designs. It
is a standard factory pattern but one of the less common ones. Most
specimens of this design date from the period 1780-1785.

*£30–40*

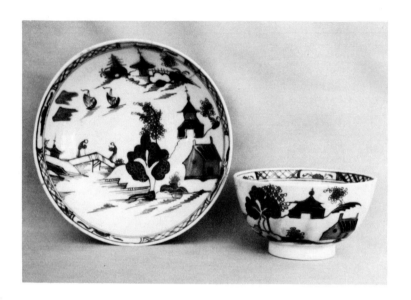

**Teabowl and Saucer c.1775**
**Diameter of Saucer 4½in. no mark**

The 'Dolls House' pattern is one of the well-known Redgrave patterns and is in fact the most common design produced at Lowestoft. It appears throughout the polychrome period from 1772-1799. Examples are usually rather artlessly painted and were perhaps done by children who are known to have worked at the factory.

*£20–27*

*Teabowl alone £5 -7*

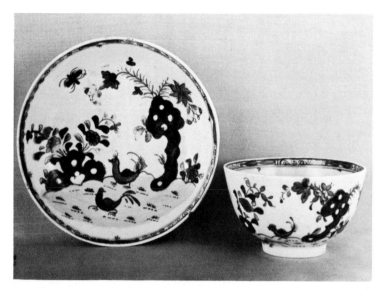

## Teabowl and Saucer c.1775
### Diameter of Saucer 4½in. no mark

The 'Two bird' pattern is another Redgrave design and is also a very common one. Again the painting usually shows signs of being the product of a rather inexperienced or perhaps youthful hand. This pattern also spans the period 1772-1799.

*£24–30*

*Saucer alone £9–12*

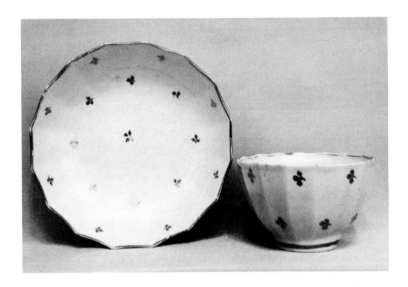

**Teabowl and Saucer c.1795**
**Diameter of Saucer 5in. no mark**

This late teabowl and saucer is decorated with gilt sprigs, a form of
decoration which occurs mainly on fluted teawares. During the last ten
years or so of the factory's life several rather sparse 'sprig' patterns
appear, most of which were derived from French hard paste porcelain.

*£20–26*

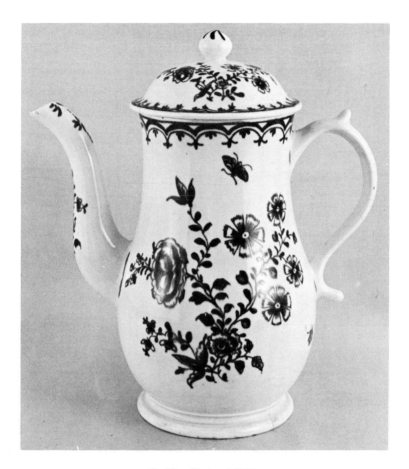

**Coffee Pot c.1770**
**Height 8½in. numeral 5**

A good, well-painted example showing the typical Lowestoft coffee pot shape of the early 1770's. The most commonly found patterns on coffee pots show scenes which include Chinese houses. After about 1780 the shapes become similar to Worcester and Caughley and some examples are transfer-printed.

*£90–120*

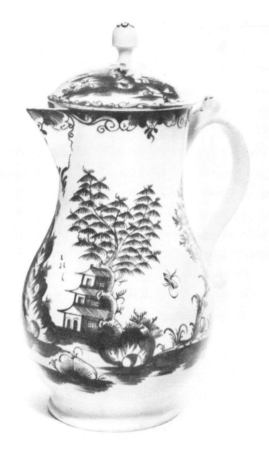

**Coffee Jug c.1768**
**Height 11in. numeral 2**

This fine, large specimen is a comparatively rare Lowestoft shape. Later coffee jugs are smaller and more common. A standard middle period pattern which is usually seen on large objects.

*£120–155*

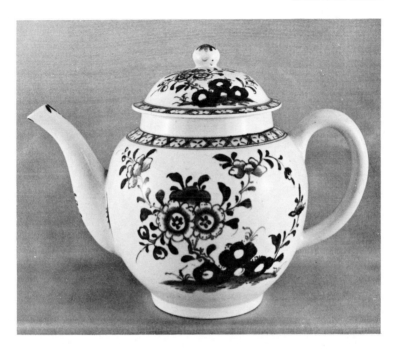

**Teapot c.1778**
**Height 6¼in. no mark**

This teapot is typical of the period in size, shape and decoration. The inside flanges of lids are always glazed and handles tend to be rather thick. Much of the post-1775 painting in underglaze blue tends to be rather mechanical. Examples in absolutely perfect condition are hard to find.

*£58–72*

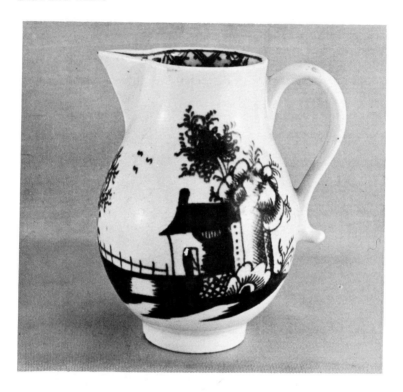

### Creamjug c.1778
**Height 3½in. no mark**

A typical Lowestoft'Sparrow beak' creamjug. These are slightly more
common in polychrome than in blue and white. They often have slight
fire cracks where the lip joins the body of the jug, but this does not
really count as damage and usually has very little effect upon the value.
Creamjugs of the pre-1768 period are scarce.

*£30—39*

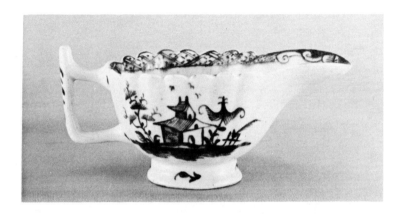

### Creamboat c.1767 .
#### Length 4¼in. numeral 11

This attractive little creamboat (or butter boat) dates from the Middle period. The squared handle and deep footring are typical. The painter's mark, numeral 11, is an unusual one. These creamboats, like the relief moulded examples of a similar shape, are fairly scarce. It appears that few, if any, creamboats were made at Lowestoft in the post-1782 period.

*£35—48*

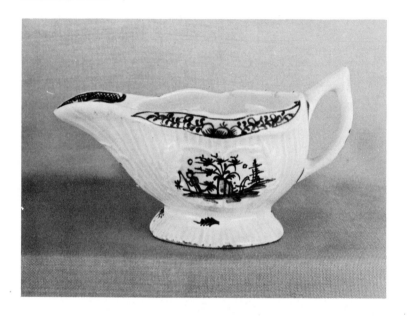

**Creamboat c.1775**
**Length 4¼in. no mark**

A later and more common form of creamboat which could almost be described as a miniature sauceboat. Most of these creamboats date from the mid or late 1770's. The shape was produced in polychrome but examples are very scarce.

*£32–42*

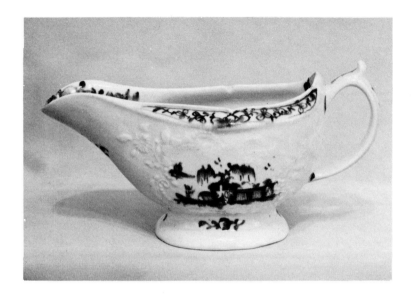

## Sauceboat c.1770
**Length 8in. numeral 8**

A typical Lowestoft sauceboat of the period c.1768-1785. These were produced in three sizes and after about 1778 examples are usually transfer-printed with flowers. The latter are worth about 35% less. It seems that no sauceboats were made at Lowestoft after about 1790. All polychrome sauceboats are extremely rare.

*£48–62*

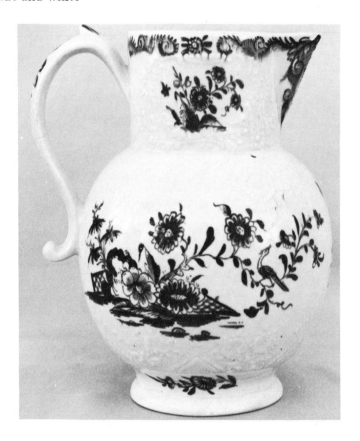

**Cider Jug c.1772**
**Height 8¾in. numeral 5**

These fine jugs were made in several sizes during the period 1760-1785
and show a characteristic Lowestoft shape. Although they must ori-
ginally have been produced in large numbers, they are now fairly scarce
particularly when in perfect condition. Some examples have mask lips
and these are rare and more expensive.

*£70—90*

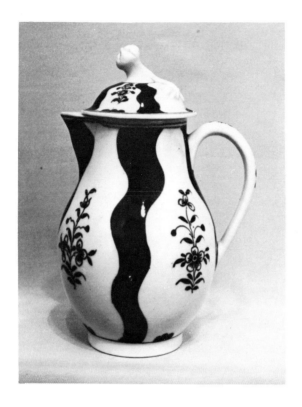

**Milk Jug c.1780**
**Height 5½in. crescent mark**

The 'Robert Browne' pattern is one of the most sought-after of all the underglaze blue Lowestoft patterns and spans the period c.1771-1785. This milk jug has the additional advantage of being complete with its cover which adds some 30% to its value. Examples of this pattern are not as rare as the price might indicate.

*£48–62*

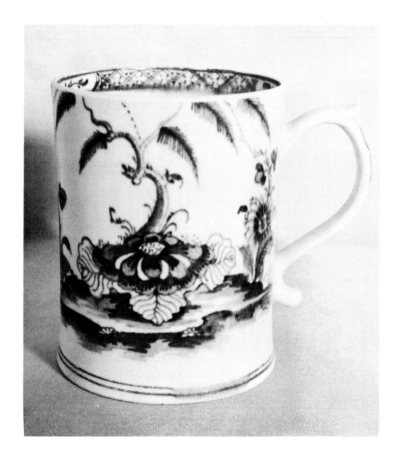

**Mug c.1763**
### Height 4¼in. numeral 2

A fine early example of a cylindrical mug. The double line border around the slightly flared base is indicative of an early date. Very rare.

*£75–90*

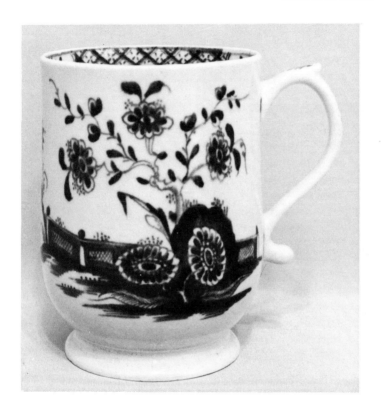

**Mug c.1767**
**Height 4½in. numeral 3**

Bell-shaped mugs of this type were produced in three sizes from c.1761-1775; later examples are tapered towards the rim. Polychrome specimens of this shape are very scarce.

*£65–80*

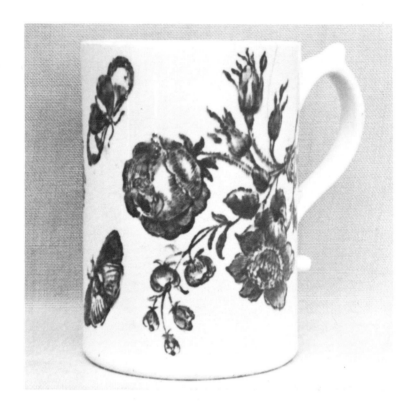

## Mug c.1775-1780
### Height 4½in. no mark

A typical Lowestoft cylindrical mug of the period. The transfer-print was copied from Worcester. These mugs were produced in three sizes: 3½inches, 4½inches and 6 inches.

*£50–65*

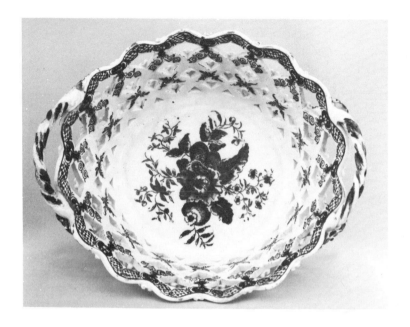

### Basket c.1785
**Width 9¾in. crescent mark**

These baskets are direct copies of the more common Worcester examples and are usually decorated with the popular 'pine cone' transfer. They are not as well potted or printed as the Worcester specimens and are much more heavily glazed. They were made in several sizes and date from about 1775-1785. No Polychrome decorated baskets have so far been recorded.

*£80–110*

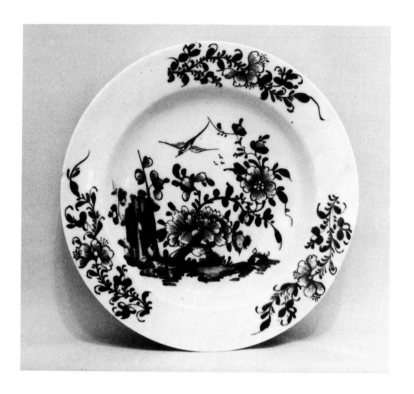

**Plate c.1768**
### Diameter 7in. numeral 3

All Lowestoft flatware is scarce and therefore specimens are usually considerably more expensive than their equivalents in Bow. Some of the larger plates have attractively painted Chinese figure designs and these tend to be especially costly. Nearly all plates of the post-1775 period are printed rather than painted.

*£55—70*

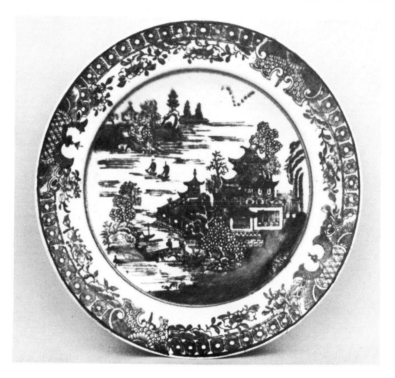

**Plate c.1790**
**Diameter 7¾in. no mark**

An example of the Lowestoft version of the 'Willow' pattern. This print occurs with three different border designs. Specimens of this period are often stained. It appears that no polychrome decorated plates at all were made at Lowestoft.

*£38−45*

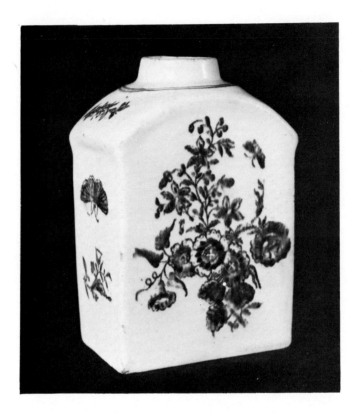

### Tea-Caddy c.1778-1780
**Height 3¾in. crescent mark**

Tea-caddies of this shape were produced at Lowestoft in the post-1775 period but although many specimens bear the crescent mark, no other factory made caddies of this shape. Polychrome specimens are very scarce. The pre-1775 Lowestoft caddy form was octagonal and either plain or moulded.

*£32–45*

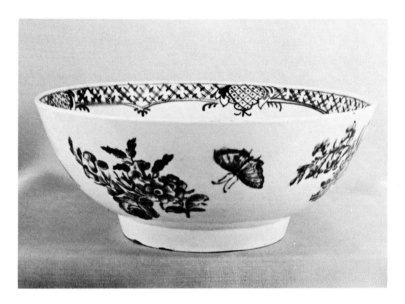

## Bowl c.1778
### Diameter 8½in. no mark

Large bowls tend not to be particularly popular with collectors because of their size and the difficulty in displaying them. This is a good cleanly printed example. Painted bowls of this size are scarce.

*£38–48*

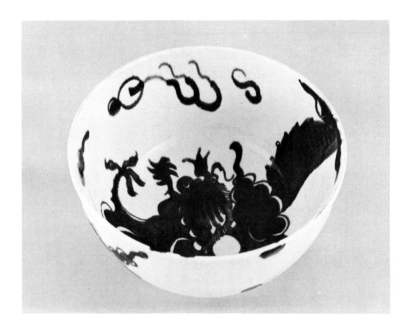

### Bowl c.1775
**Diameter 4in. no mark**

The Lowestoft version of the 'Dragon' pattern usually dates from the period 1771-1780 and is slightly rarer than its Bow counterpart. The blue is a darker tone than that found on Bow examples. This pattern, which is popular with collectors, is also found on Worcester and Liverpool porcelains. The dragon's tongue on the Lowestoft specimens is always of 'tulip' shape.

*£38–48*

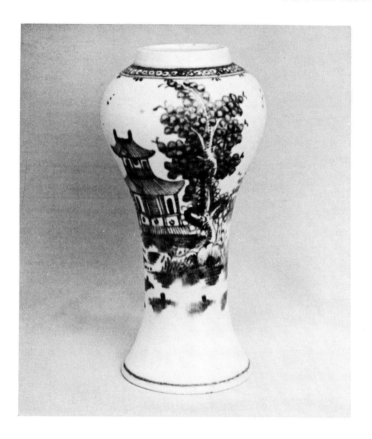

**Vase c.1785-90**
**Height 5¾in. no mark**

This late baluster-shaped vase was originally part of a garniture of five and would probably have had a cover. The blue is a bright tone and the pattern is typical of the period. All Lowestoft vases are rare.

*£80–95*

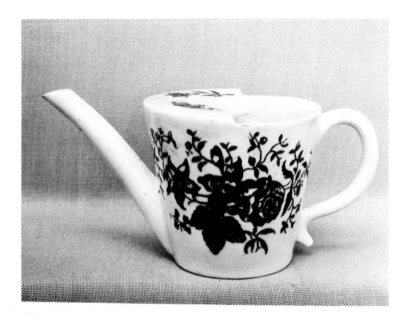

## Feeding Cup c.1780
### Height 3¼in. no mark

Feeding cups or 'pap boats' were a speciality of Lowestoft and were not produced by any other eighteenth century porcelain factory. Two different shapes were made, one straight-sided and the other with shaped sides. The former is earlier and more common. Painted specimens are usually earlier in date and more valuable than the transfer-printed ones. Rare.

*£80–100*

**Shell Dish c.1775**
**Width 5½in. no mark**

These scallop shell dishes, unlike the rarer middle period examples, could be mistakenly attributed to Bow. The blue is a lightish tone and the pattern seldom varies. Made in two sizes of which the one illustrated is the less common.

*£38–48*

### Pickle Leaf c.1770
**Height 3½in. numeral 4**

The most common form of pickle leaf produced at the factory. Later examples have a similar design but their shape is slightly different. The blue is a darker tone than that of the Bow specimens with which these are sometimes confused. Polychrome examples were made but they are extremely rare.

*£28−36*

**Patty Pan c.1775**
**Diameter 3½in. no mark**

This fairly common Lowestoft form was produced from c.1762-1782 but most examples date from the 1770's. Several patterns were used but the one illustrated is easily the most common. These patty pans, which appear in several sizes, are often stained and this considerably reduces their value. No polychrome decorated specimens are known.

*£30–38*

**Birth Tablet 1796**
Diameter 3in. no mark

Birth tablets which are peculiar to the Lowestoft factory were produced from about 1765 until the end of the factory's life. The reverse sides are most often painted with either flowers or chinese houses. There are under thirty-five examples recorded of which only seven are polychrome. Specimens vary in size from about 2½ inches up to about 5¾ inches. All birth tablets are rare and extremely desirable.

*£250–320*

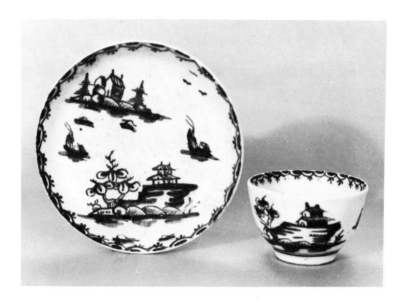

**Miniature Teabowl and Saucer c.1768**
**Diameter of Saucer 3in. no mark**

Lowestoft miniature teawares appear in three different patterns one of which is transfer-printed. They are rarer than the Bow or Caughley examples but more common than the Worcester ones. Lowestoft did produce miniature wares with polychrome decoration but specimens are nowadays extremely rare.

*£35–45*

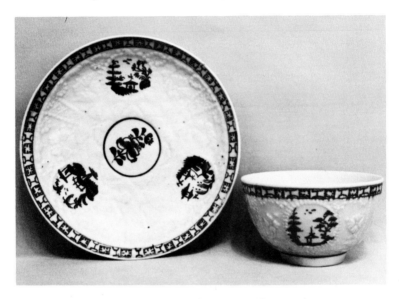

### Teabowl and Saucer c.1764
**Diameter of Saucer 4½in. numeral 7**

The 'James Hughes' pattern. This type of moulded teaware nearly always dates from between 1760 and 1765 and is very popular with collectors. The initials 'J.H.' and the date '1761' were included in the original mould and can sometimes be clearly seen in the earlier specimens.

*£32–42*

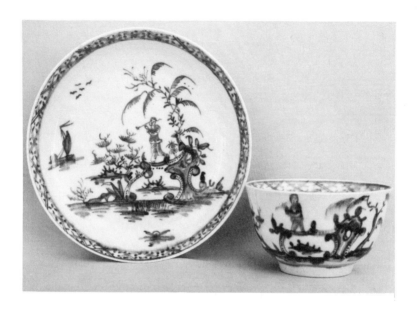

**Teabowl and Saucer c.1767**
**Diameter of Saucer 4½in. no mark**

The 'Boy on a Bridge' pattern is one of the most attractive of all the Lowestoft blue and white designs. It occurs on middle period wares of the mid and late 1760's and is usually charmingly painted in a pleasing Delft-like style. Fairly scarce.

*£30–38*

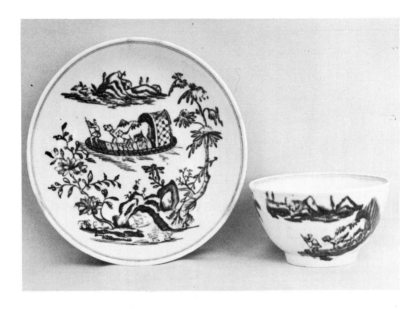

### Teabowl and Saucer c.1775
#### Diameter of Saucer 4¾in. no mark

The 'Dromedary on a raft' (above), the 'Woman and Squirrel', and the 'Good cross chapel' are the three best-known of a series of Lowestoft transfer-prints with rather unusual subjects. These three prints are much sought-after by collectors and nowadays examples are fairly scarce.

*£30–40*

*Teabowl alone £8–10*

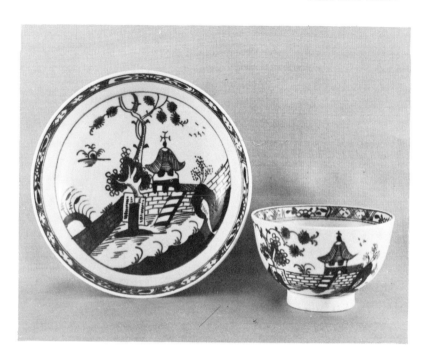

**Teabowl and Saucer c.1782**
**Diameter of Saucer 4½in. no mark**

This type of Chinese style design is particularly common in the post-1780 period. Footrings tend to be slightly taller and the blue varies from an inky tone to a bright, lightish one. Painters numerals do not appear after about 1774.

*£24–30*

*Saucer alone £9–12*

# CAUGHLEY 1772-1799

Recent research has shown that the output of the Caughley factory was considerably smaller than it was previously thought to be. In fact it would now appear that very little polychrome decorated porcelain was produced at Caughley, although many pieces were sold 'in the white' and decorated outside the factory.

As one might expect, blue and white tewares are fairly common, the majority of them being transfer printed. On the other hand, quite a large proportion of the plates and dishes are painted, often with a version of the 'Chantilly sprig' pattern. Other shapes that are relatively common are mugs, sauceboats, creamboats, cabbage-leaf masked jugs, pickle leaf dishes and bowls. The factory produced a large number of small objects, many of which are more plentiful in Caughley than in any other factory. These include egg drainers, shell-shaped dishes, spoontrays and asparagus servers. Eye baths, egg cups, spitoons, inkpots and spoons were also made, but these are now fairly scarce. Miniature tewares are considerably more common in Caughley than in any other eighteenth century factory, and one still occasionally finds tea services which are almost complete. These miniature services occur in two different patterns, one painted and one printed. A few of the transfer prints used at Caughley also occur on Worcester, but others are unique to the factory. Amongst the latter is the fine print commemorating the erection of the Ironbridge over the river Severn at Coalbrookdale in 1779. The well-known 'fisherman' pattern was produced at both Caughley and Worcester, but specimens can be told apart by certain slight variations in the print. This print was used on a variety of different shapes and such objects as asparagus servers, egg drainers, small wine tasters and asparagus butter boats rarely, if ever, appear in any other pattern. Painted wares tend to be earlier than the more common printed pieces, but there are many exceptions. Some of the later printed wares are embellished with gilding; this detracts from their value somewhat. The main marks used are the impressed Salopian mark, an S in underglaze blue and a capital C. Hatched crescents never occur on Caughley.

Some polychrome wares, which seem to be fairly scarce, are decorated with colourful 'Japan' patterns, others with floral designs which mainly date from after 1785, and are rather poorly painted. The fine cabbage-leaf masked jugs often painted with birds in the style of

Duvivier, were probably decorated by Chamberlain at Worcester. Nearly all the gilding found on Caughley porcelains seems to have been done outside the factory.

It is by no means always easy to tell Caughley and Worcester porcelains apart. The best way of learning to do so is to study carefully several marked examples from each factory and to compare their pastes, glazes, footrings and shapes. Caughley has risen in price over the last three years more than any other eighteenth century English factory with the possible exception of Newhall. This is partly because it was undervalued until recently in comparison with the other major factories and partly because there is always a tendency for the less expensive factories to be chosen by collectors who feel that they cannot afford to invest in the more fashionable ones. This inevitably means that prices are being pushed up all the time from the bottom of the financial scale.

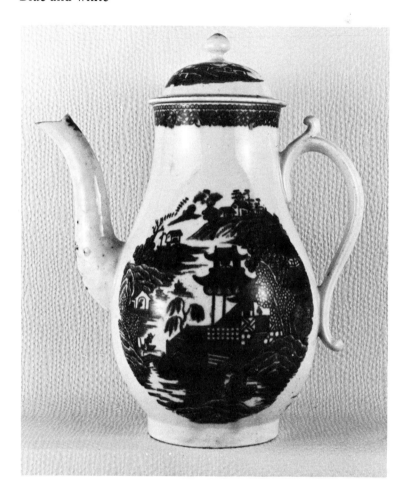

**Coffee Pot c.1785-90**
**Height 9in. no mark**

Caughley coffee pots are rarer than their contemporary Worcester counterparts. The pattern is a common one.

*£58–72*

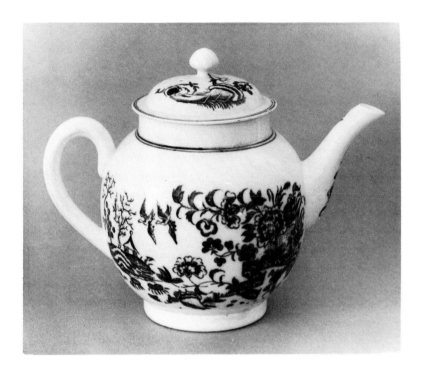

### Teapot c.1775-80
**Height 5¾in. no mark**

The 'zig-zag fence' pattern. This is a common transfer-print which also
appears on Worcester and Lowestoft. The shape of this early Caughley
teapot is typical of the period 1775-80.

*£40–48*

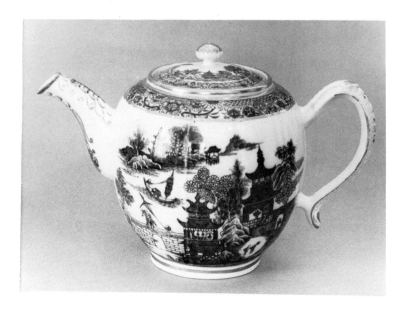

### Teapot c.1785-90
#### Height 6in. S mark

This common Caughley teapot form was made in imitation of the Chinese blue and white 'Nankin' porcelains which were imported into this country in great quantities in the late eighteenth century.

*£27–34*

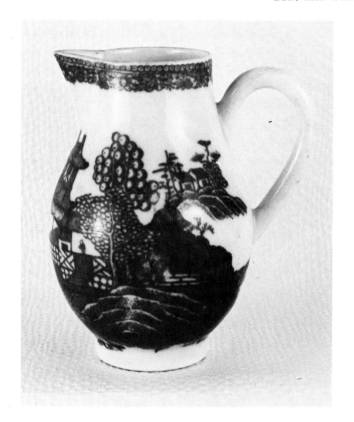

**Milk Jug c.1785-90**
**Height 4in. no mark**

This transfer-printed milkjug would originally have had a cover. This would add to its value by about thirty per cent. Fairly common.

*£20–25*

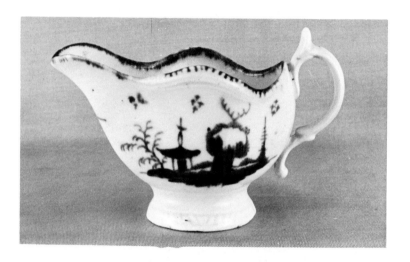

**Creamboat c.1780-85**
Length 3½in. impressed star mark

These attractive little creamboats are painted in a similar style to some of the Caughley miniature wares. The shape was also produced at Worcester in both underglaze blue and polychrome versions. Examples are usually marked with a star which is impressed into the base. Fairly common.

*£32–40*

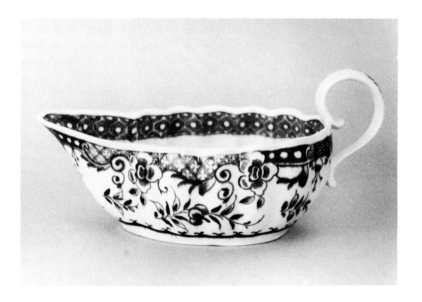

**Sauceboat c.1778-82**
**Length 8in. no mark**

These shallow flat-bottomed sauceboats were also produced at Worcester, Derby and (more rarely) Lowestoft. The Caughley specimens resemble the Derby ones but can be distinguished by their paste and painting.

*£32–38*

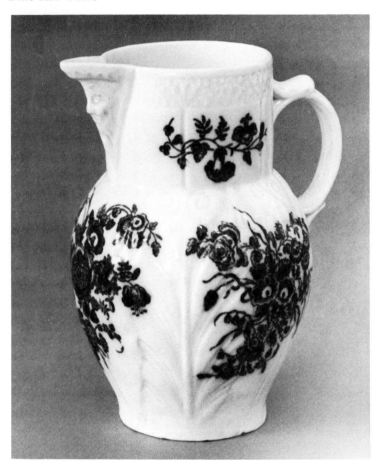

**Mask Jug c.1782-85**
**Height 7½in. S mark**

These 'cabbage leaf' moulded mask jugs were made in several sizes and occur in both blue and white and polychrome. Most of the latter were probably decorated outside the factory. Fairly common.

*£45—58*

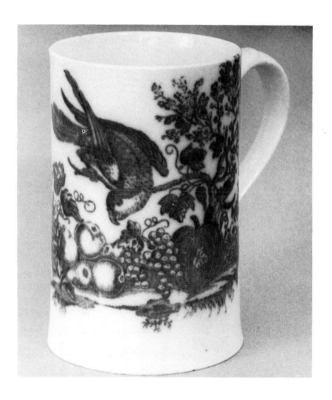

**Mug c.1790**
**Height 4¾in. no mark**

This typical late Caughley mug is printed with the 'Parrot and fruit'
pattern which was also used at Worcester. Fairly common.

*£36–42*

**Dish c.1785-90**
**Length 10¼in. no mark**

This lozenge-shaped dish was a popular form at Caughley. A similar shape was also produced at Worcester. The transfer-print is a comparatively common one.

*£24–29*

**Plate c.1785**
**Diameter 8in. impressed Salopian mark**

The 'Fisherman' pattern is easily the most common design used at
Caughley. Worcester produced a version of this transfer-print but it
differs slightly from the Caughley version in several small details.

*£20–25*

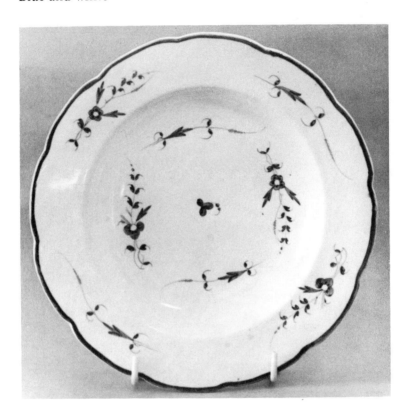

**Plate c.1790**
### Diameter 9¼in. impressed Salopian mark

A typical example of the sparse painting found on some Caughley flat-ware. This was sometimes done in imitation of the blue and white Chantilly wares. Fairly common.

*£18–24*

**Teapot Stand c.1790**
**Diameter 5¾in. no mark**

Teapot stands which occur in five shapes, are comparatively common in Caughley although scarce in all other factories. Some examples of this common transfer-print have gilded edges in imitation of Chinese export porcelain.

*£12–16*

### Spoontray c.1785-90
**Length 6½in. S mark**

Spoontrays are one of the rarest teaware shapes and one of the most desirable ones. Caughley specimens however are surprisingly plentiful and were produced in two different shapes. The gilding on this example detracts from its value as it is not strictly speaking blue and white. The bases of Caughley spoontrays are always left unglazed.

*£20–26*

**Bowl c.1785**
**Diameter 6in.  no mark**

The 'Uninhabited Pagoda' pattern. Bowls are probably the least collected
of all porcelain shapes because of the difficulty in displaying them to
good effect.

*£11—15*

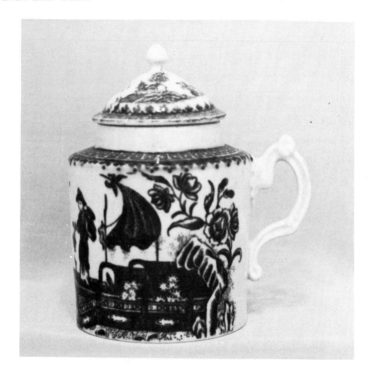

### Mustard Pot c.1780-85
**Height 3¾in. no mark**

Mustard pots are all fairly scarce, the Worcester examples being slightly more common than the Caughley ones. The latter occur in several standard patterns all of which are transfer-printed. Most 'wet' mustard pots would originally have had spoons to go with them but these fragile articles are now scarce.

*£40–48*
*£68–85 with spoon*

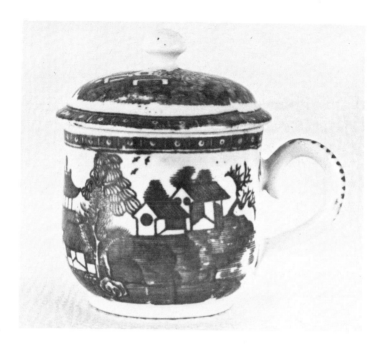

**Custard Cup c.1785-90**
**Height 3in. s+ mark**

Blue and white custard cups whilst not common in Caughley can still occasionally be found. Derby was the only other factory to make these articles in any quantity and specimens from all other factories are scarce. The pattern is a common one.

*£18–24*

### Pickle Leaf c.1785
**Length 3¼in.  no mark**

These small pickle leaf dishes were probably intended as asparagus butter
boats. Similar forms were produced at Worcester, Derby and Lowestoft.
The Caughley specimens seem only to occur in the 'fisherman' pattern.
Fairly common.

*£17–21*

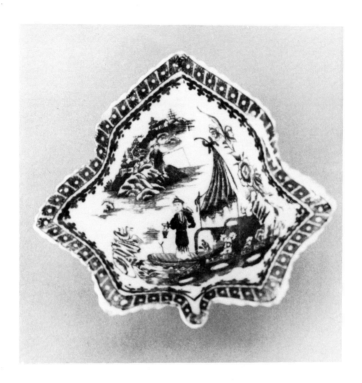

**Pickle Leaf c.1785**
**Height 4¼in. S mark**

A very common Caughley form although it seldom appears in any other pattern. Small pickle leaf dishes were produced in large quantities by nearly all the main eighteenth century factories but in most cases their exact use remains something of a mystery. These were made in several sizes.

*£12–16*

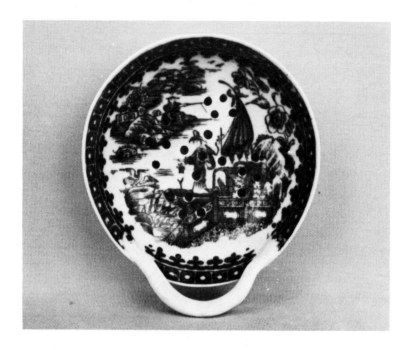

### Egg Drainer c.1785
#### Diameter 3¼in. no mark

Another example of the very common 'fisherman' or 'pleasure boat' pattern which occurs on both Worcester and Caughley. Caughley probably produced more examples of this rare shape than all the other factories put together. Other even rarer small objects made at Caughley include egg cups, eye baths and spoons; all of these are eagerly sought-after by collectors and tend to be expensive.

*£20–26*

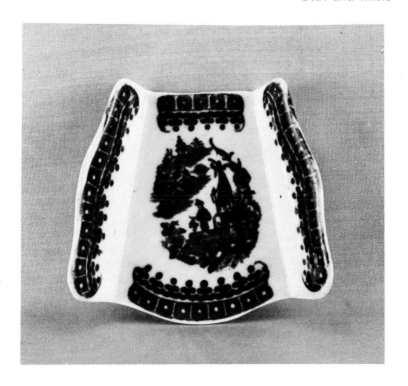

**Asparagus Server c.1785-95**
Height 2½in.  S mark

These objects are sometimes wrongly called knife rests. Derby produced this shape both in underglaze blue and in overglaze 'dry' blue but all other examples are rare. Caughley specimens are very common.

*£8–11*

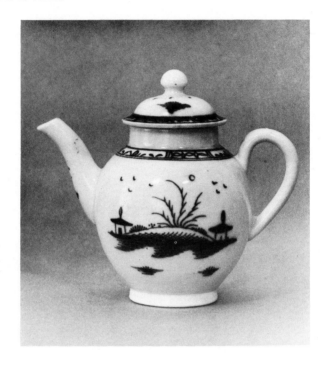

### Miniature Teapot c.1785
**Height 3in.  S mark**

Unlike most eighteenth century factories Caughley produced miniature teawares in large quantities and they are still fairly common today. Only two designs were used, a painted pattern and the 'fisherman' pattern'. Other rarer shapes that were made in miniature include plates, dishes, coffee pots, coffee cans, sauceboats and bottles.

*£40–50*

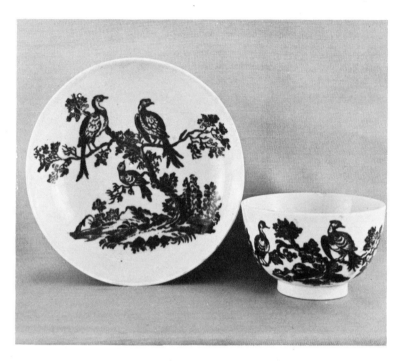

### Teabowl and Saucer c.1780-85
**Diameter of saucer 4¾in. no mark**

The transfer-printed 'birds in a tree' design appears on both Caughley and Worcester specimens. Most of the Worcester examples have a fourth bird flying in the top right hand corner of the saucer. This pattern occurs mainly on tea and coffee wares. Fairly common.

*£20–25*
*Teabowl alone £4–5*

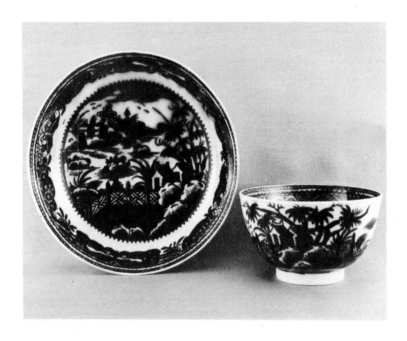

## Teabowl and Saucer c.1780-85
### Diameter of saucer 4¾in.  no mark

The 'Fence and house' design is a very common Caughley transfer-print
and it was not used at any other factory. Heavily printed patterns of
this type do not vary much in price.

*£14—18*
*Saucer alone £5—7*

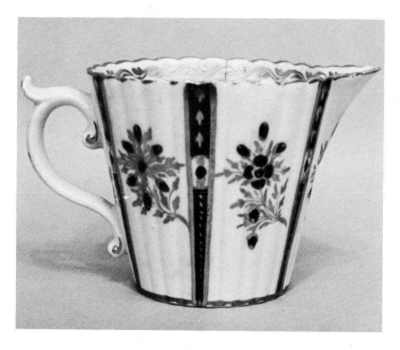

## Cream Jug c.1785-95
### Height 2¾in. no mark

A fluted creamjug decorated in underglaze blue and gilt. The shape and handle-form are typical of the period. Not a particularly desirable article.

*£9–15*

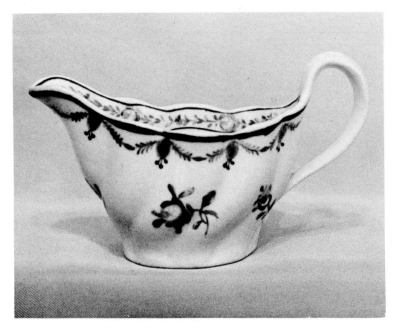

### Creamboat c.1788-92
**Length 4½in. no mark**

A very unusual spirally fluted Caughley creamboat painted in pale colours. Although it now appears that polychrome Caughley is surprisingly scarce, it is nevertheless not one of the more collected classes of porcelain and specimens tend not to be particularly expensive. This specimen resembles some pieces of Newhall in both shape and decoration.

*£28–35*

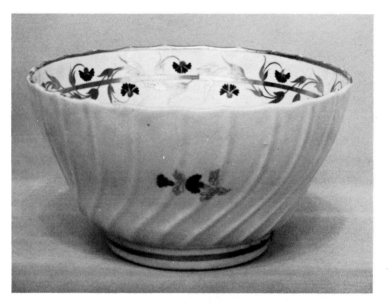

**Bowl c.1790-95**
**Diameter 6¼in. no mark**

This late Caughley bowl is decorated in underglaze blue and embellished with gilding. Spiral fluting of this type is more usually seen on Chamberlain's Worcester wares.

*£8–12*

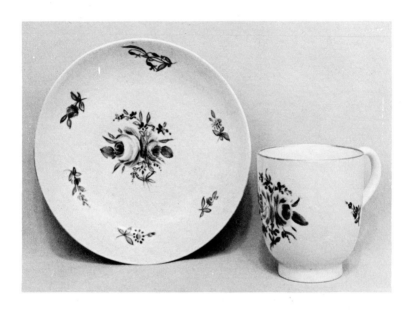

## Coffee Cup and Saucer c.1790-95
### Diameter of Saucer 5in. no mark

A late Caughley coffee cup and saucer typically painted with rather sparse floral sprays. Most of the polychrome decorated Caughley porcelain dates from after about 1785, some specimens being decorated outside the factory. Quite rare.

*£25–30*

# PLYMOUTH, BRISTOL AND NEWHALL

William Cookworthy's factory at Plymouth (1768-1770) was the first in England to make hard paste porcelain. The experimental nature of the manufacture of 'true' porcelain caused a high proportion of kiln wastage which increased the difficulties of making this ambitious enterprise a commercial success. In fact, in 1770, after less than three years at Plymouth. Cookworthy transferred the factory to Bristol where the potting tradition was much stronger.

There were some surprisingly elaborate shapes made in polychrome Plymouth, including large ornamental vases and intricate shell salts. Rather more common are mugs, sauceboats, bowls, creamboats, coffee cups and pickle leaf dishes, the latter painted in underglaze blue and overglaze iron red. Most other shapes are scarce, saucers, teabowls and plates particularly so. The decoration is sometimes in Chinese 'famille verte' style or Chinese Mandarin style, but perhaps the most successful designs are those on the bird decorated mugs which were painted by the mysterious Mons Soqui, a French decorator. The Plymouth paste is very hard and white and has numerous imperfections in the glaze. Only about 20% or so of the polychrome wares are marked and it is consequently sometimes difficult to tell Plymouth from early Bristol.

No such problem exists in separating the blue and white wares of the two factories. The Plymouth has a very blackish underglaze blue caused by the high temperature at which it is fired. The blue and white is rarer than the polychrome, but a higher percentage of it is marked (with the sign for tin- ♃ in underglaze blue). The most commonly found shapes are hors d'oeuvre dishes, sauceboats, mugs, teapots, bowls, pickle leaf dishes and coffee cups. All flatware, including saucers, is very scarce. A factory mark increases an article's value by up to 30%.

Champion's Bristol factory (1770-1781) concentrated chiefly on tea and coffee services and most standard shapes can still be found in their output of polychrome wares. Mugs, sauceboats, plates, dishes, creamboats and bowls are relatively common, but pickle leaf dishes are rare. Some of the decoration is derived from the Chinese, but many services show the influence of Meissen and Sèvres. This is especially noticeable on some of the fine 'named' services. More common are the humble floral and garland patterns which are often very sparsely decorated. The Bristol colours are bright and sharp and stand out pleasingly against the hard white paste. The quality of the gilding is unsurpassed

by any other English factory. Slightly more than half the polychrome wares bear a factory mark.

Even less blue and white was produced at Bristol than at Plymouth. Creamboats, pickle leaf dishes and coffee cups are almost the only shapes which the collector can hope to find. The blue is a bright tone, quite unlike Plymouth and the glaze has fewer flaws in it. The general appearance of these wares is nearer to the Chinese which they were striving to imitate, than the efforts of any other eighteenth century English porcelain factory. A few pieces were transfer printed in underglaze blue, but this experiment was not very successful aesthetically and examples are scarce. About 80% of the blue and white Bristol is marked with a cross in underglaze blue.

Plymouth and Bristol have risen in price rather more slowly than most other factories in the last six years. However, there is always a considerable demand for these wares, particularly in the West Country where the prices tend to be slightly higher. It is essential for all general representative collections to include at least one or two hard paste specimens, even if only for the purpose of comparison.

The Newhall factory made a hard paste porcelain from 1782-1812; thereafter bone china was produced. The output of the factory was confined exclusively to useful wares, especially tea and coffee services. The pre-1790 porcelains are nowadays quite hard to find and consist mainly of teapots, creamjugs, bowls, teabowls, coffee cups and saucers. Other much rarer forms at this period are mugs, creamboats, spoontrays, tea caddies and jugs. These pieces are usually attractively, if simply, painted and sometimes show signs of the spiral wreathing which also occurs on Bristol and Plymouth. Handles are of 'clip' form and creamjugs usually helmet-shaped.

After about 1790, the wares lost most of their individuality and the forms became standardised. Teapots, which are fairly common, are usually either boat-shaped or of diamond shape. Bowls, teabowls, coffee cups and saucers are very common, but coffee pots are scarce and comparatively expensive. The decoration is either in Chinese Mandarin style or in 'cottage' style with simple sprigs and festoons of flowers. There are also some more sophisticated and formal designs which include gilding of fine quality. The blue and white wares are nearly always transfer printed, usually with Chinese scenes of the 'Willow' variety which are often embellished with gilding.

Newhall has more than doubled in price over the last four years or

so. The output of the factory was very large and specimens are still quite plentiful. For this very reason, however, it is a much-collected factory and the price of its products will probably continue to rise, albeit at a slower rate than before.

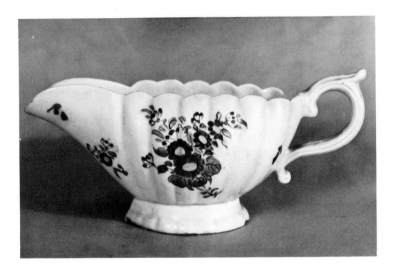

**Sauceboat c.1770**
**Length 8in. 4 mark**

A Plymouth sauceboat of fairly typical shape. Comparatively little poly-chrome Plymouth bears a factory mark. This shape was also produced in blue and white. The wares of this short-lived factory are collected more for their rarity than for their artistic merits. Consequently although the factory has a limited appeal to the general collector, its rarity ensures its relatively high cost.

*£72–88*

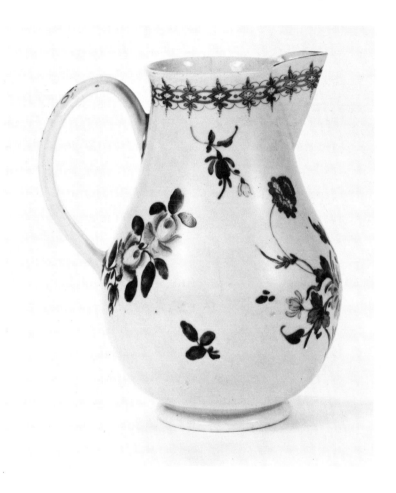

### Jug c.1770
#### Height 7½in. no mark

The shape and paste of this jug indicate that it is a late Plymouth piece rather than an early Bristol one. The border is typical of the earlier factory. Quite rare.

*£100–135*

357

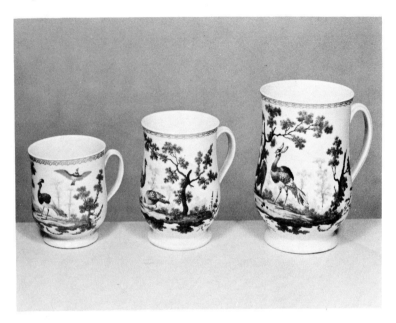

### Set of Mugs c.1769-70
**Sizes 4½ins., 5¼ins., and 6¼in. no marks**

A rare set of three fine bell-shaped mugs superbly painted with exotic birds in a landscape setting by Mons Soqui, a French decorator. This form of decoration, which also appears on large and elaborate hexagonal vases, is the finest to be found on Plymouth porcelain. These mugs are rare even as individual pieces.

*£700–900 the set*

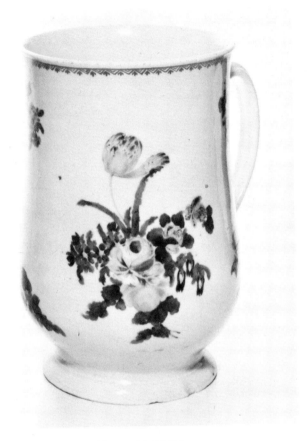

**Mug c.1768-70**
**Height 6¼in. no mark**

A fine bell-shaped Plymouth mug decorated with flower sprays. Mugs are probably the most common articles produced at Plymouth in polychrome. The majority of the mugs produced at Plymouth are bell-shaped rather than cylindrical.

*£115—150*

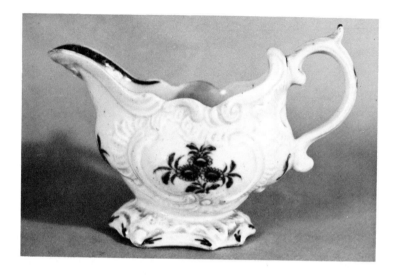

### Sauceboat c.1770
**Length 5¾in. 2⁄ mark**

This attractive rococo moulded sauceboat is a characteristic Plymouth shape which was produced in both blue and white and polychrome. William Ball's Liverpool factory also produced examples of this shape but it was not made elsewhere. Some pieces of Plymouth show signs of discolouration caused by 'smoke staining' and this reduces their value. Quite rare.

*£68–85*

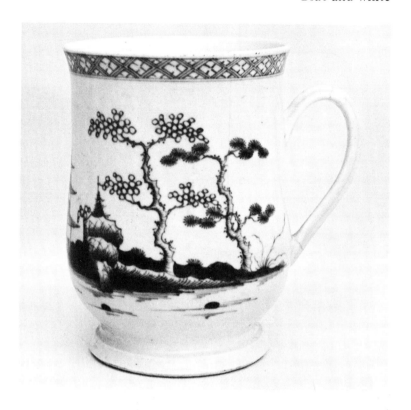

### Mug c.1770
#### Height 4¼in. ♃ mark

A bell-shaped mug painted with the 'blue rock' pattern which was used at various other factories. Only about a third of the blue and white Plymouth bears a factory mark. A mark increases an article's value by about thirty per cent.

*£62–78*

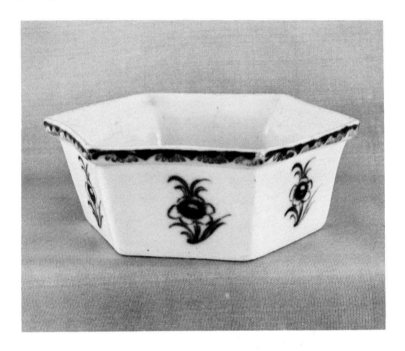

### Hors d'Oeuvre Tray c.1768-70
#### Diameter 4¼in. no mark

This is one of a set of seven hors d'oeuvres trays which fitted on a circular wooden stand. It is one of the most common and least expensive of all Plymouth shapes but examples are seldom marked. The underglaze blue is a typically blackish tone which is caused by the high temperature at which it is fired. Bases are always unglazed.

*£28–35*

### Pickle Leaf c.1770
**Height 3¾in. no mark**

This typical Plymouth pickle leaf-shape also appears with underglaze blue and overglaze red and gilt decoration. The pattern is copied from the one that occurs on Worcester pickle leaf dishes but the shape of the Plymouth leaf and the tone of the blue is different. Examples are seldom marked.

*£30–40*

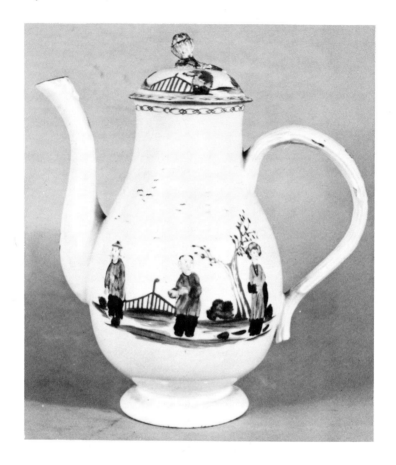

### Coffee Pot c.1775-78
#### Height 8¼in. cross mark

A Bristol coffee pot decorated with Chinese Mandarin figures. The decoration on this example does not fit the shape very well but this is nevertheless a rare and quite desirable article.

*£120–160*

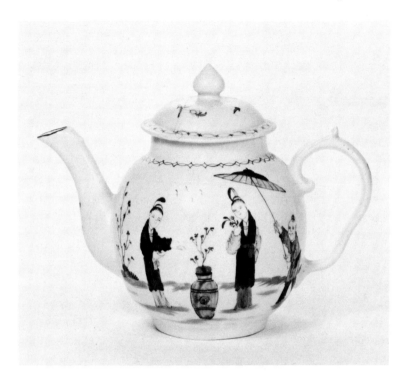

### Teapot c.1775-78
**Height 5½in. cross mark**

A Bristol teapot with typical Chinese Mandarin decoration. The shape, decoration and especially the handle are characteristic of the factory. The demand for Bristol and Plymouth porcelains is higher in the West Country than elsewhere and consequently prices are higher in that area.

*£78–95*

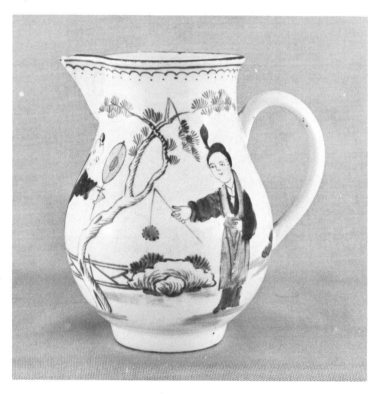

## Creamjug c.1775
**Height 3¼in. cross mark**

A Bristol creamjug of typical shape painted with Chinese Mandarin
figures. The style of decoration is derived from Worcester but the shape
is more bulbous. A factory mark is always an asset to a piece of Bristol
but it affects its price only slightly.

*£52–65*

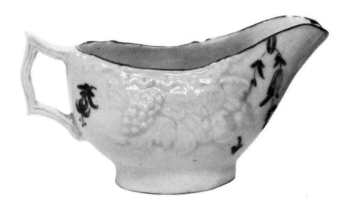

## Creamboat c.1775
### Length 4½in. no mark

A pleasantly moulded Bristol creamboat with rather restrained floral
decoration. Small and attractive articles of this type are very desirable
as they appeal to a wide range of collectors. A slightly similar form was
produced at Plymouth. Fairly scarce.

*£50–65*

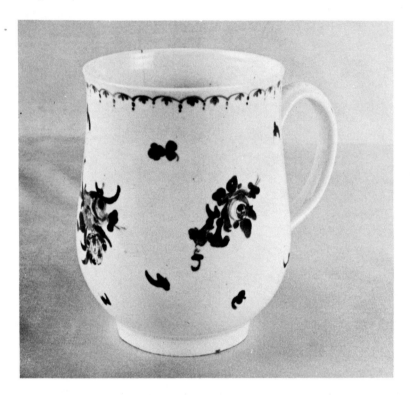

**Mug c.1778-80**
**Height 3¾in. no mark**

A Bristol bell-shaped mug of typical form with sparse flower sprays. On shapes such as coffee pots, jugs and mugs, the spiral wreathing so often found on Plymouth and Bristol is particularly apparent.

*£72–90*

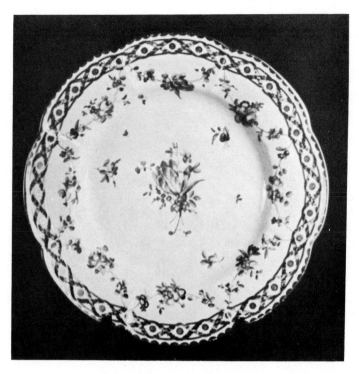

### Plate c.1775-78
**Diameter 7½in. cross mark**

This is easily the most common type of Bristol plate and it shows the
influence of the Sèvres factory. Bristol experienced some difficulty in
firing flatwares which tended to sag in the kiln. To overcome this fault
a secondary footring or support was added to many of the plates and
dishes. It should be noted that plates with similar decoration were made
at Derby in soft paste porcelain.

*£48–62*

**Plaque c.1777-78**
**Height 9in. no mark**

These biscuit ware plaques were a speciality of the factory. Most of them were presentation pieces and often have the arms of a local West Country family modelled in relief. They are usually contained in oval wooden frames. They were reputed to have cost £5 each to produce, a very considerable sum at that time. Rare.

*£150–220*

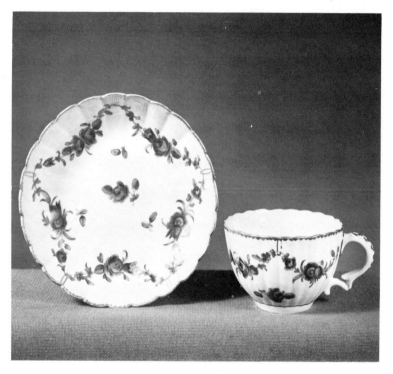

## Coffee Cup and Saucer c.1778
**Diameter of saucer 4¾in. cross mark**

This fluted cup and saucer is decorated in green camaieu and gilt, a very common form of decoration on Bristol teawares. The handle-shape is one of several which are peculiar to the factory. Less well-painted examples have a brown rim instead of a gilt one.

*£48–60*

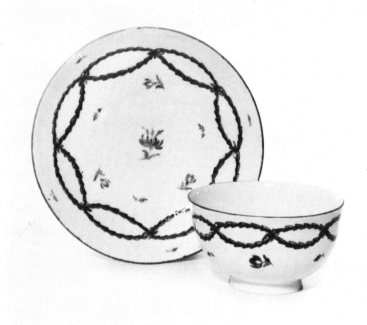

**Teabowl and Saucer c.1778-81**
**Diameter of saucer 4¾in. no mark**

A teabowl and saucer painted with small floral sprigs in crimson, below an entwined husk border tied with crimson bows. Typical decoration of the period. A factory mark affects the value of Bristol by about 10 – 15%.

*£38–48*

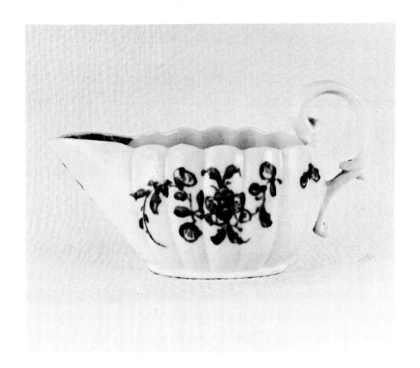

### Creamboat c.1775
#### Length 4½in. cross mark

An attractive fluted creamboat painted with flower sprays in a very bright tone of underglaze blue. This shape seems only to have been produced at Bristol. Unlike the blue and white Plymouth, most of the Bristol bears a factory mark. Rare.

*£40–50*

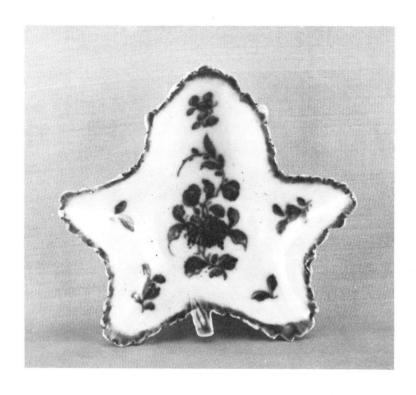

**Pickle Leaf c.1775**
**Diameter 3½in. cross mark**

One of the most common forms to be found in blue and white Bristol which is even rarer than the Plymouth. The Bristol blue is a much brighter tone than the Plymouth and the paste has a whiter appearance. Polychrome examples of this shape are fairly scarce.

*£32–40*

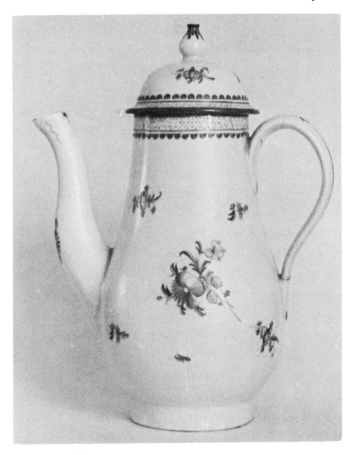

**Coffee Pot c.1790-1810**
**Height 10in. Pattern 22**

Newhall coffee pots are all of a similar shape, the earlier ones having a 'clip' handle and the others a plain loop. Later examples show the bulbous outline becoming heavier, more ponderous and with a higher domed lid. Fairly scarce.

*£60–75*

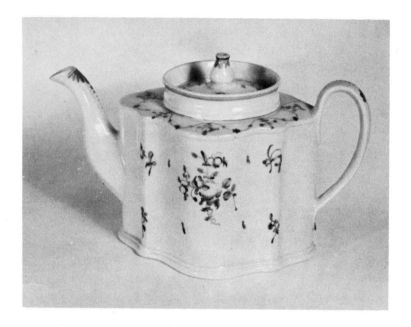

### Teapot c.1790-1810
**Height 5½in. Pattern 267**

This silver-shape specimen is the most typical of the Newhall teapot forms, although it was made at other factories. The pattern which was first used in the early 1790's is a common one and the decoration is pleasant and unpretentious.

*£32–40*

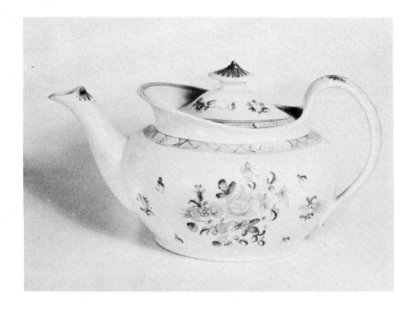

### Teapot c.1795-1805
**Length 9¾in. Pattern 593**

This is the smaller of the boat-shaped teapots made at Newhall. It is more elegant than the later examples which are taller and more bulbous. The shape is also found in enamel and gilded patterns. The design illustrated was first used in the late 1790's.

*£28–35*

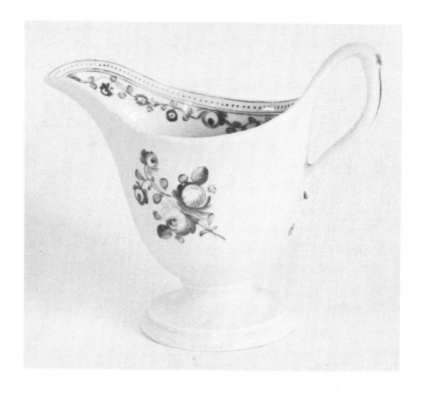

**Creamjug c.1782-90**
**Height 3¾in. Pattern 144**

This pedestal creamjug shows the characteristic 'clip' handle which is found only on pre-1790 Newhall. The design is a good example of the neat, elegant early enamel decoration. These jugs are found plain, reeded or faceted.

*£22–28*

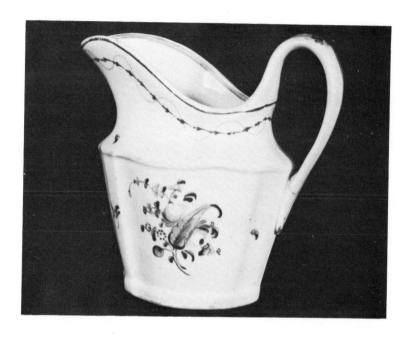

### Creamjug c.1790-1800
#### Height 4¼in. Pattern 208

This form of creamjug, which dates from after about 1790, is the most common found in Newhall and occasionally occurs in a smaller size. The decoration fits the shape well with a border around the neck and a flower spray in the middle of the side.

*£18–23*

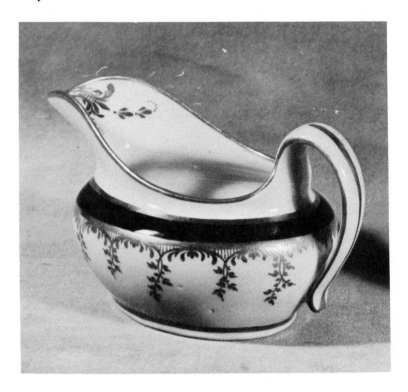

## Creamjug c.1795-1805
### Height 3in. Pattern 306

This smaller, and therefore more attractive and desirable boat-shaped jug, has elegant and restrained gilt decoration. Different patterns were created by using other coloured grounds; this one is mazarine blue. These jugs date from after the early 1790's.

*£16—20*

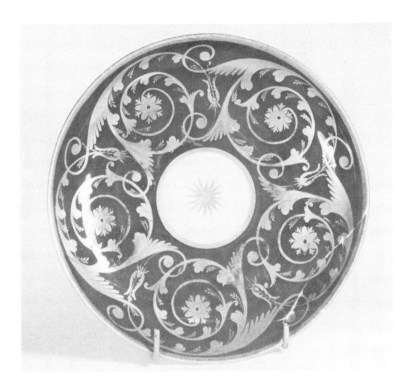

**Saucerdish c.1782-1810**
**Diameter 7¾in. Pattern 581**

Probably at least half the decoration found on Newhall is gilded. Early patterns are fairly restrained but many later ones tend to cover the whole surface and often include underglaze mazarine blue. This type of decoration was first used at Newhall in the late 1790's. Patterns which include gilding are not very popular with collectors.

*£10–14*

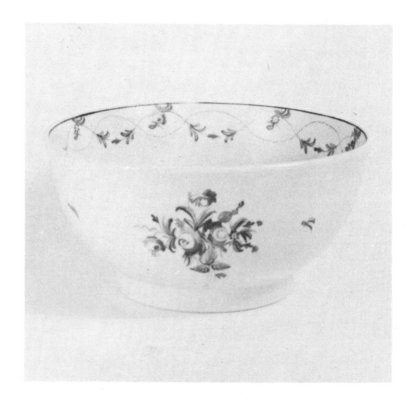

**Bowl c.1782-1810**
**Diameter 6in. Pattern 241**

A typical Newhall border and flower spray, although this particular design was used by many other Staffordshire factories. It was used at Newhall in the post-1790 period. Very common.

*£9–13*

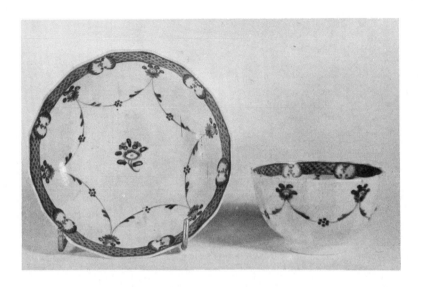

**Teabowl and Saucer c.1782-95**
**Diameter of saucer 5¼in. Pattern 78**

Tea services were made in plain, reeded, spiral-fluted and faceted shapes.
The early patterns were more restrained and neater than the later ones
and therefore more desirable. Fairly common.

*£10–13*

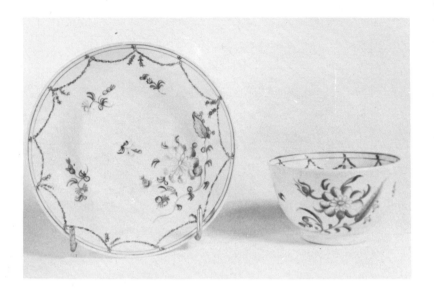

## Teabowl and Saucer c.1782-1810
### Diameter of saucer 5¼in. Pattern 596

More diffuse decoration is found on later wares, and the colours are not as bright or as clean. This fairly typical design was first used at Newhall in the late 1790's. Quite common.

*£9–12*

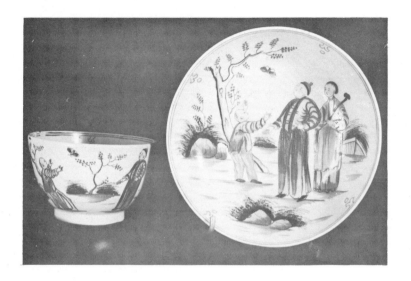

## Teabowl and Saucer c.1782-1810
### Diameter of saucer 5¼in. Pattern 421

The 'window' pattern is one of the most frequently found of the New-hall oriental designs. It was first used in the mid-1790's and is not a particularly popular pattern with collectors. Common.

*£9–12*

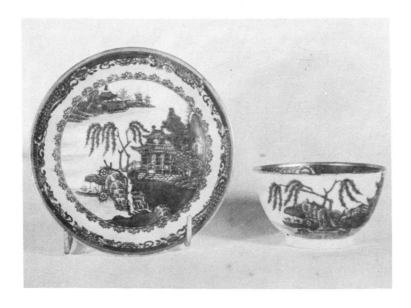

**Teabowl and Saucer c.1782-1810**
**Diameter of saucer 5in. no mark**

Like most Newhall designs in underglaze blue, this one is transfer-printed and has some added brush work. The pattern first appears in the late 1780's. The borders on the later examples are undistinguished. Fairly common.

*£6−9*

# FIGURES

Nearly all the major English factories in the eighteenth century produced figures as well as useful wares. The predominating influence until about 1760 was that of the Meissen factory which was justly famed for the beauty and technical perfection of its figures. Although most English figures lack the sophistication of their German counterparts, they have a charm, a simplicity and a simple dignity which is very appealing.

The following are a few of the more common subjects which were made at most of the factories. It will be noticed that they are mainly in pairs or sets.

1. The Four Seasons
2. The Four Continents
3. The Four Elements
4. Classical subjects e.g. Mars, Minerva
5. Gardener and Companion
6. Seated Monk and Nun
7. Sportsman and Lady
8. Gallant and Lady
9. Shepherd and Shepherdess
10. Cupids or Putti

## CHELSEA

Triangle period figures, like those from the mysterious 'girl in a swing' factory are extremely rare and correspondingly expensive and the chances of buying one outside the main London salerooms are remote.

Whilst some of the scarce raised anchor period figures (1750-53) are copied from bronzes or from Meissen originals, others were created by the factory's own modeller. There are some fine portrait busts which like many other raised anchor figures are left 'in the white' as well as a range of figures in European dress and some beautiful Chinoiserie groups. The models of birds perched on tree stumps are nowadays particularly sought-after.

The figures of the red anchor period (1753-58) are amongst the finest ever made in soft paste porcelain. The influence of Meissen is now even stronger, many German models being exactly copied. The softness of the Chelsea paste however seems to add a gentle charm to these figures which is lacking in their satirical Meissen prototypes.

Colours are sensitively though sparingly used and little gilding appears before about 1756. Allegorical subjects such as the Arts and the Seasons appear, the latter being produced in five different versions. Classical subjects were popular, as were the fine Italian Comedy figures. These command very high prices today and are amongst the most expensive of all types of English porcelain. The standard of Chelsea modelling at this period was unsurpassed by any other English factory; all red anchor specimens are now both scarce and expensive.

The sumptuous gold anchor period figures (1758-70) seem almost to belong to another age with their heavily scrolled bases, rich gilding and elaborate bocages. The Meissen influence had given way to that of Sevrès; the rococo style had now fully arrived. Richly decorated candlestick figures are fairly common as are the models of shepherds and shepherdess's and their variants. So lavishly and fully decorated are most of these models that there is often hardly any white porcelain to be seen. The well-known Chelsea 'toys' are tiny scent bottles, snuff boxes, bonbonnierès, cane handles and seals modelled in the form of figures and animals. The majority of these date from the gold anchor period although some were produced earlier. None of these 'toys' are more than about three inches or so in height.

## BOW

Even at their best, Bow figures must suffer in direct comparison with the finest Chelsea specimens. However, as with their useful wares, the Bow factory was catering for a slightly less sophisticated and refined taste. This is reflected not so much in the quality of their figures as in their simplicity and lack of pretentiousness.

During the period 1750-54 most if not all of the Bow figures and groups were modelled by the anonymous 'Muses' modeller. The subjects include actors and actresses, classical subjects and subjects taken from everyday life such as fruit-sellers, sailors, pedlars and domestic servants. These pleasantly modelled figures are heavily glazed and usually have low square bases.

For the next five or six years Bow figures retain their simplicity, freshness and charm but a greater range of subjects appear as the Meissen influence grows stronger. Amongst the most common are figures of monks, nuns, huntsmen, shepherds, classical subjects and sets of Seasons, Senses and Elements. The painted decoration is fine and varied; typical colours are yellow, emerald green and an opaque light

blue. Many Bow figures of the 1750's were left undecorated and these as one might expect are not quite as desirable as the coloured specimens.

The figures of the 1760's correspond roughly in date and style to the gold anchor Chelsea models. Ornate versions of the Continents, the Seasons and of Classical subjects have elaborate scrolled bases or sometimes rococo bases with four S-shaped feet. These figures are heavily rather than tastefully decorated. Pairs of candlestick figures are common and these invariably have elaborate bocages. Simpler, but intended for a very different market are the small cupids or putti which are more common in Bow than in any other factory with the exception of Derby.

## DERBY

Derby concentrated on the production of figures to a far greater extent than any other English factory. Not surprisingly the models vary considerably in quality but as a result of this degree of specialisation more Derby figures have survived from the pre-1780 period than those of all the other factories put together.

The earliest Derby figures (1750-54) take their family name from the 'dry edge' left free of glaze around the lower sides of their bases. The paste has a rich creamy appearance and the glaze is typically thick and glassy. The finest and most desirable figures of this period are the superb Chinoiserie groups representing the Senses. Most 'dry edge' figures are vigorously modelled and bear a resemblance to the early French specimens both in their paste and their decoration.

For several years after 1754 the Meissen influence became strong. The modelling and the paste is inferior to that of the earlier figures but the decoration in pale delicate colours, is pleasant. The characteristic Derby base of this period is rather wide. Variations of the gallant and companion theme constantly recur at this time.

In the late 1750's the influence of gold anchor Chelsea began to make itself felt, with its intricate bocages, rich gilding and exuberant colours. Candlestick figures are very common as are Classical figures, groups and various allegorical subjects. The large 'Ranelagh' figures were also popular, their name being taken from the pleasure gardens in Vauxhall. Nearly all the Derby figures of the 1760's have three or four unglazed patches under their bases; these are known as 'patch marks'.

In 1770, Derby took over the Chelsea factory but although the latter was kept as a going concern it was naturally stylistically dependant on

Derby. An even larger range of groups and figures was produced than before although their style was now less flamboyant. Some of the finest of the Neo-classical figures were left unglazed and sold in their 'biscuit' state. The inspiration for these models came from Sèvres. From about 1775-1784 numerals appear incised in the bases of most Derby figures.

## LONGTON HALL

It is probable that the first figures made at Longton Hall were the so-called 'snowman' figures. Most of these were undecorated and their poor modelling and thick glassy glaze combine to give them a rather crude primitive appearance. These figures which date from 1750-51, are all very scarce.

The figures of the middle period (1754-57) show a startling improvement with a variety of attractive and well-modelled figures being produced. Some of these were copied from Meissen but others were original creations. Models include pairs of cooks, Turks, gardeners and fruit and flower sellers. Whilst a few models are fussy and over-elaborate, others have a beauty, a simplicity of line and a sense of movement rarely seen elsewhere. The typical Longton Hall tone of yellowish-green is much in evidence as is a bright purplish pink.

During the last two or three years of the factory's life, the Chelsea gold anchor figures served as an inspiration, and some large and lavishly decorated figures were produced. Many of the late Longton Hall models also appear in hard paste versions at Cookworthy's Plymouth factory.

## PLYMOUTH AND BRISTOL

Most Plymouth figures were adaptations of Longton Hall models but the hard paste specimens can be immediately recognised by their hollow bases. The small range of models made include the Seasons, the Continents and groups of 'two putti with a goat'. A characteristic colour is the dull brownish crimson found on the rococo scrollwork bases. Fire cracks occur quite frequently on Plymouth figures and the glaze is sometimes stained brown by smoke.

Many Bristol figures somehow lack the character of the cruder Plymouth models and have a stiffness and awkwardness which is not compensated for by their detail and technical competance. Some figures are little more than coarsened versions of Derby models but others seem to be original creations. Subjects include the Elements,

several versions of the Seasons and some Classical figures. Instead of the rococo bases, Bristol figures usually have rectangular or rockwork supports.

## OTHER FACTORIES

All Worcester figures are very scarce and the few models known always fetch very high prices. Lowestoft figures are also extremely rare but of course much less valuable. Some undecorated models of nuns have recently been proved to have been made at Liverpool by Chaffers; they are slightly smaller than the similar models made at Bow and Longton Hall. Recent excavations have shown that Gilbody's Liverpool factory also produced some figures.

## ANIMALS AND BIRDS

Most factories produced models of animals and birds, although some of these are now extremely rare. The following are a few of the main subjects:

BIRDS made at Chelsea, Bow and Derby. All others are rare.

PUG DOGS made at Bow, Derby, Longton Hall and Lowestoft. Others rare.

LIONS made at Bow. Other examples are rare.

CATS made at Bow and Lowestoft but scarce.

SHEEP made at Derby and Bow. Others are scarce.

STAGS made at Derby. Other examples are rare.

SWANS made at Derby and Lowestoft.

BOARS made only at Derby.

It should be noted that some of the seated pug-dogs traditionally attributed to Longton Hall are now known to have been made at Lowestoft.

Few figures in anything like perfect condition can be bought nowadays for much under £150, and many will cost considerably more. Most collectors however, are willing to accept some slight damage on a figure especially if it is well restored. As a general rule, the price of rare models is likely to be less affected by any damage.

# Figures

### Chelsea c.1755
**Height 5½in. red anchor mark**

A well-modelled figure of a nun reading a book. Models of seated monks and nuns were also made at Bow, Longton Hall and at the Chaffers' Liverpool factory. Most of the latter were left undecorated and the modelling never matches that of the Chelsea specimens. The Chelsea version is rare.

*£330–420 (less if unmarked)*

## Chelsea c.1755
**Height 4¾in. red anchor mark**

A red anchor figure of Geography, a model which was also produced at Bow. The Chelsea figures of this period are the finest made at any factory in this country and the better specimens can bear comparison with Meissen examples. All red anchor period Chelsea figures are rare.

*£150–190*

# Figures

**Chelsea c.1754-55**
**Height 3¾in. red anchor mark**

A red anchor period figure of a child playing a tambourine. Chelsea putti are not nearly as common as their Bow or Derby counterparts. The red anchor mark should be a small one and is usually to be found low down near the base of the figure. A large anchor mark should be treated with suspicion.

*£100–125*

### Chelsea c.1765-70
**Height 11½in. gold anchor mark**

A gold anchor period figure of a gardener's companion. The lavish painted decoration and the heavily scrolled base are typical of the period.

*£240–280 each*
*£600–750 a pair*

# Figures

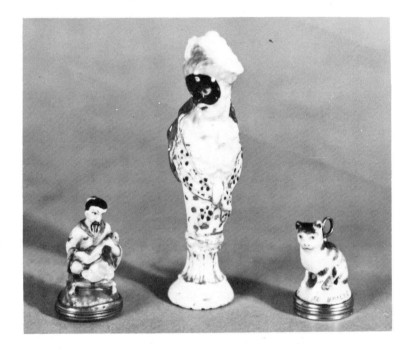

## Chelsea 'Toys' c.1755-60

A selection of Chelsea 'toys' the centre one of which is a cane handle. A number of different forms were made including miniature scent bottles, bonbonnières, seals and needle cases. Some models date from the red anchor period, others are by the 'girl-in-a-swing' modeller but most of them were produced in the post-1757-8 period.

*left to right £110–140*
*£180–250*
*£110–140*

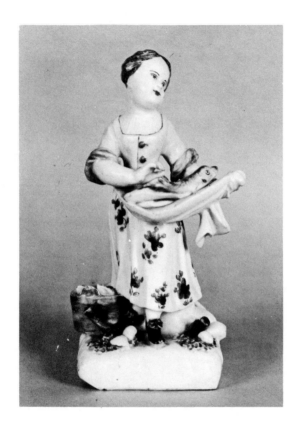

**Bow c.1754-56**
**Height 6in. no mark**

A charming early Bow figure of a fish-seller painted in bright colours. A square base of this type in Bow always indicates an early figure. This particular model is taken from a Meissen original. Very rare.

*£400–520*

# Figures

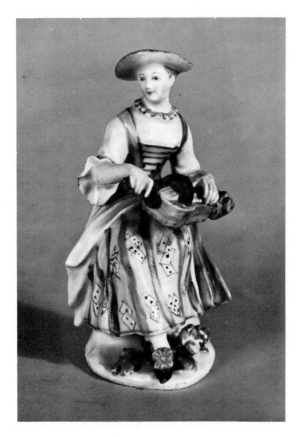

**Bow c.1755-60**
**Height 4½in.  no mark**

A figure of a seated woman playing a hurdy-gurdy. A similar model was produced at Longton Hall. This is one of the most common Bow models of the period and it also appears in an undecorated state. There is also a later version of this model on a four-footed scroll base.

*£200–260*

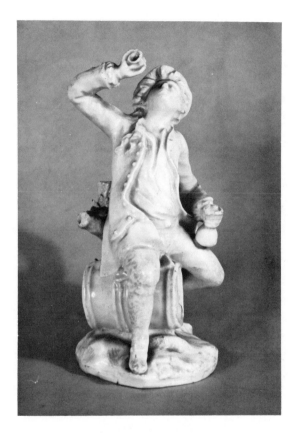

**Bow c.1755-60**
**Height 5¼in.  no mark**

A Bow white figure representing 'tasting' from a set of the Senses.
The model is sometimes known as the 'toper'. White Bow figures,
whilst not having as wide an appeal as coloured ones, are nevertheless
quite desirable particularly if the model is an interesting one.

*£120–155*

# Figures

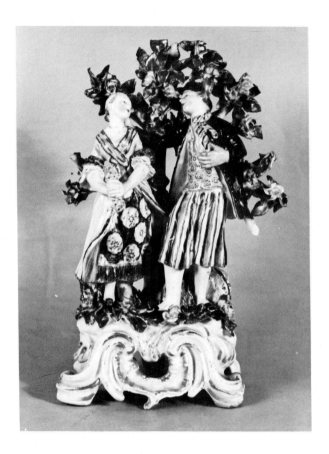

**Bow c.1761**
**Height 10in. no mark**

A fine group of a pair of lovers. The bocage and gilded scrollwork base are typical features of English figures of the 1760's. An elaborate group or figure of this type is hardly ever found in absolutely perfect condition and a slight or unimportant repair affects its value very little.

*£320–390*

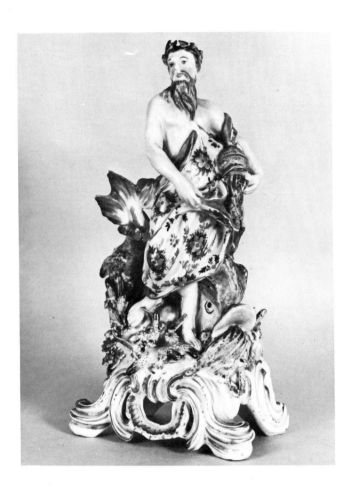

**Bow c.1765-68**
**Height 9in. anchor and dagger mark**

A Bow figure of Neptune on an elaborate scrollwork base which is typical of the period. This was a popular Bow subject and was made in several different versions during the 1750's and 1760's.

*£160–220*

# Figures

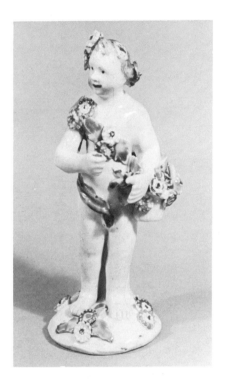

**Bow c.1765-72**
**Height 5¼in. no mark**

This is the most common of all English figures and both Bow and Derby produced these putti in large numbers. The Bow specimens do not vary much in quality, date or decoration but the Derby ones seem to have been made over a long period.

*£35–42*

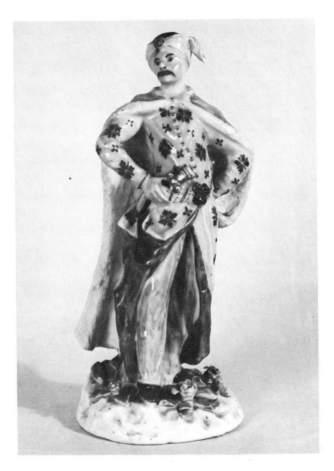

**Longton Hall c.1755-56**
**Height 7¼in. no mark**

This Longton Hall figure of a Turk dates from the middle period and was taken from a Meissen original. The model also occurs in saltglaze. Very rare.

*£450–600*

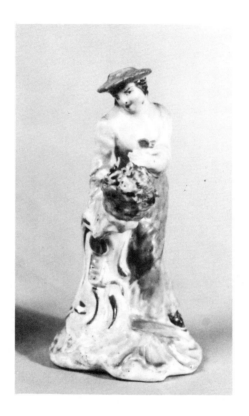

## Longton Hall c.1755-56
### Height 4¼in. no mark

A Longton Hall figure of a gardener's companion showing a typical scroll base of the factory. Most eighteenth century figures were made in pairs or sets and they tend of course to be more desirable when complete. All Longton Hall specimens are scarce.

*£290–370*

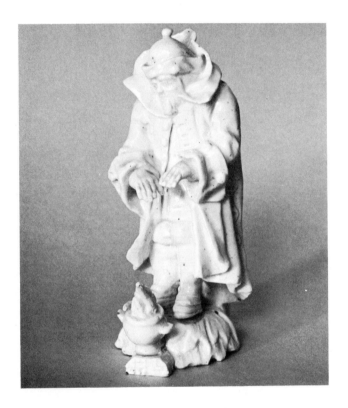

**Longton Hall c.1758-60**
**Height 4¾in. no mark**

A Longton Hall white figure of an old man warming his hands over a fire. This model which represents 'Winter' from a set of the 'Four Seasons', also occurs in the 'snowman' group of some eight or ten years earlier. The same version of the 'seasons' was made at Chelsea in the red anchor period. For some reason 'Winter' is always a more common model than any of the other three in the set.

*£120–150*

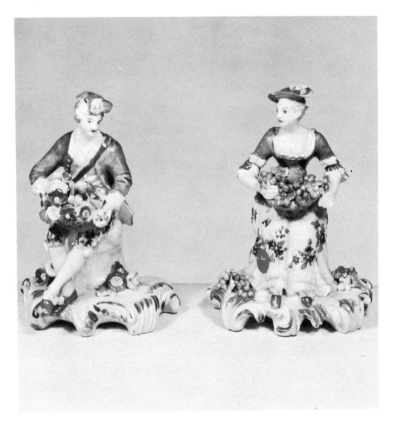

### Derby c.1756-58
#### Heights 5¼in., 5in. no marks

A pair of Derby figures with the typically wide rococo scrollwork bases. At their best the figures of this period are delicately modelled and finely detailed. The colouring is usually rather pale with a lemon-yellow often predominating and the chalky paste has a blued glaze. Most of the models are derived from Meissen.

*£450–550 the pair*

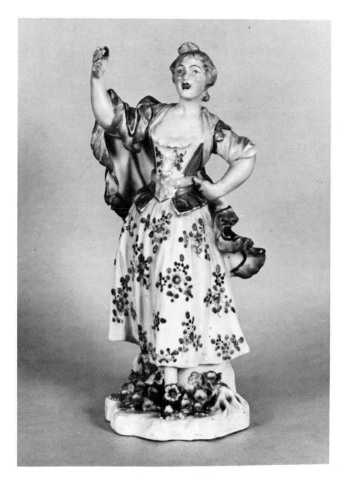

**Derby c.1765**
**Height 9in. patch marks**

An attractively modelled Derby figure of a ballad singer. This is a
fairly rare model.

*£250–300*

# Figures

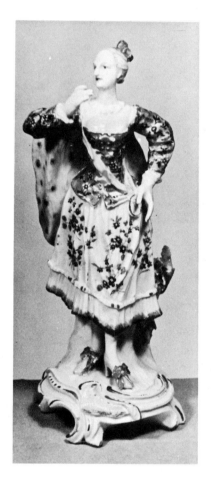

### Derby c.1765
### Height 11½in. patch marks

A typical Derby 'Ranelagh' figure showing the influence of gold anchor Chelsea. The name comes from the fashionable Ranelagh pleasure gardens which were in Vauxhall. A fairly common model.

*£175–225*

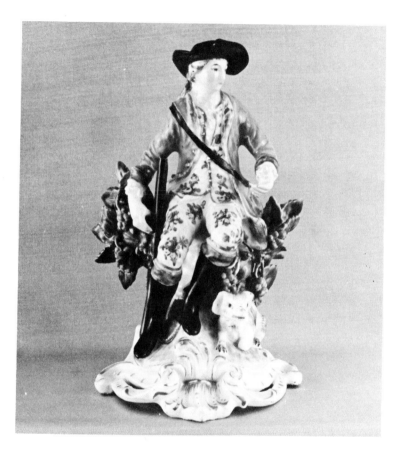

### Derby c.1765-70
#### Height 6in. patch marks

An attractive Derby figure of a sportsman. This is a fairly common Derby subject and it appears in various different models over quite a long period. Three or four unglazed 'patch marks' under the base are a constant feature on Derby figures of the 1760's.

*£120–160*

# Figures

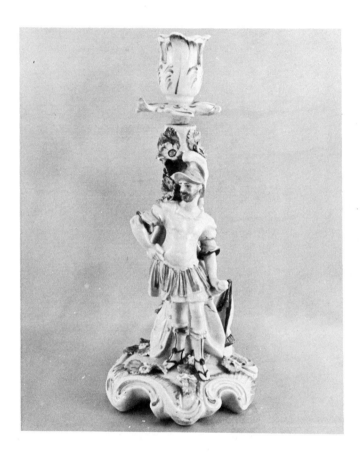

**Derby c.1765-70**
**Height 11in. patch marks**

This is one of a pair of candlestick figures representing 'Mars' and
'Venus'. This common Derby model is painted in pale colours.

*£85–110*

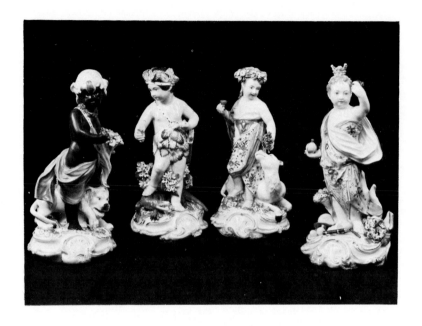

### Derby c.1770-75
**Heights 8½in., 8¾in. patch marks**

A set of Derby figures of the Continents, as children standing on pierced rococo bases, the name of each continent inscribed on the front. Most of the main eighteenth century factories produced versions of the Four Continents including Chelsea, Bow, Longton Hall and Plymouth. A complete set is always very desirable.

*£580–750 the set*

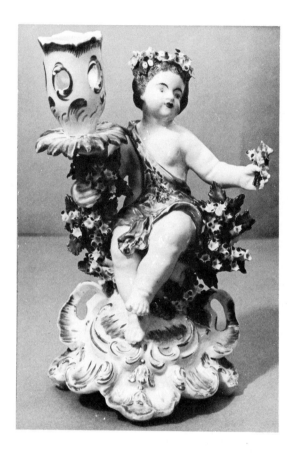

### Derby c.1770-75
**Height 7½in. patch marks**

One of a pair of Derby 'cupid' candlestick figures with elaborate scroll bases. This is a case where the pair of figures would be worth considerably more than twice the single one. Fairly common.

*£60–80*
*£150–200 the pair*

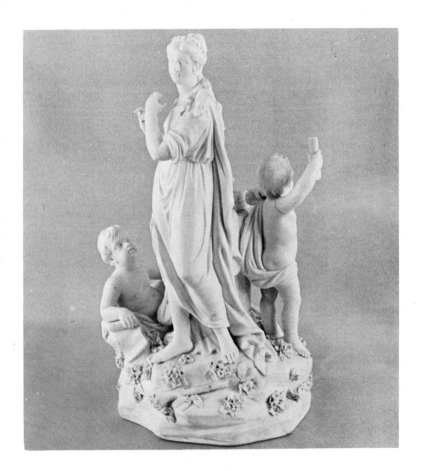

**Derby c. 1775-80**
**Height 10in. impressed numerals**

A Derby unglazed 'biscuit' figure representing 'Music' from a set of the 'Arts'. The modelling on most of these 'biscuit' figures is of excellent quality as only the finest specimens were left unglazed. A very specialized collecting field.

*£65–82*

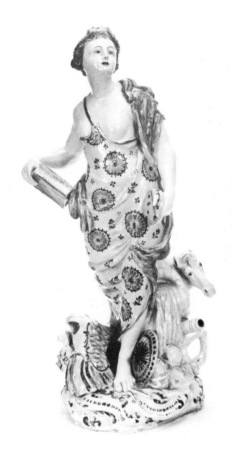

**Plymouth c.1770**
**Height 13in. no mark**

This female figure represents 'Europe' from the four Continents. The rococo-scrolled base picked out in purple is typical. Quite rare.

*£300–380*

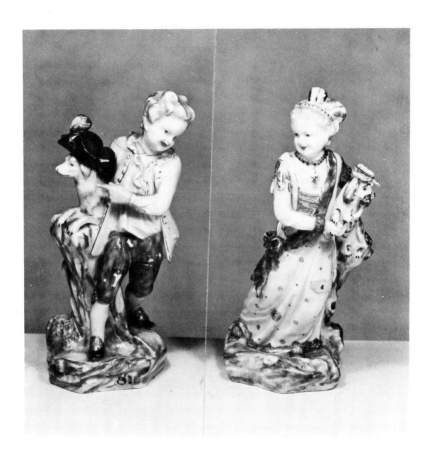

### Bristol c.1774
#### Heights 6¾in. no marks

A pair of figures of a boy and girl each holding a dog supported on a tree stump. The modelling is reminiscent of Derby and the rockwork bases are typical. All Champion's Bristol figures are comparatively scarce.

*£450–580 the pair*

# Figures

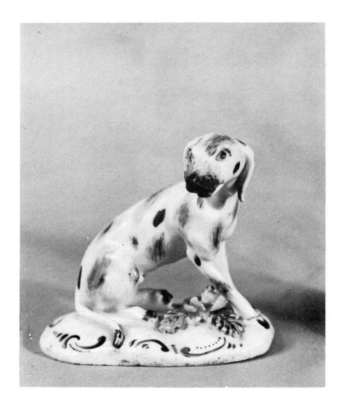

### Bow c.1755-60
**Height 3½in. no mark**

A fine Bow figure of a seated hound. These fine models are known as 'Dismal hounds' and are invariably attractively and vigorously modelled. They were originally made in pairs and are amongst the most desirable and valuable of all Bow animal figures. Rare.

*£320–400 each*
*£850–1,100 a pair*

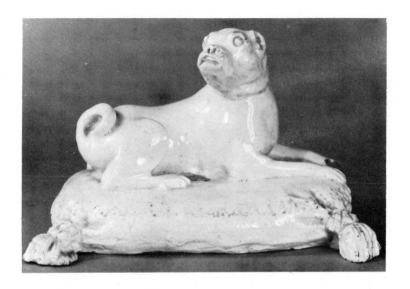

### Bow c.1754-56
#### Length 5½in. no mark

A Bow white figure of a pug dog lying on a cushion with tassels at the corners. A well-known Bow model. Other factories which produced models of pug dogs include Chelsea, Derby, Longton Hall and Lowestoft.

*£145–185*

# Figures

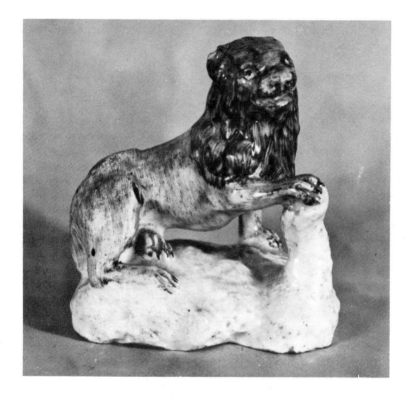

**Bow c.1755-60**
**Height 3¾in. no mark**

One of a pair of Bow models of lions. The undecorated version of this figure is more common. Models of lions were produced at various factories including Derby and Plymouth, but the Bow examples are by far the most common.

*£140–180*

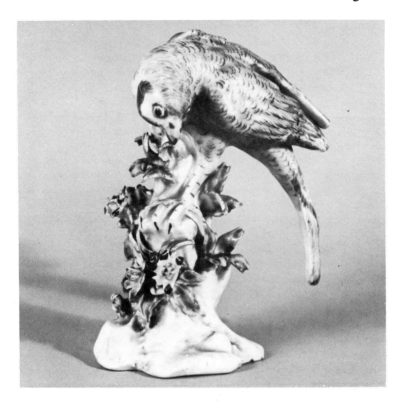

### Bow c.1755-60
#### Height 5½in. no mark

A finely modelled figure of a kestrel on a tree-trunk support applied with leaves and florettes. Its plumage is green with mauve markings. All models of birds are very desirable and the better modelled specimens are scarce and expensive.

*£800–1,000*

# Figures

### Bow c.1758-62
### Height 6¾in. no mark

A fine Bow 'Birds in branchis' group showing two buntings perched on flower-encrusted branches. The elaborate bocage is painted in a typically bright and vivid tone of green. A fine example of its type.

*£240–320*

### Derby c.1751-54
**Heights 6½in. and 4½in. no marks**

A fine pair of early Derby boars. This model was continued over a number of years until about 1765. Some slightly rarer specimens are decorated in colour. It should be noted that there are a large number of fakes of this model in existence, some coloured and some undecorated.

*£700–850 the pair*

# Figures

### Derby c.1760
**Lengths 4in. and 3¾in. patch marks**

An attractive pair of Derby figures of a stag and doe. Similar models were produced in the 'dry edge' period c.1752-53. These models are much less desirable as individual pieces. Fakes were made but they are fairly obvious ones. Other non-human figures made at Derby include sheep, squirrels, lions, pug dogs, and various birds.

*£420–550 the pair*

### Lowestoft c.1775-85
**Height 2¼in. no mark**

A Lowestoft figure of a swan. The modelling is fairly crude and the base is glazed. Swans are easily the most common of the figures or 'images' produced at Lowestoft. Other animal models made at the factory include cats, seated pug dogs, sheep and the very rare standing pug dogs. All Lowestoft figures are scarce. Human models of musicians and dancing putti are also known.

*£180–240*

# Figures

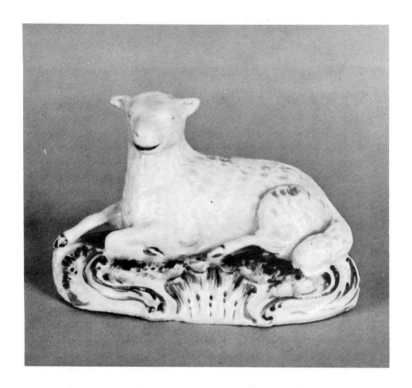

## Plymouth c.1768-70
### Length 3½in. no mark

A very rare Plymouth model of a recumbent sheep. The scrollwork base picked out in a dullish crimson is typical. Other models of animals produced at Plymouth include lions, hares and pheasants. All of these are very scarce.

*£130–165*

# COFFEE CUPS

Early English coffee cups are nowadays much sought-after as they take up little room, are easy to display and comparatively inexpensive to collect. Nearly all the eighteenth century English porcelain factories produced coffee cups, although specimens are both rare and expensive in such factories as Chelsea, Longton Hall and Lund's Bristol.

The polychrome specimens fall into eight main categories of decoration:-

1) Oriental flowers
2) European flowers
3) Oriental scenes
4) Chinese Mandarin patterns
5) 'Japan' patterns
6) Scale blue patterns
7) Bird decoration
8) Overglaze transfer prints

Most other forms of decoration are rare and correspondingly expensive. The majority of these cups can be bought for between £10−16 but rarity, quality or unusual decoration can make them more expensive. On the other hand, common, poorly decorated or late specimens might cost under £10 each.

Blue and white coffee cups tend of course to be less expensive and most examples can be bought for under £10. Possible exceptions to this are Longton Hall and Plymouth specimens which are scarce. As with the polychrome cups, certain patterns are particularly sought-after and this will affect the price. Generally speaking, the earlier the cup is, the more expensive it will be. As one might expect, painted cups are in greater demand than printed examples.

In addition to being an inexpensive means of collecting examples from all the major factories, coffee cup collecting is a useful method of learning to tell the factories apart. In comparing the various cups one is also comparing pastes, glazes, footrings, translucency and decoration. There is also always the chance of eventually finding a saucer for your cup and thereby greatly enhancing its value.

## Coffee Cups

### Chelsea Polychrome

#### c.1755
**Red Anchor mark**

A fairly typical Red Anchor cup painted with sprays of flowers. The shape and decoration is characteristic of the period. Desirable and relatively scarce.

*£25–35*

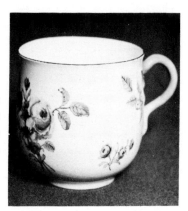

### Chelsea Polychrome

#### c.1758-62
**Gold Anchor mark**

This cup is superbly decorated with European figures in the style of Vincennes. It is one of the rarest forms of decoration to be found on early English porcelain.

*£50–65*

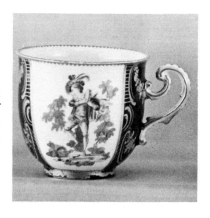

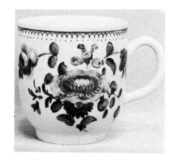

## Bow Polychrome
### c.1760-62
**No mark**

This cup is attractively painted in pleasant colours with English flower sprays. The pattern, the shape and the handle are all typical of Bow in the early 1760's. Common.

*£10–13*

## Bow Undecorated
### c.1753-4
**No mark**

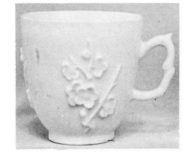

An undecorated cup with a raised prunus blossom pattern. The handle is one of the most common of the half a dozen or so different types which appear on these cups. Fairly common.

*£11–14*

## Bow Blue and white
### c.1762-65
**No mark**

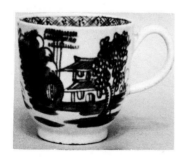

A typical Bow cup of the early 1760's painted with a Chinese scene. A 'blued' glaze near the footring is characteristic.

*£5–7*

## Coffee Cups

### Worcester Polychrome

#### c.1770
##### No mark

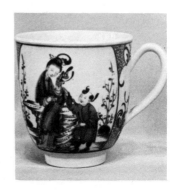

Worcester produced a large variety of Chinese Mandarin designs, most of which are more carefully painted than their Bow, Lowestoft or Liverpool counterparts. A typical and fairly common example.

*£10–13*

### Worcester Polychrome

#### c.1770-75
##### No mark

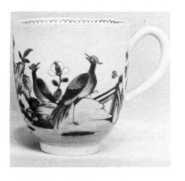

An unusual coffee cup, brightly painted with strutting birds, This type of decoration is very desirable and tends to be expensive. A rare pattern.

*£14–18*

### Worcester
### Blue and white
#### c.1770
##### Crescent mark

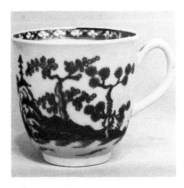

The 'blue rock' pattern is a very common one particularly in the 1770's. Both the shape and the handle are absolutely typical. Very common.

*£5–7*

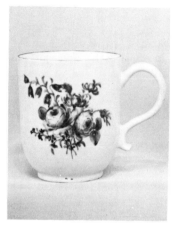

### Longton Hall
### Polychrome

#### c.1758
#### No mark

This attractively decorated cup was probably the work of the 'Trembly rose' painter, whose style resembles that found on some red anchor period Chelsea. The handle is rather similar to some found on Lowestoft, but it is better formed. Fairly rare.

*£18–25*

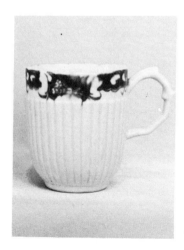

### Longton Hall
### Blue and white

#### c.1755
#### No mark

All Longton Hall coffee cups are rare and consequently expensive, whether coloured or blue and white. The handle of this example is characteristic of the factory.

*£11–16*

## Coffee Cups

### Derby
### Polychrome

### c.1756
**No mark**

This delightful coffee cup is painted with no less than seven oriental figures, some of whom are engaged in watching a cock fight. The shape of the handle is typical of the period and the footring is ground. Rare.

*£11−15*

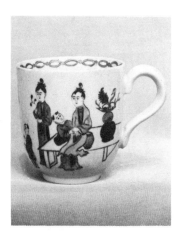

### Derby
### Blue and white

### c.1765
**No mark**

Strangely enough all blue and white Derby cups are scarce, particularly the pre-1765 specimens. The transfer print on this cup has run in places making it difficult to see the pattern.

*£6−8*

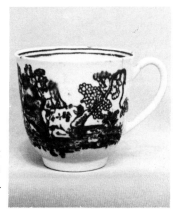

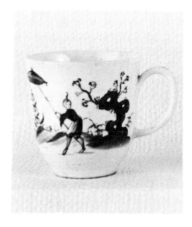

### Liverpool (Gilbody's) Polychrome

### c.1758-60
**No mark**

A charmingly decorated cup in overglaze iron-red, a form of decoration particularly favoured at this factory. Coffee cups of this group are amongst the rarest to be found in English soft paste porcelain.

*£12–18*

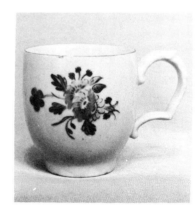

### Liverpool (Wolfe's) Polychrome

### c.1795-1800
**No mark**

Cups of this late group are usually decorated either with Chinese Mandarin subjects or with floral sprays. Some examples look deceptively early and might be mistaken for Longton Hall. The elaborate handle is typical.

*£6–9*

# Coffee Cups

### Liverpool (Ball's) Polychrome

#### c.1762-65
**No mark**

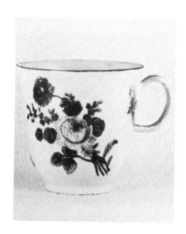

This rare coffee cup is decorated with a transfer print which is over-painted in enamel colours. As is the case with many unusual pieces of Liverpool, the rarity of this cup will not always be reflected in its price.

*£10–16*

### Liverpool (Ball's) Blue and white

#### c.1760-62
**No mark**

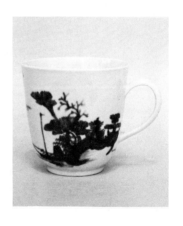

An attractively painted coffee cup painted in a bright, 'wet' tone of underglaze blue. The simple handle shape is typical. Quite hard to find nowadays.

*£7–10*

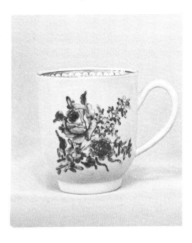

### Liverpool (Chaffers')
### Polychrome

#### c.1762-65
**No mark**

A typical Chaffers' cup with carefully executed floral painting. This factory produced a range of particularly attractive coffee cups including some fine specimens decorated with Chinese figures.

*£9–12*

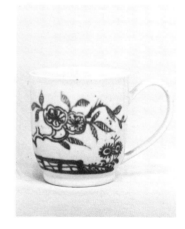

### Liverpool (Chaffers')
### Blue and white

#### c.1762
**No mark**

This thinly potted coffee cup shows the characteristic Chaffers' strap handle. The typical footring on a Chaffers' cup is curved on the outside and over-hung on the inside.

*£6–9*

433

### Liverpool (Christian's)
### Polychrome

#### c.1775
**No mark**

Many cups of this group are a little below average in height and slightly bell-shaped. The painting, handle-shape and border on this specimen are all typical of the factory. Quite common.

*£8–11*

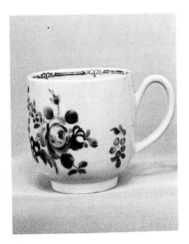

### Liverpool (Christian's)
### Blue and white

#### c.1772-75
**No mark**

These attractive moulded coffee cups bear a superficial resemblance to some Lowestoft specimens but the style of decoration is more likely to have been derived from Worcester. The border is a clue to this cup's Liverpool origin.

*£6–9*

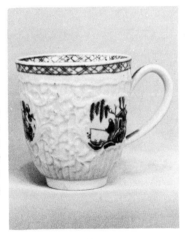

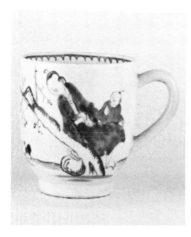

### Liverpool (Pennington's) Polychrome

### c.1782-85
**No mark**

A typical Pennington's cup painted with Chinese figures in rather muddy colours. Many Pennington's coffee cups are narrow in diameter and most of them have high footrings and crudely formed handles. Quite common.

*£6—9*

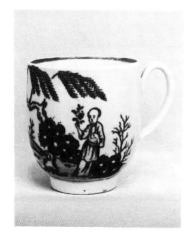

### Liverpool (Pennington's) Blue and white

### c.1778-80
**No mark**

This is a comparatively early cup and the influence of Christian's factory can be seen in its shape and its handle. The design is reasonably well-painted which is not often the case in the later examples from this factory.

*£4—6*

### Lowestoft
### Polychrome
### c.1778
#### No mark

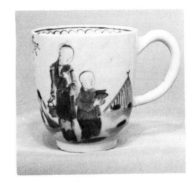

A coffee cup with Chinese Mandarin decoration of a type which is sometimes mistaken for Bow. This handle form is not seen after about 1780. The design is one of about twenty in Mandarin style of which about half are very scarce.

*£10–13*

### Lowestoft
### Polychrome
### c.1778-80
#### No mark

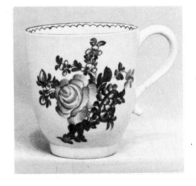

A common Lowestoft floral pattern. Polychrome Lowestoft cups tend not to vary much in price, although some of the sparsely decorated examples of the 1790's might cost under £10 each.

*£10–13*

### Lowestoft
### Blue and white
### c.1780
#### No mark

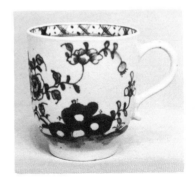

A common Lowestoft blue and white design. A more interesting middle period cup of fifteen or so years earlier would cost about 30% more.

*£5–8*

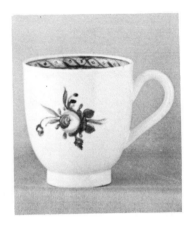

### Caughley Polychrome

#### c.1785-90
**No mark**

Polychrome Caughley coffee cups are fairly hard to come by and tend to be sparsely decorated. Despite their comparative rarity, they should not be particularly expensive.

*£5—8*

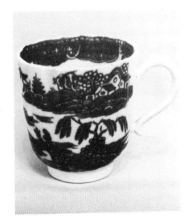

### Caughley Blue and white

#### c.1785-90
**S mark**

A typical Caughley transfer printed cup showing the popular Chinese style handle. Many cups of this type have gilded rims. Very common.

*£3—5*

### Plymouth
### Polychrome
#### c.1770
#### No mark

A typical Plymouth cup painted in 'famille verte' style. These cups tend to be taller than average and often have slightly flared rims. There are nearly always signs of spiral wreathing. Polychrome specimens are seldom marked.

*£12–18*

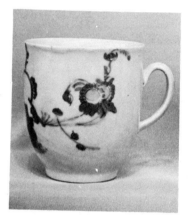

### Plymouth
### Blue and white

#### c.1770
#### ♃ mark

The underglaze blue on this cup is a typically blackish tone. Blue and white Plymouth cups are slightly rarer than polychrome ones but they are more often marked.

*£9–14*

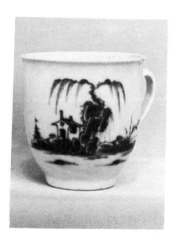

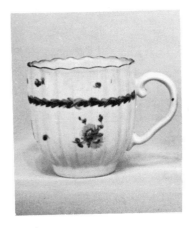

## Bristol (Champion's) Polychrome

### c.1778
**No mark**

A typical Bristol coffee cup showing one of the several handle forms which occur. The decoration on this cup is fairly unsophisticated but some specimens have richer flower painting and fine gilding.

*£10–13*

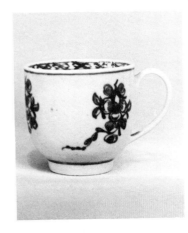

## Bristol (Champion's) Blue and white

### c.1775
**Cross mark**

This is easily the most common underglaze blue pattern to occur on Bristol. The blue is a very bright tone resembling that found on Chinese porcelain. All blue and white Bristol is rare.

*£8–12*

## Newhall
## Polychrome

### c.1795-1800
**No mark**

A typical Newhall coffee cup of the post-1790 period. Any floral decoration is usually sparse and rather artlessly done. These cups are fairly common and should be inexpensive.

*£3–4*

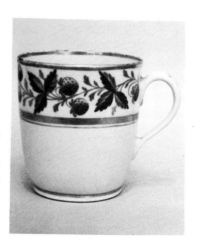

## Newhall
## Blue and white

### c.1795-1800
**No mark**

A typical Newhall blue and white coffee cup with a gilded rim. These cups, most of which are transfer-printed, are very common and not nearly as sought-after as the polychrome ones.

*£2–3*

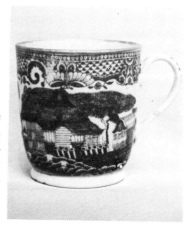

# FAKES AND COPIES

A detailed discussion of fakes in eighteenth century English porcelain is beyond the scope of this book. However I have mentioned below a few of the more commonly found fakes and copies in the hope that the collector will be put on his guard when examining similar pieces.

Chelsea 'goat and bee' creamjugs

Various Chelsea leaf-moulded wares; tureens etc.

Various Worcester blue scale decorated wares

Blue and white Worcester moulded sauceboats

Blue and white Worcester mugs printed with the 'pine cone' pattern

Pairs of Derby Boars. These were copied both in the white and in the coloured versions

Blue and white Lowestoft mugs inscribed 'Ab$^{rm}$ Moore August 29th 1765'. A set of three genuine soft paste mugs with this inscription are in existence.

Small Champion's Bristol teabowls and saucers decorated in green camaieu and with brown rims

Plymouth bell-shaped mugs decorated with exotic birds in the style of the examples on page 358.

# ADVICE TO COLLECTORS

1. The most difficult and the most essential thing that the porcelain collector must learn is to be able to tell the difference between hard and soft paste porcelain. The text of this book assumes that its readers are able to do this, but new collectors will not find it easy. The best way of learning is to buy a piece of Chinese hard paste porcelain and a piece of English soft paste porcelain and study their different textures. The outlay need not be much, as damaged pieces can be just as useful as perfect ones for the purposes of comparison. If still in doubt, take both pieces to a specialist dealer and ask him to try to explain the difference to you.

2. Try to handle as much porcelain as possible because this is far and away the best method of learning about it.

3. Visit museums with good collections of English porcelain but do not try to take it all in at once.

4. When buying from a specialist dealer always ask for a detailed invoice stating the condition, factory and approximate date of the article purchased. Any dealer who refuses to supply this should be regarded with caution.

5. When buying at auctions always decide on your price limit for a lot and do not exceed it. The fact that someone outbids you is no guarantee that you have undervalued the lot. He might want it more than you do or he might have more money than you. Remember that only the bigger salerooms offer any kind of guarantee as to the provenance and condition of what they are selling.

6. Watch out for repaired pieces. Repaired areas usually look and feel slightly different from the true body of the porcelain. A strong light will usually reveal cracks or built up areas as a darkening of the translucancy. Remember that the presence of a crack is no guarantee that the piece has not been repaired elsewhere.

7. Every now and then even the experienced collector comes across a piece of porcelain which he cannot identify. When this happens, study it and try to form your own conclusion. Then, take it either to a specialist dealer who you know fairly well or to the Victoria and Albert Museum. If neither can help you, you have at least the consolation of knowing that you have found something very unusual.

8. Make sure that your collection is adequately insured.

9. It is a good idea to keep a catalogue of your collection with a record of what each article cost, where and when it was bought and a

short description of it.

10. Take every opportunity you can of talking about porcelain. Join antique-collecting clubs where you can meet other collectors and learn from them. A friendly relationship with a specialist dealer can be very rewarding especially if you find that you can depend completely upon his advice and his knowledge.

11. When examining a piece of porcelain, always keep an open mind and do not leap to conclusions. Over-confidence can be as dangerous as ignorance.

# BIBLIOGRAPHY

The following list is of some of the most useful books on early English porcelain which have been published over the last ten or fifteen years.

## GENERAL WORKS

B.M. Watney, *English Blue and White Porcelain of the Eighteenth Century*

R.J. Charleston, *English Porcelain*

G. Savage, *Eighteenth Century English Porcelain*

## LUND'S BRISTOL AND WORCESTER

H. Rissik Marshall, *Coloured Worcester Porcelain of the First Period*

F.A. Barrett, *Worcester Porcelain*

H. Sandon, *The Illustrated Guide to Worcester Porcelain*

## LONGTON HALL

B.M. Watney, *Longton Hall Porcelain*

## DERBY

F. Brayshaw Gilhespy, *Derby Porcelain*

## LOWESTOFT

G. Godden, *The Illustrated Guide to Lowestoft Porcelain*

## CAUGHLEY

G. Godden, *Caughley and Worcester porcelains 1775-1800.*

## NEW HALL

D. Holgate, *Newhall and its Imitators*

## FIGURES

A Lane, *English Porcelain Figures of the Eighteenth Century*

# MUSEUMS

This is a selection of Museums open to the public which contain worthwhile collections of English porcelain of the period covered by this book. Specialist collections are denoted by the factory in brackets.

Many other museums have small displays of English porcelain worthy of inspection but these are too numerous to mention individually.

Bath: The Holburne of Menstrie Museum

Bedford: The Cecil Higgins Art Gallery

Birkenhead: Williamson Art Gallery and Museum. (The Knowles Boney Collection of Liverpool porcelain)

Birmingham: City Museum and Art Gallery

Brighton: Art Gallery and Museum (Worcester)

Bristol: City Art Gallery (Hard paste Bristol)

Cambridge: Fitzwilliam Museum

Cheltenham: Art Gallery and Museum

Derby: Museum and Art Gallery (Derby)

Hove: Museum of Art

Ipswich: Christchurch Mansions (Lowestoft)

Leamington Spa: Art Gallery and Museum

Leicester: The Museum and Art Gallery

Lincoln: The Usher Gallery

London: The Bethnel Green Museum

London: The British Museum

London: The London Museum, Kensington Palace (Chelsea and Bow)

London: Victoria and Albert Museum (Extensive collections of all factories)

Norwich: Castle museum (Lowestoft)

Oxford: The Ashmolean Museum of Art and Archaeology (The H. Rissik Marshall collection of Worcester porcelain)

Plymouth: City Museum and Art Gallery (Plymouth)

Preston: The Harris Museum and Art Gallery

Shrewsbury: Museum and Art Gallery

Stoke-on-Trent: City Museum and Art Gallery

Truro: County Museum and Art Gallery

Worcester: The Dyson Perrins Museum of Worcester porcelain

# INDEX